A Jew in Ramallah

and Other Essays

A Jew in Ramallah

and Other Essays

by Carla Blank

Baraka
Books

Montréal

© Carla Blank
ISBN 978-1-77186-356-8 pbk; 978-1-77186-371-1 epub; 978-1-77186-372-8 pdf

Cover by Leila Marshy
Book Design by Folio infographie
Editing and proofreading: Anne Marie Marko, Robin Philpot

Legal Deposit, 4th quarter 2024
Bibliothèque et Archives nationales du Québec
Library and Archives Canada

Published by Baraka Books of Montreal

Printed and bound in Quebec

TRADE DISTRIBUTION & RETURNS

Canada – UTP Distribution: UTPdistribution.com
United States – Independent Publishers Group: IPGbook.com

This book is dedicated
to Ishmael
and Tennessee

Contents

Carla Blank in 2019, at the Museum of Modern Art's exhibition, "Judson Dance Theater: The Work Is Never Done," standing next to the poster for "Dance by 5," an April 20-21, 1965 Judson Memorial Church performance including works by Carla Blank and Suzushi Hanayagi, Meredith Monk, Carolee Schneemann, and Elaine Summers. Poster design by Isamu Kawai. (Photo by Tennessee Reed)

Carla Blank Interviewed
by Ishmael Reed

Ishmael Reed:
I've been reading these jazz biographies, where aspiring jazz musicians go to a concert and they see some great performer, and they either want an instrument like the one they have, or they want to imitate them. Now, when you were a child, did you ever go to some concert where you saw a great dancer and that inspired you?

Carla Blank:
Oh, absolutely. Of course, Martha Graham. She was a great influence on my life and on my development as a dancer. She came to my hometown of Pittsburgh a number of times over the years. First in Pittsburgh or later in New York, and the American Dance Festival in New London. I saw her perform with her company in many of her signature works—*Appalachian Spring, Every Soul is a Circus, Letter to the World, El Penitente, Night Journey, Diversion of Angels, Acrobats of God, Clytemnestra,* and on and on. She was a woman who was widely recognized for her greatness during her own lifetime. Very unusual, especially for a dancer, and not even a ballet dancer but a modern dancer! I saw her give a speech at some sort of lady's luncheon in Pittsburgh, where I was born and raised. I don't remember what the occasion

was—perhaps it was a fundraiser, necessary to afford to bring her company to town. There she was, elaborately dressed in a fitted brocade sheath, high heels, and satiny opera gloves that extended above her elbows, stating in her imposing manner her aphorisms, sayings she was famous for, one after the other: "Everyone is born with genius, but most people only keep it a few minutes" was a favorite. Another was: "There is a vitality, a life force, an energy, a quickening that is translated through you into action, and because there is only one of you in all time, this expression is unique. And if you block it, it will never exist through any other medium and will be lost." And of course her belief that dancers are the "acrobats of God."

Ishmael Reed:
Your mother took you to these places?

Carla Blank:
We went as a family, but she was the driving force behind all this. Well, my mother and the organization she belonged to, where I was trained as a young dancer. It was called Contemporary Dance Association, and they were housed in the Arts and Crafts Center as one of a community of ten arts groups. There my teachers were Rose Mukerji and Rose Ann Lohmeyer, who both had attended summer dance work-shops at Bennington College in the 1930s and early 1940s, where the then-greats of modern dance, including Graham, Doris Humphrey, Charles Weidman and Hanya Holm were in residence.

Ishmael Reed:
So they brought those techniques to their training in Pittsburgh.

Carla Blank:
Yes, that was basically how I was trained, in the early classic modern dance techniques, rather than the way that much of my generation was being trained by the 1950s and 60s, which mixed in ballet training—something not allowed by the old school revolutionaries.

Then I also saw concerts by other dancers who influenced me, like Balasaraswati who practiced the Bharatanatyam style of classical Indian dance, and Uday Shankar, who fused classical traditional Indian dance traditions with European theatrical techniques.

Ishmael Reed:
Is he related to the musician Ravi Shankar?

Carla Blank:
He was Ravi's brother, and, if I am not mistaken, they would appear together, using the great raga improvisational form to structure their performances. And there was another Indian company who came to Pittsburgh a few times, who presented the traditional Kathakali style, a more martial arts-based form danced by men, with elaborate masks, voluminous multicolored costumes and drums. Great flamenco dancers and their companies stopped in Pittsburgh also. I especially remember Carman Amaya and José Greco. And Pearl Primus. She came to Pittsburgh twice with, as I remember, a concert of solo pieces influenced by her anthropological studies in Africa and the Caribbean. I'd never seen anyone jump like that. Actually, there weren't many modern dance touring companies when I was growing up in the forties and fifties—maybe six or seven companies. And because the Contemporary Dance Association sponsored many of them, sometimes dancers would stay at our home.

Ishmael Reed:
Like who?

Carla Blank:
Like members of the Dudley-Maslow-Bales company, which was headed by Jane Dudley, Sophie Maslow, and William Bales. Sophie Maslow and Jane Dudley had been featured dancers in Graham's company. Bales appeared with the Humphrey-Weidman company. As I remember, a lot of this company's work was based in folk tales and folk songs. I think that's where I saw Donald McKayle's now classic *Games* for the first time.

Ishmael Reed:
So your mother rented out rooms.

Carla Blank:
Not rented, just hosted modern dancers as guests because she was part of the Contemporary Dance Association, which presented most of them in concerts. Because nobody had any money. The dancers and us. And so I was able to be up close and personal with these dancers, seeing their exhaustion, their dedication. Important, unforgettable life lessons.

Ishmael Reed:
What other companies? Did any members of Jose Limón's company stay at your house?

Carla Blank:
I'm not sure if any company members stayed at our home, but I remember ironing their costumes for the *Moor's Pavane*. And being surprised at the weight of the fabric of those costumes.

Ishmael Reed:
How old were you?

Carla Blank:
Maybe ten, twelve, something like that. Limón choreographed the piece as a quartet, based upon Shakespeare's *Othello*. Limón danced Othello, Louis Hoving danced Iago, Betty Jones danced Desdemona, and Pauline Koner danced Emilia. Set to Henry Purcell's music, that great dance is considered one of the classics of modern dance. It influenced me, certainly.

Ishmael Reed:
Your mother, did she pay for your lessons?

Carla Blank:
Fortunately, she managed to find scholarships for me. I was a gifted child who just loved to dance. Starting when I was very young, I would dance when any music played on our record player. By the age of five, I was given scholarships to study modern dance, plus piano, and then violin, and by third grade I left public school to attend Falk Elementary School, an experimental private school attached to the University of Pittsburgh's Education department. Falk needed girl students, so two of my sisters and I benefitted from scholarships, which made it possible for us to go there. I spent much of my time at Falk collaborating with the music teacher, Mimi Kirkell, and other students in the school, making multidisciplinary performance works. That was a big influence on how I have lived my performance life.

And other tuition waivers or scholarships continued throughout my college years. By the time I graduated in 1963, the once revolutionary dance styles I had studied had become the academy, so I sought out the next revolution, which in New York City was happening at Judson Memorial Church.

Ishmael Reed:
And you were part of that movement. So who were some of the people you met? Dancers who are now well known?

Carla Blank:
For instance, my junior year of college I transferred to Sarah Lawrence College where two students who are well honored artists were in classes with me: dancer/choreographer Lucinda Childs was one year ahead of me, and composer/vocalist/choreographer/director/filmmaker Meredith Monk was one year behind me. They have Judson connections. A dancer in Paul Taylor's company for many years, Carolyn Adams, was also one year or two years behind me, I'm not sure which. And then Beverly Emmons, who was one year behind me, became a major lighting designer for dance and theater.

Ishmael Reed:
What was the first time you went to Judson? Do you remember?

Carla Blank:
I thought I attended my first choreography workshop in the fall of 1963, following my graduation from college, but when I checked the dates in dance scholar Sally Banes' *Terpsichore in Sneakers* and *Democracy's Body*, she sets the last Judson workshop session in Fall, 1964. (Musician Robert Dunn started leading these workshop sessions in the fall of 1961.) Other than a concert by Judson participants I attended that summer of 1963, this was what I remember as the beginning of my association with Judson. The session was located in the East Broadway loft of Judith Dunn, who at the time was married to Robert Dunn. Among those I recall being there were Judith Dunn, of course, Yvonne Rainer, Robert Morris, Elaine Summers, Sally Gross, Steve Paxton, Deborah

Hay, maybe Alex Hay and Tony Holder, and Lucinda Childs who did a spectacular piece, *Street Dance*, walking along the sidewalk across the street from the loft as we observed from a window above, while a recorded monologue of her voice described exactly what she was seeing, coordinated by a clock-timed score, down to the second. I think that's where I met Elaine Summers and Sally Gross, with whom I performed and became friends. I can't remember Robert Dunn's weekly assignments, but it was very fortunate that I was able to have that workshop experience.

Ishmael Reed:
Well, Marcel Duchamp was Judson. He killed modernism. I mean, his ideas influenced your directing of those elderly residents at the Home for Jewish Parents in Oakland—walking as dance, placing their daily life on stage for their families to see. That's life as art.

Carla Blank:
Right. The two performance projects I directed at the Home remain among my all-time favorites.

Ishmael Reed:
How many scores did you write and perform at Judson?

Carla Blank:
I think I performed at Judson around twelve times or so between 1963-1966. One big event was Concert #13, performed Nov. 19-20, 1963, whose program was titled "A COLLABORATIVE EVENT with ENVIRONMENT by Charles Ross." *Turnover* was my score within that event, in which I directed the women performers to overturn a huge, very heavy, welded steel pipe sculpture by Ross. I also performed in another piece during that program, *Room Service*, a piece credited to Rainer and Ross, in which three teams

of three people each, in the manner of the game Follow the Leader, moved around the Judson sanctuary amidst the tires, mattresses, welded sculptures, ropes, ladders, metal folding chairs and other stuff that Ross had assembled. Sally Gross and I were on the team that Yvonne led. In 1964 there was a big intermedia piece directed by Elaine Summers, *Fantastic Gardens*, where I performed a ballroom style couple dance with Rudy Perez, costumed in a slinky black ankle length slip dress. Another event I danced in that year that has been talked about a lot, maybe because it was such a campy outlier to the prevailing Judson aesthetic, was a story ballet choreographed by Fred Herko: *Palace of the Dragon Prince*, set to music by Berlioz and St. Saens. Then besides performing a couple of my own improvised pieces, mostly best forgotten, Sally and I performed two duets in 1964—*Untitled Duet* and *Pearls Down Pat*—plus I improvised in one of her own pieces, *In Their Own Time*, and collaborated with Elaine Summers on *Film-Dance Collage*. In 1965 I performed one solo improvisation, *Untitled Chase*, for Arthur Sainer, a playwright who was also a Village Voice theater critic at the time, and somewhere along those years I was in pieces by Aileen Passloff and Meredith Monk and happenings by Ken Dewey and Al Hansen, although Hansen's took place at a private estate on Long Island which included a swimming pool.

For me, the most important work I created and performed at Judson was *Wall St. Journal*, in 1966, which was my fourth collaboration with Japanese dancer Suzushi Hanayagi. It was motivated by two real life events: the death of Suzushi's two-week-old baby girl and the then-expanding Vietnam War. It revealed to me how I needed to find my own ways of working. To tell the truth, for me, a lot of what went on at Judson was good to experience as a performer, but as audience, was better to contemplate in theory. I was never completely in love with having abstraction be the sole motivation for my work—most often there was some narrative going on in my

mind too—what you might call "social realism" behind the abstraction.

Ishmael Reed:
You dealt with politics which critics viewed as a no-no during that time. A lot of these critics were former radicals themselves but got scared into art for art's sake by McCarthy. What was the first play that you directed?

Carla Blank:
I think it might have been a medieval mystery play, *The Second Shepherds' Play*, that was performed by high school girls, my students at Convent of the Sacred Heart in San Francisco. That school, built like a castle in 1915 by James Leary Flood, one of San Francisco's robber barons, had a beautiful wood-lined space similar in design to early Renaissance theaters, where I taught dance and drama classes from 1974-1976, so the setting was already there for the taking.

Ishmael Reed:
And so did you get the hook for directing then?

Carla Blank:
Yes it was a fresh challenge, partly inspired because my students were more interested in drama than they were in dance. That high school was probably the first place where I really worked on developing how to direct plays.

Ishmael Reed:
Didn't you know a lot about directing before then...?

Carla Blank:
Of course I had been directing myself and other people in dance works. And from a very young age, I saw a lot of theater, read a lot of plays, studied mime at Carnegie Tech

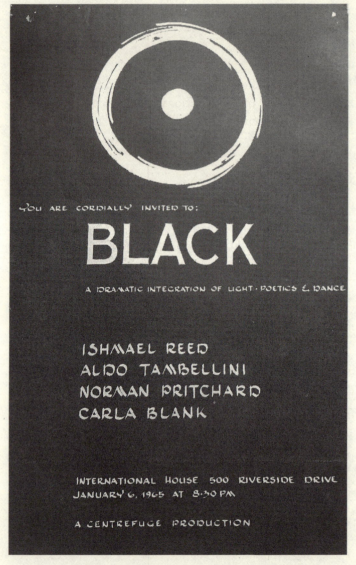

Poster by Aldo Tambellini for a multi-disciplinary
performance collaboration with visual art projections by Aldo
Tambellini, poetry by Norman Pritchard and Ishmael Reed,
and dance by Carla Blank. Performed at Columbia University's
International House and the Bridge Theater, in 1965.

(now Carnegie Mellon University) with Carlo Mazzone, and Dalcroze eurhythmics with Cecil Kitkat, and took courses in theater theory and design with Wilford Leach and scene study with Charles Carshon at Sarah Lawrence. Actually, the way I was trained as a dancer was similar to the way actors are trained in the Stanislavski method. When I choreographed my first big solo to Ravel's *Pavane for a Dead Princess*, around the age of thirteen, Rose Mukerji coached me by having me tell her what I was thinking: what is this, why are you doing that? For every action in the dance. That approach, which must have been consistent with Graham's, was really the polar opposite of how, for instance, people worked at Judson, where you might be variously asked to execute a task, or follow a list of rules, like rules of a game, or decipher a visual score like a musician would interpret a musical score.

Ishmael Reed:
So you've directed a bunch of stuff since then?

Carla Blank:
Oh yes—My training to direct theater works was mainly through on the job by the seat of my pants style training— figuring it out with non-professional actors in schools or community arts programs. I read a lot of books by directors, taking clues from what I could glean from their methods that would apply to whatever I was directing. I studied Viola Spolin, especially for ways to warm up actors and develop an ensemble out of a pick-up group; Constantin Stanislavski, Richard Boleslavsky, and various American Method style directors for creating back stories and motivations; Antonin Artaud and Bertolt Brecht for their alienation and critical techniques; and those experimenters who were being watched in the 60s and 70s like Jerzy Grotowski, Joseph Chaikin, Augusto Boal, Tadashi Suzuki. Many of the

pieces were original works, written by the students, which is a way I really enjoy working. And some were existing plays like Bertolt Brecht's *He Who Says Yes, He Who Says No*, *Twelve Angry Jurors* by Reginald Rose, Thornton Wilder's *Our Town*, *The Day Room* by Don DeLillo, Jean Giraudoux's *The Madwoman of Chaillot*, Agatha Christie's *The Mouse Trap*, and David Ives' one act plays. Plus you helped write a play for the Berkeley high school students, *Poppa Bizzard's Feast*, weaving together tales that all the participants had created for themselves as an animal character. And a high school production of your play, *Mother Hubbard*, convinced Miguel Algarin to bring it to the Nuyorican Poets Café as a musical. Later, I again directed a non-musical *Mother Hubbard*, for a literary conference in Xiangtan, China, in a production performed in English by Chinese college students.

Ishmael Reed:
But some of these works were viewed as though you were doing adult theater, reviewed in the newspapers. In the San Francisco Chronicle.

Carla Blank:
Yes. When I was teaching at Arrowsmith, a private Berkeley high school that no longer exists, I was often able to arrange to have these works mounted in U.C. Berkeley's well-appointed theaters, which were located a short walk from the school, besides being allowed to borrow items from the U.C. drama department's great cache of costumes and set pieces. Those spaces and design elements helped frame the productions to their advantage. And then there were the works I co-directed with Jody Roberts for the Children's Troupe, the performing arm of our non-profit after-school program where the performers ranged from five to eighteen years of age. We and the children created original works between 1979-1992, often in collaboration with other adult artists.

The performances happened at libraries, arts festivals, parks, senior citizen centers, shopping malls, schools, theaters, and museums. We even opened an AIA national convention with a performance called "Horse Ballet" in San Francisco's Union Square, inspired by the equestrian spectacles in sixteenth and seventeenth century European courts. (There is a little more information about horse ballets in my book review, "Apollo Could Be a Bitch: Jennifer Homans's Coffee Table Ballet.") These were some of the most exciting projects I ever worked on. Nothing like the magic of young performers.

My directing wasn't limited to working with children and young adults. I continued to work with adults, sometimes trained professionals and sometimes not. From 2003-2011, I worked as dramaturge and director of *The Domestic Crusaders* by Wajahat Ali, following a day in the life of a Pakistani-American family. From 2008-2010 I worked with director/designer Robert Wilson on *KOOL-Dancing in My Mind*. I write about that work in my essay, "Suzushi Hanayagi in Mulhouse." In 2013, I lived in Ramallah, Palestine, co-directing Palestinian and Syrian actors in an Arabic translation of American Philip Barry's play, *Holiday*, at the Al-Kasaba Theatre and Cinematheque, which presented this production in partnership with the American Consulate General in Jerusalem. My essay, "A Jew in Ramallah," recalls that experience. From 2013-2017 I was dramaturge and director of an international cast of dancer/actors and musicians in Yuri Kageyama's *News From Fukushima: Meditation on an Under-Reported Catastrophe by a Poet*. And most recently I directed two productions of your plays Off-Off Broadway at Theater for the New City: *The Slave Who Loved Caviar*," which I also choreographed; and a "Living Newspaper" styled play, *The Conductor*.

Carla Blank giving notes to the cast of *The Conductor*, a play by
Ishmael Reed. Sitting on the stage set, in the process of being
prepared for the premiere run at Off-Off Broadway's Theater for the
New City are, left to right: CB with open notebook, Emil Guillermo,
Imran Javaid, Kenya Wilson, and Laura Robards.
(Photo by Ishmael Reed)

Ishmael Reed:
And then, you started writing books, beginning with *Live
On Stage!*, which was based on your experiences with chil-
dren, right?

Carla Blank:
Yes, I think that was a twenty-year project as I began writ-
ing about my teaching experiences in the late 70s or early
1980s and it eventually evolved into a two-volume text-
book, co-authored with Jody Roberts, to help classroom
teachers integrate arts into their basic curriculum. The
anthology mixes performing arts traditions from around the

world, making cross disciplinary connections and generally expanding concepts of theater training to include traditional and experimental techniques. Everything was grounded in classroom and workshop experiences. Besides being used in schools around the country, it was officially adopted in four states: Tennessee, Idaho, Mississippi, and North Carolina, all places that I have barely stepped foot in, so that was amazing.

Ishmael Reed:
And then you did *Rediscovering America, the Making of Multicultural America, 1900-2000.*

Carla Blank:
That timeline book was inspired by my students at U.C. Berkeley, where I taught a course in twentieth-century art innovations on and off during the 1990s. When I realized many of the students didn't have much background in events that surrounded developments in the art world, I put together a timeline as part of their course materials to help them better understand the governmental, technological, and social changes that were occurring along with the artistic innovations. The timeline expanded as I continued to teach the course. Students suggested innovations they felt important to include, as eventually, once I signed a contract to write the book, did members of the Before Columbus Foundation, who also wrote the introductions to each decade, and many scholars and artists who wrote sidebars and served as consultants. That was about a ten-year project. The first essay in this collection, "Postmodernism," was written for *Rediscovering America.*

Ishmael Reed:
Next was the architecture book, *Storming the Old Boys' Citadel: Two Pioneer Women Architects of Nineteenth Century North America.*

Carla Blank:
Another ten-year or so project. You provided the impetus for that book, when you returned from a trip to Buffalo with a tale about how you noticed a plaque on the outside of a downtown hotel saying that it had been designed by Louise Blanchard Bethune, the first professional woman architect in the United States, who started practicing before the turn of the twentieth century. You had never noticed the building while growing up in Buffalo, and you wondered how it had fallen into such a state of disrepair, given this architect's history. Since I had never heard of Bethune, I began researching her life. As a woman working in the male dominated field of architecture, Bethune's story appeared very similar to stories I had learned about women scientists and other twentieth-century women professionals while writing *Rediscovering America*. It sounded like an important story to tell. Once Robin Philpot, publisher of Baraka Books, expressed interest in publishing it, Canadian architectural historian Tania Martin agreed to join the project. She wrote about Mother Joseph of the Sacred Heart, a Québec-born nun who is credited with architectural works built in the Pacific Northwest, following her arrival in Oregon Country in 1856. Three essays relate to how this project evolved from 2006-2014: "Neglecting A Grand Old Lady," "How Buffalo's Hotel Lafayette Went from Fleabag to Fabulous," and "Storming the Old Boys' Citadel."

Ishmael Reed:
You've performed as a jazz musician. So now you have been heard internationally all over Europe and in Japan as a violinist.

Carla Blank:
I was trained as a classical violinist, and still need to have a score to read as I don't improvise. I have heard the early jazz violinists didn't improvise either. A precedent!

Ishmael Reed:
Veteran jazz musicians at the Sardinia Jazz Festival admired your tone, and the CD *The Hands of Grace* on which you perform is a best seller in Japan. You also appeared on the CD *For All We Know*, featuring David Murray and Roger Glenn. Tell me about the essays in this book.

Carla Blank:
Yes, the twenty-three essays in this book were written over the past twenty years. Like those books I wrote and edited that we've talked about here, many were inspired as a way to bring attention to events and individuals who have been forgotten or widely neglected in most historical and critical accounts. Or who I felt just deserved more attention. They mainly appeared in *The Wall Street Journal, ALTA Journal,* and online at *CounterPunch* and *Konch* magazine, and in published anthologies.

Ishmael Reed:
How old were you when you got your first award nomination down there at the Los Angeles Press Club?

Carla Blank:
Those happened in 2022 and again in 2023. So I was 81 and 82.

Ishmael Reed:
You are competitive with some of the top journalists in the country.

Carla Blank:
Funny.

Ishmael Reed:
So what's next? I mean, we've gone through about four careers here.

Carla Blank:
Yes. I've been directing your newest play, *The Shine Challenge,*
2024. And I have a couple more book projects in mind.

March 2024

2

Postmodernism[1]

Critical theorists seem to agree only that postmodernism means "after modernism." Some critics place modernism's start in the early nineteenth century, when critic William Hazlitt labeled arts as "modern" that were made as urban, secular, industrialized societies arose. That art is now called Romanticism. Some others place it with the Futurists and Dadaists and their sense of life's absurdities that resulted from experiencing World War I, continuing through the Cold War and Abstract Expressionism. The two terms have a kind of call-and-response relationship, with most postmodernism expanding modernism's principles and experiments. By the mid-1960s, the arts are becoming more inclusive, more hybrid, and more exact in process. They exhaust everything about a subject, giving images a higher resolution by appropriating the particular process or object itself, as in Andy Warhol's Campbell's Soup tin-can paintings, Brillo box constructions, and silk-screened photos of celebrities and himself; or composer Anthony Brown's performance of Duke Ellington's hybrid compos-

1. First appeared as a sidebar essay in *Rediscovering America, the Making of Multicultural America, 1900-2000,* written and edited by Carla Blank. (Three Rivers Press, 2003), p. 336.

ition, "Far East Suite," where he translates the score using the particular instruments and scales that originally served as Ellington's inspiration. Just as modernism parodies the Victorian age of ornament, postmodernism parodies modernism, breaking away from parlors, galleries, or salons full of rich or elite patrons in order to travel to deserts and fields for site-specific installations, to cheer at poetry slams, and to experiment with computers. The establishment of Black, Hispanic, and Asian American studies programs reveals the populist impulse of postmodernism. Where scholars once dissected classical literature, ballet, and opera, they now also consider it worthy to investigate the dynamics of blues, jazz, rock and roll, hip hop, advertisements, television series, and movies. For feminism, a daughter of postmodernism, the modernist icon Sigmund Freud is considered a fraud. In fiction, the modernists' standbys of character development and plot are jettisoned, causing some critics to accuse postmodern writers of creating cartoons especially when a modernist icon such as Karl Marx morphs into the Marx Brothers. Postmodernism becomes so fashionable by the end of the 1970s, simultaneously invoked by intellectuals, journalists, sociologists and psychologists, and the advertising and fashion industries, that hierarchical distinctions like "high" or "low" culture and art become blurred. By the 1980s, postmodern aesthetic theories are ablaze with new jargon, such as the term *deconstruction* that particularly catches both popular and scholarly attention. It posits that all forms of communication—images, writing, speech, gestures, buildings, etc.—can be considered as texts that no longer have one objective truth, but are ambiguous, shifting in meaning and open to self-reference for nations, cultures, genders, classes, races, ages, and every individual.

3

Whose Abstract Art?[1]

"What is tradition today was contemporary yesterday,
and it can still be both—contemporary and traditional."

Jody Folwell, Santa Clara Pueblo potter

In *The New York Times* (April 7, 2006) art critic Holland Cotter
began a Weekend Arts review of "Energy/Experimentation:
Black Artists and Abstraction 1964-1980" at the Studio
Museum in Harlem stating, "Histories get lost. That's how
life is. Then, when the time is right, they get found." He then
calls abstraction "one of the most radical forms of 20th cen-
tury art...." This is your typical White phallocentric statement
which is not only applied to visual arts but to jazz criticism as
well. It's like the term post colonialism, which holds African
history should be defined in terms of European arrival and
exit from Africa.

 Holland Cotter's statement ignores the fact that examples
of abstraction can be found prior to the twentieth century
and appears to imply that White artists invented abstract art.
He continues: "also, abstraction raised authenticity issues. It

1. Contents from this essay first appeared in *The Green Magazine*,
 (08/09/06); a different version appeared in *CounterPunch* (01/18-
 20/13), with more additions integrated in March 2024.

Wall of the atelier of André Breton as displayed
in Centre Pompidou in Paris, France. (Alamy Stock)

is widely seen as white art, academic art. Whites view black
practitioners as copycats; blacks dismissed them as sellouts."
While this statement may contain some truth, it neglects to
mention that copious documentation exists to prove that
those late nineteenth and twentieth century visual artists,
living in Europe and the United States, who were looking
for new ways to express their individual visions, were at
least, in part, inspired by examining objects made by Native
American people, as well as other cultures based in Africa,
Asia, Mesoamerica, and the Pacific Islands. When even
court art styles practiced in Japan, Southeast Asia, Persia,
Egypt and other African civilizations were labeled under the
"primitive" or "tribal" rubric and relegated to ethnography
museums, where they often still remain, western artists'
exposure to the multitude of world art forms was not just a
matter of a few chance encounters.

Fact: Fossilized engravings were found in the South
African Blombos Cave, proven to be about 77,000 years old,
provide the earliest known evidence humans were creating

abstract images since at least the Middle Stone Age era. This find was first reported in January 2002 in the well-respected journals *Science* and *Scientific American*. Well documented abstract images have been found in cave paintings, as figurines, and decorative detailing on utilitarian objects made during the Upper Paleolithic era, lasting from about 50,000-40,000 years ago to 10,000 years ago. Then there are colossal monuments of archaic cultures such as Stonehenge, and the pictographs over fifty miles of Peruvian desert, thought to have been created between 500 BC and 500 AD by the Nazca Indians, a United Nations World Heritage site since 1994. Closer to home, explorers, adventurers, and archeologists have uncovered abstract images in the altered landscapes of earth mounds, scattered throughout the Midwest and Southern United States, some dating as early as 3500 BCE, including artifacts such as copper figures, shards of pottery, and bits of fabrics. All these examples demonstrate abstraction was a widely popular form of representation long before the twentieth century.

Fact: In the eighteenth and nineteenth centuries it was common for homeowners in Europe and the United States to display their family's collection of objects meant to fascinate in their front parlors, some of which were accumulated during Grand Tours, a refinement required of upper-class families. Known as a "cabinet of curiosities," it generally contained a mixture of specimens from natural and human creation. P.T. Barnum was the most famous American proprietor of public displays of "interesting curiosities." His American Museum, which opened in New York City in 1841, was filled with a jumble of rare and extravagantly "exotic" curiosities, including such odds and ends as a Turkish lady's boot and a dog sled from Kamchatka, objects that would later be labeled "found art."

Fact: By the later decades of the nineteenth century, universities systematically gathered ethnographic specimens from cultures under study by their anthropologists

and archeologists, which when stored became anthropology museums. The extensive collection of Tlingit carvings at U.C. Berkeley's Phoebe A. Hearst Museum of Anthropology, founded in 1901 in Kroeber Hall, exemplifies objects that fascinated the Surrealists, who, as was common to these relocations, stripped works of their indigenous context while admiring their aesthetics.

Fact: Non-realistic art was also on display at the over forty international expositions and world fairs held between 1870 and World War I. Among the most famous were Philadelphia's Centennial Exhibition (1876), Paris' Exposition Universelle (1889 and 1900), the Chicago World's Columbian Exposition (1893), Brussels' Exposition Universelle (1897), Buffalo's Pan-American Exposition (1901), and the Louisiana Purchase Exposition in St. Louis (1904), also known as the St. Louis World's Fair, where over seven months, nineteen million visitors viewed exhibits from forty-three participating nations. These ground shaking events brought American and European artists in direct contact with living artists of color from Asian, African, Pacific, Latin American, and Native American indigenous cultures, who were put on view in designated open air "native habitats" or "living anthropological exhibits," alternatively described as "human zoos," where they were directed to conduct their daily lives and practice their traditional art forms, including dance and theater performances as well as demonstrations of how their arts and crafts were made, which later would be called "happenings." Since these fairs were grounded in not-so-hidden objectives to demonstrate the spoils of Western colonial conquests and to prove the biological superiority of Whiteness, not surprisingly some terrible tragedies occurred related to abusive conditions endured by the inhabitants of their human exhibits. For example, 1,200 Filipinos, prized embodiments of the recent emergence of the United States as a major world power, were transported to the St. Louis World's Fair

in boxcars, causing some to freeze to death. At least three others died during their encampment on the fairgrounds. Mourning rituals, viewed by heedless White fairgoers as another performance, had to be practiced without access to the bodies, which had been immediately removed from the fairgrounds and eventually showed up in the Smithsonian and other museum collections.

Fact: By the end of the nineteenth century, artists could easily collect inexpensive curios in flea markets, brought by sailors, missionaries, and other travelers returning from colonized territories, and many gallery dealers offered quality examples of ancient African and Oceanic arts. In 1905 photographer Alfred Stieglitz founded the Little Galleries of the Photo-Secession, commonly known as "291" for its Fifth Avenue address. Evolving from its initial ambition to promote photography as art, Stieglitz began displaying avant-garde paintings and sculpture by European and American artists. In 1914, "291" mounted "Statuary in Wood by African Savages: The Root of Modern Art." Credited as the first U.S. exhibit of Central and West African sculpture, in spite of the title's mixed message, these works, created in the nineteenth century, were called "art" rather than "ethnography," and given their due for inspiring modern artists. Much of the statuary in this exhibit could be described as abstract.

Fact: Surrealism's philosopher André Breton displayed a "wall of objects," behind his desk in his Paris atelier where he lived from 1922 to 1966. This collection easily fulfills standard definitions of abstraction. Along with paintings and engravings by his friends and associates, including Francis Picabia, Roberto Matta, Wassily Kandinsky, and various famous others, there were sculptures from Africa, Easter Island, the South Pacific islands of New Guinea and New Ireland, besides other artworks including pre-Hispanic Mexican, Native American, and Inuit objects. (On the Surrealist map of the world, that appeared in 1929 in the Belgian periodical

Variétés and was probably drawn by Paul Éluard, Alaska is bigger than the whole United States.) Breton's wall was transferred and installed at the Centre Pompidou's show, "La Révolution Surréaliste" (2002) and was featured in critic Alan Riding's article for *The New York Times* (December 17, 2002) when everything in Breton's estate except the wall was being prepared for a 2003 auction. Riding says that Breton was especially inspired by Oceanic art, considering it "one of the great lock-keepers of our heart." Ishmael Reed, after viewing Breton's wall at the Pompidou in Paris commented that "instead of being called a Surrealist, Breton should be called an Africanist."

Fact: After its founding in 1929, New York City's Museum of Modern Art mounted various shows in the 1930s and 40s that heightened awareness of connections between contemporary arts and non-Western and indigenous traditional arts of the Americas. The aesthetics of Aztec, Mayan, and Incan art were featured in "American Sources of Modern Art (1933)," and "Indian Art of the United States (1941)" acknowledged the huge revival and popular reinventions of Native American arts by the early twentieth century, such as the prized plates and bowls by the Hopi master potter Nampeyo, and the Kwakiutl blankets, carved masks and boats, and ceremonial songs and dances documented in Edward Curtis's 1914 film, *Land of the Headhunters*. Including over one thousand examples of ancient, historic and contemporary arts and crafts made by American Indians living in the present continental United States, Alaska and Canada, *Newsweek* magazine said this show set Indian art "among American fine arts." Major MoMA exhibits of African and Oceanic art were assembled in 1935 and 1946. In 1985, when William Rubin, then director of MoMA's Department of Painting and Sculpture curated their famously controversial show, "'Primitivism' in 20th Century Art: Affinity of the Tribal and the Modern," he placed quotation

marks around the title word "Primitivism," to acknow-
ledge difficulties inherent in using this prevailing term.
Mr. Rubin also noted the word's embodiment of Western
Europeans' ambivalence when considering objects and cul-
tures based in traditional communities of Africa, Oceania,
Native America, Mesoamerica, and other non-Western
locales in his two-volume publication that accompanied
the show. The volumes included many photographs of art-
ists' studios and homes, revealing significant collections of
"primitive art." In the exhibit and two volumes, individual
works, similar to or the actual traditional objects owned or
viewed in museums by various icons of Modernism, were
juxtaposed with the modern works they influenced. These
European and American artists, soon to be considered
the vanguard of abstraction, included philosopher and
poet Guillaume Apollinaire, Georges Braque, Constantin
Brancusi, Alexander Calder, André Derain, Arthur Dove,
Maurice de Vlaminck, Max Ernst, Paul Gauguin, Marsden
Hartley, Henri Matisse, Jean Miró, Amedeo Modigliani, and
Pablo Picasso who proclaimed that "primitive sculpture has
never been surpassed."

As recently as 2012-13, New York's MoMA opened an
exhibition titled "Inventing Abstraction, 1910-1925." Their
promotional materials asserted:

> "Abstraction may be modernism's greatest innovation. Today
> it is so central to the conception of artmaking that the time
> when an abstract artwork was unimaginable has become hard
> to imagine."

This claim ignores the fact that American born artists
associated with Abstract Expressionism acknowledged their
study of the arts of other cultures. Jackson Pollock said his
action-based painterly approach was influenced by Native
American dance and painting. Barnett Newman focused
on Oceanic and pre-Columbian American arts, Adolph

Gottlieb on prehistoric petroglyphs, and Kenneth Noland on Diné (aka Navajo) blankets. American artists identified with earthworks or site-specific installations, including Michael Heizer, Maya Lin, Richard Long, and Robert Smithson, have cited the influence of monuments of archaic cultures such as the so-called Adena and Hopewell earth mounds of Native American cultures who were located in the Ohio River Valley and across Eastern and Midwestern America from about 1,000 BC-AD 500; pre-Columbian ritual cities like Teotihuacan; and the ball court at Chichén Itzá in the Yucatán.

So many artists have utilized pre-existing objects and monuments, ancient or not, to create new works that the art world accepted and defined the practice with terms such as "found," "borrowed," and "appropriated." "Reinvented," a term with similar meaning, is buried in the second paragraph of the press release for MoMA's "Inventing Abstraction, 1910-1925." So why did MoMA choose not to use it, as "Reinventing Abstraction" would have conveyed a more accurate description of the contents of this show?

Painter and printmaker Vincent D. Smith is quoted discussing the world of Black artists who worked in Greenwich Village during the 1950s, the center of Abstract Expressionism in the United States, in Sharon Patton's *African-American Art* (Oxford University Press, 1998). Mr. Smith says, "The art scene was in transition. There were the social expressionists and the up and coming abstract expressionists. We were influenced by everything. The French painters, Picasso, Brancusi, Klee, the Dutch painters, the Flemish school, Zen Buddhism, the Mexican painters, the German expressionists, the Japanese woodcut and African sculpture. Within the styles and forms and techniques of these schools we painted and experimented and attempted to find our way." It would be helpful to everyone's sense of history if critics and cultural historians could maintain this generosity of spirit

and consistently acknowledge all sources of what is generically referred to as abstract art. Moreover these influences shouldn't be admired because they inspired White male artists; they speak for themselves.

The Palace of the Governors was built on the north side of Santa Fe
Plaza between 1610 and 1614 by the Spanish, serving as their royal
palace during their occupation of the southwest. The oldest public
building in continuous use constructed by European settlers in the
continental United States, this one-story adobe structure then served
as the official New Mexican governor's residence until 1909, and was
rehabilitated, with a few minor modifications, into the anchor of the
New Mexico History Museum, which opened in 1913, one year after
New Mexico became a state. (Alamy Stock)

4

"America, the Beautiful"[1]

The recent visit of Britain's Queen Elizabeth to Jamestown, Virginia, [in 2007] was accompanied by a flurry of articles about the founding of the United States by Anglo-Saxons. These narratives accurately state that Jamestown was the first permanent English settlement but err when calling Jamestown the first permanent European colonial settlement in America. *Time* magazine's May 7th edition had a banner headline on the cover, "America At 400, How Jamestown colony made us who we are." Inside, the headline to Richard Brookhiser's feature article called it "An in-depth look at the place where our nation began to take shape." Buried in the *Time* article was an acknowledgement of some Spanish presence by 1607: "The 104 English settlers were late entrants in the New World sweepstakes. Spain had conquered Mexico by 1521, Peru by 1534."

These claims ignored the first permanent territorial settlements on the current U.S. mainland, which were also Spanish:

• In 1565, the capital of the Spanish colonial territory of La Florida was founded at San Agustín (now Saint Augustine)

1. First appeared in *CounterPunch*, 27 June 2007. Also translated by Mireia Sentis as "El olvido del papel espanol en la fundacion de Estados Unidos" in *El Pais*. 10 September 2007.

by Spanish naval commander Pedro Menéndez de Avilés, and remained a possession of Spain until 1817.

- In 1607, in the Spanish territory of New Mexico, an area that would become the southwestern United States, the Spanish settled Santa Fe the same year as Jamestown's first settlers arrived. In 1610, Santa Fe was formally founded and designated as the capital, making it the oldest capital city in the country. By 1610, the Palace of the Governors, from which the Spanish ruled New Mexico, was built on the new town's plaza using a style and materials adopted from the local Indian pueblos. It continues to stand there today.

Our national preference for claiming English ancestry is not a new trend. Most historically oriented U.S. literary anthologies start with the Puritans, without a hint there were non-English literatures already published before the Puritans even arrived. The earliest ethnographic account of life in the lands that would become the United States was written in Spanish, not English: Alvar Núñez Cabeza de Vaca's *La Relación* (1542). How many U.S. citizens are aware that Spanish letters and learning initiated important institutions of what became U.S. culture? According to Nicolás Kanellos' introduction to *Herenica, The Anthology of Hispanic Literature in the United States*:

> "For better or worse, Spain was the first country to introduce a written European language in an area that would become the mainland United States. Beginning in 1513 with Juan Ponce de León's diaries of travel in Florida, the keeping of civil, military, and ecclesiastical records eventually became commonplace in what would become the Hispanic South and Southwest of the United States. All the institutions of literacy—schools, universities, libraries, government archives, courts, and others—were first introduced by Hispanic peoples to North America by the mid-sixteenth century."

But Kanellos' facts are ignored by public intellectuals whose access to the media is immense.

The late historian Arthur M. Schlesinger, Jr. defended the myth that the nation is influenced by one European culture in his 1992 book, *The Disuniting of America: Reflections on a Multicultural Society*:

"The white Anglo-Saxon Protestant tradition was for two centuries—and in crucial respects still is—the dominant influence on American culture and society. This tradition provided the standard to which other immigrant nationalities were expected to conform, the matrix into which they would be assimilated."

Schlesinger's defense brings up another popular stance of public intellectuals: that the Anglo-Saxon Protestant tradition has been granted immunity from its own ethnicity, allowing them to claim the United States has entered a post-ethnic period. In "Trans-National America" (*The New York Review of Books*, 11/22/1990), political science professor Andrew Hacker reviewed five books on subjects related to ethnicity in U.S. classrooms. His discussion revealed the books held many conflicting viewpoints and questions. Hacker nonetheless concluded that Alexis de Tocqueville's one hundred-and-fifty-year-old assessment of the United States—that the "prevailing model [for the] country has remained 'Anglo-American'"—is still accurate "in many respects."

If this viewpoint has become a standard for educational indoctrination, it was encouraging to see that 26 percent of the mail received by Time, as reported in their "Inbox" on May 21, felt that "focusing on Jamestown excludes other cultures that helped make America," even though 74 percent voted *Time*'s "Taking an honest look at life in Jamestown enriches our democracy."

Omitting the multiplicity of events and cultures that evolved over more than two thirds of the territory of the U.S. mainland only continues to keep us from recognizing and therefore understanding fundamental aspects of our national identity.

Whitlock's collection of Ethiopian melodies. As sung with great applause by William Whitlock at the principal theatres in the United States (circa 1845). (Library of Congress Prints and Photographs Division, Washington, D.C.)

5

Elvis Presley:
King or Apprentice?[1]

In James Brown's *I Feel Good: A Memoir of a Life of Soul*, Brown recounts that when he first watched Elvis Presley in performance, Presley imitated him so closely that Brown commented, "That's me up there."

Peter Guralnick (in his 08/11/07 Op-ed in *The New York Times* titled "How Did Elvis Get Turned Into a Racist?") is the latest critic to distance Elvis Presley from the Black artists from whom he borrowed, claiming that Presley fused rock and roll (Black), with what is known as country western or "hillybilly" music (White). This achievement was credited by one NPR commentator with "changing American music forever."

One problem with this description, which seems to be the consensus among White critics, is that others had accomplished this fusion before Presley. And Mr. Guralnick's article, even though pointedly including Elvis Presley's acknowledgement of his Black mentors, still presents a musical racial divide that historically did not occur. He, like many critics, omits the Black contributions to country

1. First appeared in *CounterPunch*, 15 August 2008; with additions integrated in March 2024.

western music, an amalgam of African and Celtic musical traditions which evolved across the American South.

Country music is considered, along with southern folk hymns and the New England hymns, to be an indigenous American music form, one that provided the basis of what is called the "American" music tradition. Case in point, the easily documented development of the banjo, a signature instrument in the country music sound: In the 1740s it was introduced to colonists by enslaved West Africans, as a two or three stringed instrument made out of a gourd, called the banjer, which was played in a melodic downstroke "picking" style. Travelers' journals document the banjo had reached Wheeling on the Ohio River (in present day West Virginia) by 1806, twelve years ahead of the new National Road, and was heard in western Kentucky by the early 1820s, with its evolution into the five-string banjo occurring by the late 1840s, when one of the earliest known White banjo players, Virginian Joel Walker Sweeney (1810-1860), was making the instrument popular while appearing in early minstrel shows.

In regard to the critics' claims that Elvis Presley set the precedent in fusing country western and rock 'n roll, the bestselling hits of Fats Domino ("Goin' Home/Reeling and Rocking," 1952; "Goin' to the River/Mardi Gras in New Orleans," 1953; "Thinking of You/I Know, 1954;" "Ain't That a Shame," 1955; "Blueberry Hill," 1956) and Chuck Berry ("Maybellene/Wee Wee Hours," 1954; "Roll Over Beethoven," 1956; "Rock and Rolll Music," 1957; "Johnny B. Goode," 1958) could as accurately be said to deserve the credit for that innovation.

Also around this time, the Black performing artists Wynonie Harris ("Bloodshot Eyes," 1951), The Orioles ("Crying in the Chapel," 1953), Ray Charles ("I'm Movin' On," 1959), Bobby Hebb ("Night Train to Memphis," 1960) and Solomon Burke ("Just Out of Reach," 1961) were creating some of the many other "soul" hits by Black performers which also fused country western and rock 'n roll.

In addition, Presley often collaborated with Black song-writers, such as Otis Blackwell (1931-2002), who wrote the following classics, given with the dates they were recorded by Presley: "Don't Be Cruel," 1956; "All Shook Up," 1957; "Return to Sender," 1962; and "Fever," 1960. When Blackwell was interviewed by David Letterman on January 10, 1984, he explained that Presley's credit as co-writer was required in order to sell his work, a common practice of the time. He also related how Presley's renditions were modeled upon his own performing style, as sent to Presley on demo tapes. Then accompanied by Letterman's house band, Blackwell exhibited this similarity with his delivery of "Don't Be Cruel."

Moreover, to claim that country western music is White music is to ignore Black country western artists, who have been disappeared from American musical history by chauvinistic critics. Some of these Black musicians were recorded in the 1920s to 1940s, often as members of integrated string bands, their music mixing traditional ballads and fiddle tunes with blues and ragtime. In *My Black Country*, Alice Randall recounts how country music history was made July 16, 1930, with the recording of "Blue Yodel #9" by Louis Armstrong, Jimmy Rodgers as vocalist (who was White and often called the "Father of Country Music"), and Lil Hardin on piano. With this recording, Hardin, a Fisk graduate and Armstrong's wife at the time, became the first Black woman to have a country hit that sold a million copies.

Other Black country music musicians were mainly soloists, like the legendary twelve-string guitarist Huddie William "Lead Belly" Ledbetter (1888-1949) whose concerts and Library of Congress recordings of folk classics such as "Midnight Special," "Goodnight Irene," and "Rock Island Line" in the 1930s and 1940s, which, when re-recorded by many White folk and country singers, fueled an American folk music revival in the 1950s and 1960s; and DeFord Bailey (1899-1982), the master harmonica stylist who was the first

star of the Grand Ole Opry, the premier country western showcase located in Nashville, Tennessee. Bailey appeared as a regular Grand Ole Opry act for fifteen years, between 1926 and 1941. Since its beginning in 1925 as the radio station WSM (after the logo of its sponsor, National Life and Accident Insurance Company: "We Shield Millions"), the Grand Ole Opry's radio show and performance space has been home to country western music's top performers. As the legend goes, even Grand Ole Opry's name was inspired by a DeFord Bailey performance in 1927, when the announcer, George Hay, commented, "For the past hour we have been listening to music taken largely from the Grand Opera, but from now on we will present the Grand Ole Opry." The Grand Ole Opry has made billions; DeFord Bailey died penniless. Finally, after years of debate, Bailey was inducted into the Country Music Hall of Fame in 2005.

White country western stars like the Carter Family, White rock 'n roll musicians—like Elvis Presley, the Beatles, and the Rolling Stones—and White jazz musicians like Gene Krupa, admit to their indebtedness to African American mentors. It's the critics who claim that these White musicians have somehow transcended the efforts of those who inspired them. These critics not only insist that White males be at the center of their own narrative, but also the American narratives of everyone else.

6

Neglecting a Grand Old Lady[1]

Christened "Queen City of the Lakes," Buffalo, New York, sits on the shore of Lake Erie. Like many major cities of the world, Buffalo's prime location beside great water resources was largely responsible for it's becoming a boom town during the nineteenth century, and a gateway to the western frontier. While today, Buffalo's growth is something like 2.5 percent, and many consider the city to be on life support, the city was once a thriving lakeport metropolis with a soaring economy based on grains, railways, steel, and an important water system, the Erie Canal.

In 1825, the Erie Canal opened, making Buffalo the central transfer point between Albany and New York City and the Atlantic Ocean, via the Hudson River, and between Chicago and points west, via the Great Lakes. Because the canal made it possible to transport manufactured goods and raw materials cheaply and rapidly, the resulting development of the shipping industry jump-started the city's economic success. In 1835, Buffalo could process 112,000 bushels of grain a year. After Buffalo grain merchant Joseph Dart invented grain elevators in 1842, the city became the world's busiest transfer point for grain storage and processing. By 1855, 22,400 bushels of grain

1. First appeared in *CounterPunch*, 13 September 2008.

A postcard depicting the Hotel Lafayette, designed by Louise Bethune, which opened in 1904 on Lafayette Square in Buffalo, New York.

could be unloaded onto ships per hour. (Modernist architect Le Corbusier called Buffalo's collection of concrete grain elevators "The first fruits of the new age!")

Buffalo's population tripled during the last three decades of the nineteenth century as more workers were needed to service the city's burgeoning business as a railroad transportation hub. By 1869, when the transcontinental railroad system began operation, railroad technology was overshadowing the canal's success.

In 1888, the Westinghouse Electric Company won an international Niagara Falls Commission contract to harness the energy of Niagara Falls, using Nikola Tesla's polyphase system of alternating current. By 1896, three hydroelectric generators built by Westinghouse were providing inexpensive power to Buffalo's emerging industries, and this unique opportunity encouraged more industries to settle in the area.

The new hydroelectric technology was featured at Buffalo's 1901 Pan-American Exposition.

Although it is not a widely known distinction, historically, Buffalo has consistently been privy to the best of the country's architectural heritage. This tradition was established at the beginning of the nineteenth century. In 1804, the city fathers commissioned Andrew Ellicott to devise an urban plan. The design was based upon that of Washington, D.C.'s, a grid system of radiating avenues punctuated by circular park hubs. Ellicott knew Washington's urban plan because he had served as head surveyor of the federal city site in 1790-91, and he was successor to its original designer, Pierre Charles L'Enfant.

Buffalo soon could claim more millionaires than any other city in the nation, and during the last half of the nineteenth century and the beginning of the twentieth century, the city became host to most of the major architects working in the United States. Richard Upjohn, Henry Hobson Richardson, Daniel Burnham, John M. Root, Frank Lloyd Wright, Louis H. Sullivan, and the firm of Charles McKim, William Mead and Stanford White, and landscape architects, Frederick Law Olmsted and Calvert Vaux all won important design commissions and established offices in town. Their completed projects soon contributed to the heady mixture of prosperity and conspicuous consumption that earned this time its name, "The Gilded Age," as inspired by the title of an 1873 satirical novel co-authored by journalist Charles Dudley Warner and Mark Twain.

On a visit to Buffalo in 2006, I interviewed three of the city's women architects: Beverly Foit-Albert, president of Foit-Albert Associates; recently retired Fellow of the American Institute of Architects, Adriana Barbasch; and Kelly Hayes McAlonie, Senior Associate at Cannon Design and Education Chair of the Buffalo/Western New York chapter of the AIA. In their discussion of Buffalo's architectural legacy, they stated

that the buildings these famous male architects designed for Buffalo are considered prime examples of their work. Their assessment was confirmed by a quote in the city's official visitor's guide from *The New York Times*, that Buffalo is "a textbook for a course in modern American buildings." These male architects gained worldwide attention and are the subjects of many books, papers, and articles, but neglected is a woman who strode among these architectural giants as an equal.

This architect was Louise Blanchard Bethune (1856-1913), a woman with deep roots in America's colonial past. She was born Jennie Louise Blanchard in the upstate New York town of Waterloo, located next to Seneca Falls, where Elizabeth Cady Stanton and Lucretia Mott held the first Women's Rights Convention in 1848. Her mother, Emma Melona Williams Blanchard, was a schoolteacher whose Welsh ancestors arrived in the Massachusetts colony in 1640. Her great-grandfather Ebenezer Williams, born in Lebanon, Connecticut, in 1749, served as an enlisted minuteman from Richmond, Berkshire County, Massachusetts, during the Revolutionary War. Her father, Dalson Wallace Blanchard, was descended from French Huguenots, known to have emigrated to New England in 1639 after their flight from France, by way of England, because of religious persecution as Protestants. He was the principal of Waterloo Union School, where he also taught mathematics.

Louise was a sickly child whose parents home-schooled her until the age of eleven.[2] Their undivided attention to her education resulted in her developing strong mathematical skills and unwavering self-confidence and self-reliance,

2. In Kelly Hayes McAlonie's *Louise Blanchard Bethune* (Albany, NY: Excelsior Editions, 2023) she writes that Louise Blanchard had twin siblings, a girl who died at one- and one-half years of age, 10/15/1865, and a boy who died at age four-and-one-half, 01/09/1869, both of unknown causes.

three attributes which would serve her well as a woman practicing architecture. The Blanchards moved to Buffalo in 1866, to secure better jobs, and Louise graduated from Buffalo High School in 1874. Said to have shown an early interest in designing houses and other buildings, her decision to become an architect was sealed the day someone challenged her ambition with the argument that no woman could perform such work.

Over the next two years, as Louise Blanchard prepared to gain entrance to Cornell University's recently opened school of architecture, she engaged in travel, study, and teaching. In 1876, she changed her mind, and decided to bypass Cornell's architectural program. Instead, she chose to follow what was the era's traditional professional training method, to apprentice in the office of a professional architect. The invitation she could not refuse came from the prestigious Buffalo architectural and building firm of Richard A. Waite and F.W. Caulkins, considered one of the most prominent architectural offices in Buffalo at the time. Over the next five years as their apprentice, Louise was given a small salary, full access to the firm's library, and opportunities to master skills of technical drafting, construction detailing, and architectural design. They kept a small staff in a building of their own design, the German Insurance Building (built 1875, now demolished) and soon Waite entrusted her to be his assistant. The firm secured many commissions, designing residences, schools, and police and fire stations in the city, and she is known to have worked as drafter on the firm's initial planning for Buffalo's 174th Armory. Her apprenticing years coincided with the firm's engagement on one of their most elaborate projects, Pierce's Palace Hotel (1876-1881, now demolished), a Victorian confection of a structure, similar in style to the Chautauqua Institution's Athenaeum Hotel (built in 1881). The firm favored Romanesque style, the current local favorite fashion most famously employed by Henry

Hobson Richardson on the red Medina sandstone twin towered administration building of the Buffalo Psychiatric Center (built 1870-1881), and this exposure equipped Louise Blanchard with the expertise necessary to render all details required to achieve this style.

When Louise Blanchard announced the opening of her own Buffalo architectural office in October 1881, simultaneously with the Ninth Congress of the Association for the Advancement of Women in Buffalo, Adriana Barbasch states that the occasion "marked what is considered the entry into the field of the first professional woman architect in the United States." That same year, Robert Armour Bethune, a draftsman from Ontario, Canada, and former colleague at R.A. Waite's office, joined her office and shortly thereafter they married. The firm's name changed to Bethune & Bethune. William L. Fuchs, who had been an apprentice in the office for nine years, became the firm's third partner in 1890, when the firm became Bethune, Bethune & Fuchs. Documentation in city records and newspapers researched and compiled by Ms. Barbasch in the 1980s, confirm Bethune's design contributions that were built between 1881 and 1904 include fifteen commercial buildings, eight industrial buildings, eighteen schools, and various public buildings, such as a police station, a church, a woman's prison for the Eire County Penitentiary, baseball grandstands for the Queen City Baseball and Amusement Company (later renamed Offerman Baseball Stadium), the Seventy-Fourth Regiment Armory (converted later into the Elmwood Music Hall), the transformer building that provided the first power line in the nation which was used for operating the city's electric trolley system, besides single and multiple residential projects. All of these projects were constructed in the city of Buffalo and its suburbs. An October 1893 article in *American Woman's Illustrated World* indicates Louise Blanchard Bethune functioned as the head of her office as

"for some years she had taken charge of the office work and complete superintendence of one-third of the outside work." As a result of her contributions to the architecture of Buffalo, in 1885 Louise Bethune became the first woman to be approved as a member of a professional architecture association, the Western Association of Architects. Daniel Burnham, Louis H. Sullivan, and John M. Root served on the review board that unanimously conferred Bethune's professional credentials. They stated, "If the lady is practicing architecture and is in good standing, there is no reason why she should not be one of us." In 1888 she became the first woman member of the American Institute of Architects. In 1889, she established another precedent, becoming the first woman fellow of the American Institute of Architects.

Acting on her own adage that "the future of woman in the architectural profession is what she sees fit to make it," Louise Bethune's professional reputation was furthered by her principled refusal, in 1891, to enter the national competition to design the Woman's Pavilion at the 1893 World's Columbian Exposition in Chicago. As an early and adamant advocate of women receiving "Equal Remuneration for Equal Service," she objected to the fact that, while male architects were "appointed" to design assignments at the Exposition for which they received $10,000 artistic commissions plus coverage of their construction drawing costs, women architects were asked to compete for a $1,000 "prize," and the costs of their construction drawings had to be paid out of their own pockets. In fair and full disclosure, a board of men selected the woman architect, although all the terms of the plan and further decisions pertaining to the Woman's Pavilion were overseen by an appointed Board of Lady Managers, a volunteer group of society and professional women of Chicago, chaired by the town's reigning society matron, Mrs. Bertha Potter Palmer.

My meeting with the three contemporary women architects from Buffalo began in front of the Hotel Lafayette,

Louise Bethune's most famous architectural design. The Hotel Lafayette was intended to be completed in time for the 1901 Exposition, but due to financial delays caused by a change in ownership, the seven-storied, 225-room, million-dollar hotel was not completed until 1904. Located in heart of Buffalo's downtown, at 391 Washington Street in Lafayette Square, the Hotel Lafayette was billed as the "Gateway to Niagara Falls." Done up in "French Renaissance Revival" style, the hotel was constructed with red brick, rusticated stone, and white terra cotta trim. Its exterior's ornamental surface decorations include small stone balconies with cast iron railings, terra cotta cartouches, and a lacy garland of leaves, flowers and wreaths as a projecting cornice round the roof. Bethune took full advantage of the latest technological inventions by installing fireproofing, electric lighting, hot and cold running water in all bathrooms, and telephones in every room, allowing the hotel to advertise itself as "the best that science, art and experience can offer for the comfort of the traveling public." The hotel was considered among the nation's fifteen finest during the years it was owned by three generations of the same family.

Unfortunately, Buffalo has a history for not finding ways to preserve even their internationally respected architectural gems. Frank Lloyd Wright's Larkin Administration Building, built in 1904 to great acclaim for its innovative office structure and its coordinated interior with built-in cabinets and futuristic metal office furniture, was demolished in 1950 only to remain an empty lot. The city appears to have learned from its mistake, as Wright's only example of a multi-residential structure, the Darwin D. Martin House Complex, is a highly featured item in Buffalo tourist literature.

Although the Hotel Lafayette is still standing, it was allowed to decay. We could see traces of the grand lady's glorious past in spite of the deteriorating façade's broken cast iron balconies, chipped stonework, and cobalt blue

paint interrupting the integrity of the red and white motif so central to Bethune's original elegant styling. We entered the main lobby, to find that it has mostly been stripped of its opulent past, though it still maintains the original Numidian marble column bases, plus two 1920s additions: a terrazzo floor with its curving pattern of green, gold, and white swirls that lead guests to the elevators, and the Frontera mahogany paneled walls and entrance desk. Two of the lobby walls exhibit handsome murals assembled using various types of inlaid woods, probably added during the late 1920s or 30s, as they feature modes of transportation including a propeller airplane and a type of ship that were not yet invented in 1904. Even though we had telephoned ahead and requested a tour of the building, when we asked to view other parts of the building's interior we were told we would have to check with one of the current owners, Hung Nguyen, who lives out of town. When I called later that day, I was told she had turned down our request, perhaps thinking that we were building inspectors.

The desk clerk on duty described his fascination with details that remain today, hidden in the basement. Otherwise, I have read reports of leaded-glass skylights, mahogany-paneled coatrooms, an English oak-paneled men's bar and dining room, a red and gold grill room, wine rooms and billiard rooms. The fabled crystal chandelier-hung grand ballroom, added to the original structure in 1916, was still being used in the 1970s according to Bonnie Foit-Albert, when it was adapted by an architecture firm for their office space.

Where once it housed presidents and movie stars, the hotel had become a crack house. According to Buffalo's Mayor Byron W. Brown, whom I interviewed in 2006, the building had been cited by the city for committing a number of code violations, and some tenants had been evicted for engaging in criminal activities or having substance abuse problems.

Mayor Brown gave me an update on the hotel's story when I returned to Buffalo in the summer of 2007, as did architect Clinton E. Brown, who filed an application with the United States Department of the Interior's National Park Service, to gain historic preservation certification for the hotel. This time we were allowed to tour down the hotel's long halls and enter some of the guestrooms, which were undergoing basic maintenance upgrades necessary to be in compliance with current building codes. We observed repairs to correct deterioration of window frames, to replace faulty plumbing that caused significant water damage to walls and ceilings, and carpeting removed that was long past its prime. Tenants who were causing disturbances had already been evicted, and Clinton Brown was proposing ways to generate income for the hotel, such as promoting its use by students and other travelers from overseas as a good bargain base when touring Niagara Falls and other sights in the region.

Clinton E. Brown's June 2008 update on the Hotel Lafayette did not sound as upbeat. He stated that at present "we are not involved in and do not know of any work underway," and his office's efforts to achieve historic preservation certification have only achieved Part I approval—certification that the Hotel Lafayette is historic for tax purposes. So the question remains as to whether it will be possible to continue to salvage and restore this historic hotel—historical not only because of its style and its period, but because of Ms. Bethune.

The AIA gives prominent acknowledgement to Louise Blanchard Bethune's "firsts" in their literature and on their website; and on March 9, 2006, the Buffalo/Western New York chapter of the AIA succeeded in having her inducted into the Western New York Women's Hall of Fame, the same year they placed an historic marker on her grave in Forest Lawn Cemetery. However the Buffalo architects' effort to have her inducted into the prestigious organization, the National

Women's Hall of Fame, was met with rejection in 2007. It remains a puzzle why, even at this late date, the nation's first woman to be formally designated as a professional architect was judged not worthy to receive this national honor.

In 1934, twenty-five muralists were selected by the Work Progress Administration to create murals inside Coit Tower, built in 1933 at the top of Telegraph Hill in San Francisco. They depict California scenes of industry, immigration, politics, capitalism, social class, and urbanism during the Great Depression, and this agricultural scene. (Photo by Tennessee Reed.)

A New New Deal for the Arts[1]

"We are definitely in the era of building the best kind of building—the building of great public projects for the benefit of the public and with the definite objective of building human happiness."

Franklin Delano Roosevelt

In response to President Obama's call to all Americans, to think about how we can contribute to the future of our country, many suggestions being offered gain inspiration from New Deal programs, instituted by President Franklin Roosevelt to help the nation revive from the financial devastation caused by the Great Depression of the 1930s.

As an artist, I suggest President Obama and Congress include projects that employ creative ideas and energies of artists, as did two famous New Deal programs, the Public Works of Art Project, instituted in 1933 and its successor, the Works Progress Administration (WPA), formed in 1935, when more than 8.5 million jobless Americans worked on

1. An abbreviated version of this essay appeared in the *San Francisco Chronicle* Op-Ed, 6 February 2009, was reprinted in *CounterPunch*, 16 February 2009, and was the inspiration for a KQED Spark special on Bay Area's WPA projects, in which Carla Blank was interviewed.

arts-related projects that paid the equivalent of today's minimum hourly wage.

According to Bureau of Labor Statistics found on the National Endowment for the Arts' website, "unemployment rates for artists are nearly twice as high as rates for all professionals." Using the national unemployment rate figure of 7.2 percent, released in January 2009, artists are likely to have an unemployment rate of 15 percent. This figure could well go much higher as in earlier recessions, many non-profits shifted funding priorities away from the arts to civic and social causes, and as a general rule, arts related expenditures are usually among the first line items to be drastically reduced or cut from city, county, state, and national budgets.

The Bureau of Labor Statistics classifies the following occupations within their arts category: visual artists, such as painters, sculptors, and illustrators, multimedia arts and animators; art directors; writers and authors, encompassing writers for communications media and advertisements, magazines and trade journals, company newsletters, newspapers and online publications as well as those who write original fiction and non-fiction books; photographers; dancers and choreographers; actors, directors, and producers; musicians and singers; entertainers and performers; announcers; commercial and industrial designers, including fashion, interior, floral, and set and exhibit designers; and architects and landscape architects. The 1930s New Deal also included technicians, archivists, and teachers in their programs.

The twenty-first century version of New Deal arts programs could feature creative partnerships between artists and scientists, engineers, businesses, educators, skilled labor, urban and environmental planners, and community leaders throughout our nation's cities and rural communities. Besides reducing unemployment, the partnerships could add valuable creative thinking to projects that invest in

infrastructure, revitalize education, and develop new and greener technologies.

Based on 1930s programs and more recent models, here are four examples of programs that could be instituted:

- Innovative Technologies Projects: Like Xerox PARC, founded in 1970 as a computer research center in today's Silicon Valley by Xerox Corporation, which became the birthplace of many innovations that were developed into basic tools and components of computer science technology, this program could team artists with scientists and engineers to design innovations that help reduce energy consumption, increase use of recycled materials, restore environments destroyed by natural disasters, and conduct experiments to invent materials and technologies for functions not yet imagined.

- Federal Writers Project: By updating documentary research projects, such as the gathering of oral histories and the encyclopedic American Guide Series that preserved much of the nation's geographic, cultural, and political heritage up through the years they were completed, writers, journalists, and photographers could build on these great resources, retrieving memories and images from our present fifty states and territories that could be lost without an organized effort. This updated documentation could be stored in the Library of Congress or National Archives, digitized for online retrieval by anyone.

- Community Art Projects: In addition to funding regional, state and local festivals, and other events, this program could offer professionally directed classes and workshops in theater, dance, music, photography, videography, animation and visual arts. People of all ages could thereby gain access to training and appreciation of arts that have for many years been routinely omitted from public school curriculums, because of budget cuts, although indicators

consistently prove that standardized test performances increase in direct relationship to the amount of students' creative experiences. For adults no longer in school and especially the retired who greatly benefit from retrieving old skills or learning new ones, these programs could be placed in community centers, libraries, and other public places with easy access. Similar programs, offered since 1971 under National Endowment for the Arts' Expansion Arts and Community Cultural Programs, have documented how increased understanding and respect for all arts, through greater accessibility, also increases the quality of life in a community, besides increasing community revenues as visitors partake of these activities.

• Renovating for a Greener & Leaner America: Architects and landscape architects in collaborations with community welfare groups, urban and environmental planners, and the Army Corps of Engineers could team with skilled craftspeople to design and help rebuild, preserve, renovate or find new uses for schools, malls and other kinds of empty retail centers, industrial parks, public and private buildings and open spaces, and private homes that have been damaged or destroyed by natural disasters such as fire or flood, or vacated due to foreclosures and other financial forces. The designs would seek to reduce costs while promoting materials that satisfy pragmatic concerns, support and sustain their surrounding environment, and reduce energy consumption, while increasing architectural aesthetics for their inhabitants and their neighborhoods. Besides those already trained in building crafts, engineering and landscaping, the general public could be involved in these projects, using training and supervision modeled after systems such as those that made Habitat for Humanity such an ongoing success, and useful methods discovered or perfected in these projects could be disseminated through internet sites.

The 1930s WPA programs financed projects other than ones I have mentioned, including public art projects which continue to provide a source of wonder, such as San Francisco's Coit Tower murals that still draw tourists from all over the world. Moreover, WPA projects provided enough income to make it possible for many artists to continue their careers, making them today's canonized icons, such as Richard Wright, Orson Welles, Dorothea Lange, Jacob Lawrence, and Jackson Pollock. Artists have collaborated with architects, scientists, educators, and businesses for centuries. When such collaborations are successful, they are called a renaissance.

A ukiyo-e (color woodcut, circa 1845) by Utagawa Kuniyoshi
(1797-1861) depicts the character Ashigaru Ichiemon, a foot soldier
on a highway in the drama *Chūshingura*, as he contemplates
a bee's nest, a sign of ill omen. (Library of Congress,
Prints & Photographs Collection, Washington D.C.)

8

When Kabuki is not Kabuki[1]

July 2010

At least since 2006, it has become fashionable for politicians and pundits to use the term "kabuki" to describe a frustratingly slow legislative process. As recently as June 1, Thom Hartmann of KNEW-AM Green 960 described the new Supreme Court rules about Miranda rights, in which a suspect now has to be the first one to invoke such a right, as "kabuki," meaning intricate or involved. Neither of these uses define what "kabuki" actually means.

Because the real Kabuki is a Japanese theater form full of spectacle involving dance and music, with fabulously painted sets that can magically change before your eyes by revolving on the stage or by appearing and disappearing through trap doors or by being built up by stage carpenters in plain sight, accompanied by elaborate costumes, mask-like makeup, and hand props of startling array.

The word is said to have been derived from *kabuku*, "a now obsolete verb of the Momoyama period (1573-1603), originally meant 'to incline,' but by the beginning of the seventeenth century it had come to mean 'to be unusual or

1. First appeared in *CounterPunch*, 7 July 2010.

out of the ordinary,' and carried the connotation of sexual debauchery," according to Earle Ernst in *The Kabuki Theatre* (The University Press of Hawaii, 1974, p. 10) who also notes that today it is written with three Chinese characters meaning "song," "dance" and "skill."

Its stories can variously involve violent and revengeful transgressions or heroic feats based in historical events or biographical studies called *jidaimono*; tragic sorrows of the heart from family loss or a lover's betrayal, sometimes ending in suicide, called *sewamono*; ghostly legends made scary enough to cool the hottest summer night, and dance plays, called *shosagoto*.

While Kabuki acting style can involve slow or static moments, especially in the motionless tableaux-like convention of *mie*, when the actor, in extreme emotion, freezes, the audience's overall experience is achieved through heightened action expressed in rhythmic patterns which structure speech and movement. In fact Kabuki actors' training demands a gymnast's strength and flexibility, a dancer's agility and grace, and a singer's vocal techniques, as the text is delivered with a wide range of sung tones and qualities accompanied by prescribed movement sequences that have evolved over time for each character.

Like two other classical Japanese theater forms, the Noh plays and Bunraku puppet plays, which both contributed much to Kabuki style, earlier in its history (the form has flourished since the seventeenth century Edo Period) Kabuki plays used to go on all day. However, since the reestablishment of Kabuki after World War II (as the occupying forces banned Kabuki performances until 1947 and it was necessary to rebuild many of the great theater houses which had been demolished by aerial bombing), today Kabuki theater performances are likely to be completed in three hours or less, an adjustment acknowledging contemporary audiences' preferences that prevails in American theater as well, unlike

earlier eras when plays by such an American great as Eugene O'Neill could take four and even five hours to perform in entirety.

As media fashions demand new buzz words (remember hearing "bottom line," "paradigm shift," and "at the end of the day," over and over, and today's other current faves such as "game changer" and "tea bagger"), I wonder what the Japanese make of our referencing their traditions, particularly recently, with the Health Care debate, when the word kabuki almost seemed to function like a drumbeat? If Japan is to be the chosen country of reference, the classic Noh Theater, their earlier, more esoteric and austere form, would provide the more accurate term to infer purposeful slowness. But maybe that theater form was avoided because it gives away the true nature of the Republican opposition, which appears to be to achieve a "No" vote by any means necessary.

Various figures of horse ballet by Stefano della Bella, 1652 (Italian, Florence 1610-1664). (Etching, Metropolitan Museum of Art. The Elisha Whittelsey Collection, The Elisha Whittelsey Fund, 1967.)

Apollo Could be a Bitch[1]

The dust jacket of *Apollo's Angels, A History of Ballet* by Jennifer Homans (New York: Random House, 2010) announces its coveted listing on *The New York Times Book Review*'s 10 Best Books of 2010. Having received wide media coverage in print and internet outlets, including *The New York Times, Huffington Post*, and *The New York Review of Books*, the book's 643 pages, including sixty-two pages of notes and bibliography, are there to wow the reader into believing the claim by the publicity department that this is the most definitive ballet history ever written. On closer examination, however, this claim seems guided more by the power of the publisher's advertising budget and a critical establishment that has come under pressure to support the publishing conglomerates no matter how weak their products might be.

As the lengthy section of notes testifies, Jennifer Homans, former professional ballet dancer turned historian and *The New Republic*'s dance critic, has researched ballet's history widely and writes about it enthusiastically. Many sections read as entertaining stories; however, starting with the Introduction, where she contradicts her basic arguments frequently, this book could have used some strong editing.

1. First appeared in *CounterPunch*. 7 January 2011.

Some will see Ms. Homans' claim that ballet has evolved into "this most refined, most exquisite art of aristocratic etiquette," and "the highest form of the human physique" as an arrogant display of ethnic chauvinism, starting with its dismissal of all the other glorious court dance forms of Java, Japan, India, and Ghana, to mention a few.

She contradicts her claim that ballet discipline is "a hard science with demonstrable physical facts" whose "laws corresponded to the laws of nature," by following it with a description of the many "differences" that evolved in various national styles of ballet: the Italians and French followed by Danes, Brits, the Soviet Russians, and the Americans trained by Balanchine. Since the early twentieth century, advances in kinesiology and sports medicine research have continued to refute there is perfection to ballet's "hard science." Some movements, such as the deepest knee bends of the grand plie, were eliminated from daily technique drills by such master teachers as David Howard, because over time, they proved certain to harm most bodies more than they benefitted them. In fact ballet technique is so stressful to the skeletal and muscular structure of most bodies that most ballet dancers have to retire from performing by their thirties or forties. Jennifer Homans retired in her twenties.

Ms. Homans chooses to ignore ballet's precursors. Declaring in her Introduction, that "the origins of ballet lie in the Renaissance and the rediscovering of ancient texts," does not inform the reader that important stylistic elements that were incorporated in the evolution of ballet—the court dances, the geometric spatial patterns or tracks of footsteps on the floor, and the training of performers' body positions— all have earlier origins.

Ms. Homans allows only that "Dance was taught in fencing and riding schools," so that "Dancing was thus an adjunct military art, a peacetime discipline akin to fencing and equestrianism, with which it shared some of its movements and a

disciplined approach to training and physical skill." There are many standard historical sources crediting how ballet's spatial patterns or "figures," and framework for the dancer's body placement evolved from militaristic origins. Historians have documented the existence of horse ballets in military training practices as far back as ancient Egypt and Rome. By the 1500s, equestrian pageants had been well established as a popular ingredient of the European court spectacles, where the horse ballets involved "four types of dance: *terre á terre, courbettes, cabrioles* and *pas* and *saut*," according to an entry in "Ballets de chevaux," *Encyclopédie ou Dictionnaire raisonné des sciences, des arts et des métiers*, 2:46 (Paris, 1752). Their dressage formations, as they have come to be known, provided the basic geometric patterns still apparent in classic choreographic placements of the corps de ballet today. And to say, "It was Beauchamps who first codified the five positions of the body, providing 'the crucial leap from etiquette to art,'" does not clearly acknowledge their similarity to the four basic fencing positions. It was the same Queen Catherine de Medici who brought Italian fencing masters to France, when this military form of training was formalized, around the time these first ballets were being mounted in the courts of Italy and France.

The court dance forms essentially came from ancient community ritual or festival folk dance forms, such as round dances, contra dances, and processionals which were appropriated as ballroom dances by the aristocracy. Court dances eventually became known as the pavanes, galliards or gigues, and later minuets, which continued to be basic ingredients as court pageants evolved into the professional ballet, opera, and theater arts. These dances play as large an influence on the ballet as fencing and equestrian formations associated with nobles' military training.

While many historians agree with Ms. Homans that ballet's shift from ceremonial social ritual into a professional

classic form started with *Ballet Comique de la Reine*, a 1581 extravaganza choreographed and staged by Balthasar de Beaujoyeulx (Italian as Baltazarini di Belgiojoso), and commissioned by the Queen of France, Catherine de Medici, on the occasion of her sister's betrothal, Lincoln Kirstein's *Movement & Metaphor: four centuries of ballet* traces the beginnings of what he calls "figured dancing" to a 1573 indoor Palace of the Tuileries celebration, "Le Ballet des Polonais," also mounted by Queen Catherine de Medici, to celebrate her second son's crowning as the King of Poland.

So the absolutes in *Apollo's Angels* are not quite as absolute as presented. In fact, as early as the 1300s the courts of Italy and France held elaborate spectacles for occasions such as weddings, births or funerals, or purely to be shows of power, and they featured members of the royal court dancing in combination with music, singing, poetry, costume displays, and lavishly designed set elements.

Ms. Homans quotes Deborah Jowitt's biography of choreographer Jerome Robbins, *Dances with Demons*, where he wonders if his love of ballet "has something to do with 'civilizationing' of my Jewishness." She fails to note that many of the earliest European dancing masters, the codifiers of ballet tradition, were Jewish. The first European dancing manual, *De arte saltandi et choreas ducendi* ("On the Art of Dancing and Directing Choruses"), was published in 1415, authored by a Jewish dancing master known as Domenico da Piacenza.

How did so many critics miss these omissions and contradictions?

Later sections of the book, especially the Epilogue, have generated the most critical disagreements, especially because Ms. Homans belittles ballet activities of the past two decades, following the death of Balanchine. Her claim that "Over the past two decades ballet has come to resemble a dying language: Apollo and his angels are understood and appreciated by a shrinking circle of old believers in a closed corner of culture," is either reflective of one person's opinions and taste or guided

by the sales department's attempt to boost Christmas sales for this coffee table book by sparking a bogus controversy. *The New York Times* dance critic Alastair MacCaulay took the bait.

Ms. Homans believes the acclaim of audiences should not be the measure of enduring art, and states she grounds her discussion in experience, by actually going into the studio and performing whatever is known about the dances she discusses. But especially when writing about the recent past and present, the dancer's viewpoint is hard to discern and appears to express her personal "tyranny of the beholder." Choreographer William Forsythe is barely mentioned, and other important contributors of the recent past or present are left out completely, such as Angelin Preljocaj, Maguy Marin, and Alexei Ratmansky. Ms. Homans says that the "sleeping art" of ballet may find its revival "from an unexpected guest from the outside from popular culture [in a repeating cycle as in its origins] from artists or places foreign to the tradition who find new reasons to believe in ballet." Couldn't it be said this is exactly why works by Merce Cunningham, Twyla Tharp, Mark Morris, and Akram Khan to mention some of the most familiar choreographers first identified with "modern dance," have been either mounted on or licensed into the repertories of ballet companies world-wide? It is likely that some of their works could survive because of these adoptions.

For her overarching theme, as reflected in the book's title, Ms. Homans invokes Apollo as the embodiment of ballet's highest formal ideals. Crediting Apollo's noble and aristocratic bearing, she ignores his darker aspects because Apollo is equally famous for placing a curse on Cassandra after she refused his sexual advances, by vowing that her prophecies, although true, would never be believed. Apollo could be a bitch. This lack of candor at least makes a good illustration of how the scary underbelly of ballet provided so much energy to the recent film sensation, *Black Swan*. If this film wins an Oscar or two, will that mean that ballet has a chance to survive in the twenty-first century?

A mold cast from an existing Corinthian capital, demonstrates how replacements were created to replicate damaged or missing sections of columns in the original Hotel Lafayette's ceilings and columns. (Photo by Tennessee Reed)

How Buffalo's Hotel Lafayette Went from Fleabag to Fabulous[1]

It was a cold January day in 2011 when I had last seen the Hotel Lafayette, the grand French Renaissance Revival styled brick building that sits on the corner of Washington and Clinton Streets in downtown Buffalo, New York's Lafayette Square. Built between 1901 and 1904, it was originally designed by Louise Blanchard Bethune (1856-1913), lead architect on the project with her firm Bethune, Bethune & Fuchs, which included her husband Robert Bethune and former apprentice William L. Fuchs. Louise Bethune carries the mantle of being the first woman in the United States to be recognized as a professional architect, with her inclusion in the Western Association of Architects in 1885, and then in 1888, when she became the first woman member of the American Institute of Architects (AIA) and then the first to become a Fellow, (FAIA), in 1889.

Since Spring, 2010, the seven-story dark red brick building with its distinctive white glazed terra cotta decorative trim had been closed for business. The exterior's wrought iron balcony railings and chipped terra cotta surfaces still bore the scars of long neglect. Signs pasted on the front

1. First appeared in *The Wall Street Journal*, 11 September 2013.

doors and street level windows indicated big changes were about to take place, with promises that the hotel would be ready to assume a new life as a multipurpose destination for weddings and other special events, with both hotel and long-term apartment accommodations available, reopening for business in May 2012.

The Lafayette's French Renaissance style was in high fashion in 1898, when Bethune designed the hotel in the grand manner of the City Beautiful/Beaux Arts' aesthetic, acclaimed since Chicago's 1893 World's Fair. Her choice of style was a fitting complement to Lafayette Square's other existing buildings, of which the Liberty Building, on the corner of Main and Lafayette, remains today. Intended to open in time for the 1901 Pan American Exposition held in Buffalo, after various financial delays, the Hotel Lafayette's construction only got started in 1901. When it was completed in 1904, the hotel was considered one of the nation's fifteen luxury hotels. Although the façade and architectural details were Renaissance inspired, Bethune took full advantage of the latest technological inventions of the day—steel, fireproofing, and electric lighting, hot and cold running water in all bathrooms, and telephones in every room. The Lafayette featured energy saving devices way ahead of what was present in even the most luxurious hotels of that time: the electric lights in the guests' rooms were wired to shut off when patrons closed and locked their doors; a central air vacuum system extended to every room and corridor throughout the building with steam heat functioning to both heat and humidify the building during the winter; and the elevators were operated on a unique system using electricity in the summer months and steam during the winter months.

Up through the 1940s the hotel served as a destination for presidents, movie stars, tourists, and businesspeople. The second generation of additions expanded the hotel's original footprint by at least another third and included the first

floor's Grand Ballroom. Further additions brought the hotel to its present size of five seven-story wings. Each addition brought new elements and aesthetics. The first changes to the original building were designed by Bethune, from 1909 to 1911, including everyone's favorite promenade space, Peacock Alley, although actual construction did not begin until four years after ill health caused her to withdraw from active practice at the age of forty-five. (This was twenty-four years after Bethune opened her first office, although her name was not legally removed from the partnership until 1912 when signatures on building permits which her firm registered in the city records changed from "Bethune, Bethune and Fuchs" to "Bethune and Fuchs." She died in 1913, from complications of diabetes.)

In spite of remodels and additions, by the 1950s, the hotel was no longer looking grand, and its luxury clientele disappeared as it continued to decline into seediness, and evolved into a "boarding house for a social services population." This basically remained its function until the middle of the first decade of the twenty-first century, when some of Buffalo's architects, preservationists, and civic leaders began to actively search for ways to change its fate. However lack of funding continued to block all efforts to solve how to go about significant changes or restoration, until August 2010, when the hotel at last earned placement on the National Register of Historic Places. With full landmark status, and the passage of a bill through the New York State legislature shortly thereafter, which made the Lafayette eligible for two million dollars in New York State's historic preservation tax credits, developer Rocco Termini, president of Signature Development, cobbled together the means to move forward with what was recently reported to be a $43 million "makeover."

Luckily, few major alterations had significantly gutted the early architectural detailing, as original vaulted ceilings, walls,

A postcard showing Lafayette Square in downtown Buffalo,
with the Hotel Lafayette, designed by Louise Bethune, situated
in the upper center corner of the square.

and marble floors were often just covered over in successive
past remodels, with many surprises uncovered, such as sliding
doors stored inside of walls and even a speakeasy, discovered
in the basement. Tim Jones who had been the Lafayette's chief
engineer for eighteen years and is Construction Superintendent
on the renovation describes the demolition crew that carefully
removed layer after layer of materials. He recalls their mantra:
"It's the Lafayette—it's like an onion; it's got layers." (*Buffalo
Spree*, by Barry A. Muskat, 12/2010) Over the years, Tim Jones
stored away detailing bits large and small as he found them,
in case someday they'd prove useful. He said that's the way he
was raised on a farm, where everything was saved as you never
know when you might need something again.

That time arrived with the renovation plans of Rocco
Termini, and the architects, Carmina Wood Morris, who
have wisely chosen to honor the layers of historic styles
embedded in the hotel, particularly, to restore or replicate
the Renaissance Revival style of the original building and
the Art Moderne motifs from the 1940s. Decisions large
and small have their historical basis, with research behind

every aspect of the renovation and reclamation: from layers of paint carefully scraped to be able to accurately match the original colors of ceilings and walls to the fonts on publicity and restaurant menus replicating those found in materials from the time of the Pan American Exposition, and a line-up of wood telephone booths in a corner of the lobby providing their old function of privacy for today's wired generation. In late March, the two-story Grand Ballroom, part of the 1916-17 addition, looked just about ready to house grand events again, its original crystal and brass chandeliers cleaned and polished to their original shine and its domed stage or bandstand, added during another renovation circa 1924-26, now revealed to justify their former fabled glory. Years of dirt and grime were removed from the lobby's marble wainscoting, polychromatic terrazzo flooring, and the decorative murals and wood marquetry and inlay motifs of the 1942 Art Moderne remodel, to complete that all-important first impression establishing the hotel's claim to grandeur in the form of a warm welcome. Even where spaces were reconfigured to comply with present day building codes, those changes employ craftsmanship and architectural detailing so seamless and consistent with the overall style of the hotel that they will appear to be resurrected from earlier times.

I saw much of this work in progress in mid-March 2012, during my most recent Buffalo visit with my husband Ishmael Reed and our daughter Tennessee, when Construction Superintendent Tim Jones graciously provided me and my family with a guided tour. We quickly felt there was no longer need to feel concern for Louise Bethune's legacy, as evidence abounded that her signature piece has lucked out this time. Buffalo developer Rocco Termini, Managing Partner of Lafayette LLC and President of Signature Development Company has truly come to her rescue. According to Tim Jones, the development team's determination to make the hotel regain its rightful claim as a destination of tasteful

luxury is proving a smart business model as well, with its restaurant and retail spaces all taken up for use: a combination restaurant, bar and cocktail lounge, which originally functioned as a billiard room until after Prohibition when it became a popular hangout known as the Lafayette Tap Room, will become the Pan American Grill and Brewery, operated by Earl Ketry, Managing Partner of the Hotel at the Lafayette and the Pan American Grill & Brewery and owner of Buffalo's highly respected Pearl Street Grill; with other occupants including Get Dressed, a formal wear and tuxedo rental shop and Mike A's Steak House, located in the hotel's original Grill Room space, with its elliptical groin vaulted ceiling and walls covered in their original Flemish oak. We could see stainless steel fixtures waiting to be set in place for Woyshner's Flower shop, located where the hotel's former corner main entrance had been; and further preparations for a new configuration of shops in the basement to include Butterwood Desserts, a bakery and dessert bar, set in a space where former subway tiles and quarry tile floors were found intact. The Lafayette's upper floors have been reconfigured into 115 market rate apartments, ($895-$1195 for one and two bedrooms). 75 percent had been rented at the time of our visit in late March; multiple weddings and other events were already booked as well.

Located one or two floors above the commercial spaces and lobby will be thirty-four themed hotel suites, to be known as The Hotel at The Lafayette where, through a recently formed partnership with the Buffalo and Erie County Historical Society (BECHS), the rooms will feature design elements culled by the renovation's architects and designers from research in BECHS' collections of Western New York historical memorabilia. Reproduced images from historical photographs and other items will appear on such decorative details as murals on headboards in the bedrooms and displays throughout the corridors. Constance Caldwell,

BECHS' Director of Communications and Community Engagement related in an email to me, that "authentic wallpaper pattern swatches, in BECHS keeping, from the M. H. Birge and Sons Wallpaper Company [are] to be replicated for the walls in the Pan-American Grill and Brewery." She says BECHS' partnership with Termini and Ketry will help "support fundraising at BECHS by offering sponsorship naming opportunities for the bridal and bedroom suites. The Historical Society will curate mini exhibits about the sponsor or a relevant local story and receive 100% of the donation proceeds." This partnership is one of many ways that the city of Buffalo stands to benefit from this project.

In late March, we saw the exterior's terra cotta was being cleaned and repaired. The cobalt blue ribbon of paint, which for many years was to me an eyesore covering the building's circumference at street level, had almost vanished from the exterior—just a bit on one window frame had yet to be removed, but photos appearing in Buffalo newspapers and websites subsequent to our visit showed that part of the work has also been accomplished.

As we walked toward the hotel, I had seen workmen maneuvering a large crane on Washington Street to hoist flats of drywall into windows on upper floors slated to become apartment rental spaces. Tim Jones explained that the layout of the original hallways would be the only floor plan unaltered on the upper floors.

When I asked Tim Jones what the new entrance area would look like he assured us it will be completely consistent with the meticulous craftsmanship and taste being applied to the interior's environment. He explained how "the more they fought with the building, they realized they had to go with the building" as it "pushed back" against their efforts to make major layout changes, and they found themselves placing kitchens and the lobby and commercial spaces in basically their original relationships on the first floor, with the major

exception of restrooms which had to be brought up from the lower level to the first floor to comply with today's codes.

On April 11, Buffalo's WIBV TV reported that Termini would host a tour of the Hotel Lafayette project by the New York State Historic Preservation Office to

> "...recognize it as 'the largest privately financed historic preservation effort currently underway in the nation.'"
> "Termini says a banner will be strung in front of the building to signify the designation...."
> "Termini tells WGRZ-TV the first tenants will begin moving into the building on May 1st, prior to renovations being completed on May 29th."

Louise Bethune is sometimes omitted, dismissed, or barely noticed in standard histories of architecture, often according to whether a writer thinks she deserves the distinction of being called the first American woman to practice as a professional architect. Even the National Women's Hall of Fame has turned down repeated applications for her to be included in their honored ranks, although the AIA features her "first woman" credits on their website. Starting in May, when all the festivities get underway to celebrate the renewal of Bethune's signature piece—the Hotel Lafayette—may at last grant her the place in history she certainly earned and deserves.

The Education of Paul Ryan[1]

Paul Ryan recently insinuated that the poor "in our inner cities," are lazy, and revealed the source of his code for criticizing a "culture" of "men not working," by citing Charles Murray's infamous *Bell Curve*, where Murray argued that Blacks are genetically inferior to Whites. Many were quick to point out Ryan's gross and offensive inaccuracies.

We could charitably add that Ryan is likely a victim of a deficient education, as the full story of how our nation's capital came to be is rarely included in elementary or secondary U. S. history courses. Could Paul Ryan not know that every day he goes to work as a member of Congress, he enters a building built by ancestors of those he targets with these kinds of inaccurate statements and his recent cruel budget offering, because the builders of Washington, D.C. were the poor, immigrants, and enslaved and free Blacks?

The newly invented "Federal Territory" that would come to be known as Washington, D.C. could not be justified as the nation's center of finance, commerce, culture, fashion, and learning, as was the case with most European capital cities. Counter to those Northerners who wanted to maintain Philadelphia as the capital, it was chosen to appease

1. First appeared in *CounterPunch*, 16 April 2014.

The Capitol, which was built largely by slaves, in 1800.
"Taken from advanced proof of plate 38 History of
the United States Capitol by Glenn Brown." (Library of Congress
Prints and Photographs Division, Washington, D.C.)

slaveholding lawmakers who needed the capital's location moved to an area south of the Mason-Dixon Line, where slavery was currently legal.

Southern Congressmen were already in a state of alarm because in the current capital city of Philadelphia, "any slave brought into the city could be held for no longer than six months, after which he or she was automatically manumitted." Both Jefferson and Washington were concerned this ruling could cause them to lose, among other valuable slaves, their prized cooks as the quality of guests' entertainment was an important asset to any public official. Washington, a lavish entertainer, jested that his guests were turning his home into a tavern. In Jefferson's case his cook, James Hemings, a slave who had been trained to prepare fine French cuisine while Jefferson was serving the U.S. in France, was so irreplaceable that he even paid Hemings a salary to keep him content with his position.

Washington, D.C. functioned as a major hub of the domestic slave trade because of its location midway between

the upper and lower South. Sightings of Africans in chains being transferred to a holding pen or to board a ship caused President James Madison's secretary to complain, in 1809, about "the 'revolting sight' such 'gangs of Negroes' presented in the streets of the capital that prided itself on its democracy and freedom." In fact, slave labor was widely employed on federal city projects from their beginnings in 1790, from ground breaking and initial construction continuing through replacement and renovations on the White House and capital buildings, until President Lincoln's Compensated Emancipation Act became law on April 16, 1862.

The combined skills of many laborers and craftsmen were necessary to build this new capital for the nation. Surveyors and draftsmen, mechanics, teamsters and wheelwrights, carpenters, brickmakers and bricklayers, stonecutters or stone masons and stone carvers, painters, plasterers, glass makers and glaziers, roofers, blacksmiths, axe-men and ditch diggers were some of the job titles for work that needed to be done. Americans from all states showed up to work at the site, and sometimes orders to supply custom-made items involved businesses as far away as Baltimore, Philadelphia, Boston, and other parts of Virginia. Recent European immigrants—from England, Ireland, Scotland, France, Italy and Germany—were pressed into service, many arriving as indentured servants, enticed with offers of plentiful jobs. Heads of American consuls in European capital cities were required to facilitate recruitment efforts. In a common arrangement, "A worker agreeing to come would immediately get 30 shillings to pay the expenses attendant to leaving England. The commissioners would pay passage and retain half the weekly wages until the passage money was paid off. In some cases a wife's passage would be paid. Wages would be the same as what others already in the country with similar qualifications got." (Arenbeck, 144) The immigrants provided both skilled and unskilled labor. In 1792, British minister George Hammond

complained that craftsmen were "being lured to bring over the latest techniques of British factories...." (Arenbeck, 134)

Free Blacks also were hired for skilled jobs and many enslaved Blacks were rented from their owners to do the heavy lifting. To ready lands that were to become the wide boulevards and the canal running from Capitol Hill to the Eastern Branch, slaves were used to dig trenches and ditches. Slaves cleared trees and brush to ready the area now known as the National Mall. Slaves hauled lumber, bricks, and other building supplies. For the construction of the Capitol and the White House, slaves dug sandstone out of quarries in Aquia, Virginia, and transported it to Washington by ferries, where they placed the cut stone into wall formations.

According to U.S. Treasury documents discovered in 2000 by Ed Hotaling, a Washington-based television producer researching for a special program on the U.S. Capitol building and White House, those two buildings required 650 laborers, of whom 200 were immigrants from Ireland and Germany, 50 were free Blacks, and 400 were slaves. The Treasury's promissory notes specified payment to the slaves' owners of $5 a month for each slave working on the construction. Irish and German immigrant laborers were paid $4.65 to $10.50 per week for their work. In 1794, Jerry Holland, a free Black working as a measurer in the surveying department and called the best man for the job, was paid $5 a month, compared to $8 a month paid to his White coworkers. In 1797, seven stone carvers were paid $1.63 per day, representing a wage increase of 17 cents. In 1798, stone masons received 10 shillings a day, a return to their previous wage level, which had dropped to 8 shillings per day since the winter of 1795, when twelve masons out of thirty-two quit the job in protest of the wage cutbacks, thus reducing governments' costs from $944 to $510. The overseer at the capitol, Samuel Smallwood, only got a raise of $3.00 a month in 1797. He logged a complaint that he could barely afford a

diet consisting of "nothing more than salt meat for breakfast, dinner and supper which is neither palitabel (*sic*) nor constitutional...," (Arnebeck, 431) although he must have been eating better than the men he was supervising, as his wage was far higher than theirs. Later, Smallwood's indispensable work was acknowledged with an increase reaching $40 per month (Arnebeck, 562).

During the summer, workers were often expected to work on the job six days a week, from sun-up to sundown; in winter, wages were reduced when not as much work could be accomplished due to harsh weather conditions. Many lived in shacks they built on the grounds near their construction assignments, much to the dismay of investors who felt they could not properly entice city lot buyers with such ragtag looking shanties nearby. It was no wonder that even by Jefferson's inauguration in 1801, travelers new to the "federal city" had difficulty recognizing they were in the right location, even when standing in the center of town.

Work on the Capitol building continued, including additions by artists commissioned to create friezes, murals, frescoes, statues, and mosaics to decorate the building's interior. During the Civil War, although other capital construction projects were halted, President Lincoln personally approved ongoing work on a new iron dome, calculating that it would be seen as a metaphor, encouraging belief in the strength and ultimate preservation of the Union. His guess proved correct. Philip Reid (also spelled as Reed, b. circa 1820), the most famous enslaved African American laborer to work on the Capitol, is featured on the government website: http://www.aoc.gov.

Philip Reid's self-taught ingenuity and skills were critical to preparing Thomas Crawford's full figured bronze sculpture of a woman, named *Armed Liberty*. Once approved, in April 1856, by the nation's then Secretary of War, Jefferson Davis, who was charged with the Capitol's construction projects, the

sculpture was cast in five sections, each weighing over a ton, in Bladensburg, Maryland, at the Mills Foundry in 1860. Reid got the job because his supervisor, the foundry's foreman, was striking for higher wages. Resuming work on the sculpture, in hiatus since the start of the Civil War, Reid was among the team of slaves who spent thirty-one days on the Capitol grounds in 1862, assembling the five sections into the completed 6-m/19.7-foot bronze figure. It continued to be displayed on the Capitol grounds until December 2, 1863, when work on the new dome was sufficiently far along to support the bronze statue and its cast-iron pedestal wrapped with the nation's motto, *E Pluribus Unum*. With bronze points tipped with platinum, attached to her headdress and shoulders, to keep her and the building safe from lightning, *Armed Liberty* was hoisted into its place of honor, 288 feet above the east front plaza, where it continues to crown the Capitol today, though her name has been changed to *Statue of Freedom*.

It is not known if Reid was among the celebrants, as he had finally become a free man April 16, 1862, when the District of Colombia Compensated Emancipation Act was signed by President Lincoln. However in 1865, S.D. Wyeth reported in *The Federal City* that "Mr. Reed, the former slave, is now in business for himself, and highly esteemed by all who know him."

So one question to Paul Ryan is, if the former generations of African Americans did not do valuable work for this country, as just this one project demonstrates, why did economics historian Doug Henwood call the emancipation of slaves "the largest ex-appropriation of capital in history"?

Partial list of sources:

Arnebeck, Bob. *Through A Fiery Trial: Building Washington, 1790-1800.* Lanham, Maryland: Madison Books, 1991.

Berg, Scott W. *Grand Avenues: The Story of the French Visionary who Designed Washington, D.C.* New York: Pantheon Books, 2007.

Bustard, Bruce I. *Washington: Behind the Monuments*. Washington, DC: National Archives and Records Administration, 1990.

Holland, Jesse J. *Black Men Built the Capitol: Discovering African-American History in and Around Washington, D.C.* Oxford, Connecticut: The Globe Pequot Press, 2007.

Rakove, Jack N. "From the Old Congress to the New," in the *American Congress: The Building of Democracy* edited by Julian E. Zelizer. Boston: Houghton Mifflin, 2004, page 6-22.

The ornate indoor Roman Pool at Hearst Castle, designed by architect
Julia Morgan between 1919 and 1947 for newspaper magnate William
Randolph Hearst atop a hill in California's San Lucia Mountain
Range, near San Simeon. (Photo by Carol M. Highsmith.
Library of Congress Prints and Photographs.
Division, Washington D.C.)

Storming the Old Boys' Citadel[1]

When people ask how I came to write *Storming the Old Boys' Citadel: Two Pioneer Women Architects of Nineteenth Century North America* with architectural historian Tania Martin, I sometimes answer I got hooked once I discovered that the work of these women is generally unknown or habitually omitted from histories of architecture and, if mentioned, often disparaged.

On KPFA, a Pacifica radio station in the San Francisco Bay area, on March 10, 2015, Middle Eastern scholar and media analyst Edmund A. Ghareeb discussed the consequences of the destruction of written records and artifacts created by the ancient cultures of Iraq and Syria. He paraphrased a traditional saying from the region, that those who do not know their past will not have a future.

That has certainly been the dynamic affecting generations of North American women who unknowingly followed paths first forged in architecture by thirty-some nineteenth century women. Who knows how many other names have yet to surface. At the American Institute of Architects (AIA) ceremony posthumously designating architect Julia Morgan (1872-1957) as its 2014 Gold Medal winner, Beverly Willis, an

1. First appeared in *CounterPunch*, 13 March 2015.

architect and long-time advocate for women in architecture, noted her ignorance of women who practiced architecture early in the twentieth century: "Women in the '50s, '60s, '70s and '80s were denied the incredible role model of a successful practitioner."

It might seem amazing that anyone interested in contributing to the built environment would be unaware that Julia Morgan was the first woman in the world to be admitted to the École des Beaux-Arts in Paris (in 1898), considered the most prestigious training anyone could find at the time, who then became the undisputed designer of over seven hundred buildings, including her most famous project for William Randolph Hearst, where for twenty-eight years she designed and supervised the erection of most buildings comprising his San Simeon estate and ranch, known to many as the principal set of the Orson Welles' film, *Citizen Kane*. But, actually, Julia Morgan's emergence as the best-known woman architect of those practicing in the first half of the twentieth century was spurred by the discovery of her first significant chronicler, Sara Holmes Boutelle, when as late as 1972, she found Morgan identified as Hearst's secretary in a photograph in San Simeon's guest book. (In a March 2015 search of their website, hearstcastle.org, Morgan's role in creating Hearst Castle, as it is most familiarly known, is now celebrated and documented.)

For over twenty years I have been researching moments of American innovation or change, particularly those omitted from standard historical references, such as the ones included in my twentieth-century chronology *Rediscovering America, the Making of Multicultural America, 1900-2000* (Three Rivers Press, 2003). Routinely when men, particularly White men, achieve an important "first" they are justly celebrated. In fact you can find many books of "firsts." But search their indexes for female names, for instance, and you will quickly see how rarely women appear in these ranks.

Like Boutelle, who was inspired to begin fifteen years of research, writing and lecturing on Morgan after seeing the Hearst Castle guestbook error, I plunged into nine years of research and writing centered on Buffalo, New York-based architect Louise Blanchard Bethune (1856-1913) and the thirty-some other North American women who began their careers as architects before the turn of the twentieth century, when I learned Bethune had designed one of the country's turn of the century premiere luxury hotels, Buffalo's Hotel Lafayette (1904-1912). As it quickly became evident, Bethune was also the first woman architect in the United States to open her own architectural office (1881); the first woman to be acknowledged by her peers with her admittance into a professional organization of architects, the Western Association of Architects (1885); the first woman elected a member of the AIA (1888); and the first woman Fellow of the AIA (1889). In part what struck me about this list of Bethune's firsts was to find out how hidden her achievements had remained outside of the Western New York area, until the recent $43 million renovation of her signature work, now renamed Hotel @ The Lafayette, brought much attention to her achievements.

In *Storming the Old Boys' Citadel,* co-author Tania Martin chronicles the work of Mother Joseph of the Sacred Heart (1823-1902), a Catholic nun born Esther Pariseau in Saint-Elzéar, Quebec. Her works were built to serve the mission of her order, the Sisters of Providence, and pre-date much of Bethune's work. In 1856 Mother Joseph traveled from Providence's Mother House in Montreal to Vancouver, the Catholic seat in the Northwest Territory, where she immediately set upon building between twenty-eight and thirty-two structures to serve as schools, hospitals, orphanages, and chapels, besides provide housing for the aged and her religious community. Mother Joseph continued this work until shortly before her death in Vancouver, Washington, the

site of her remaining signature work, known as The Academy (1873). Recently purchased by the Fort Vancouver National Trust, The Academy is slated to receive its own major renovation, becoming the centerpiece of a multi-use campus.

Though we are led to believe what we learn in school is *the complete* historical record, we clearly are only taught a selected version of the facts. The disappearance of these nineteenth century women architects' names from the historical record provides a clear illustration of how the retelling of "History" is political. This is not surprising, as the facts in "official" histories are likely to be selected by the winners. And when each following generation perpetuates this official version of our nation's story, it is very difficult to reintroduce different facts or newly found information. An example of how habits become so ingrained can be found in architecture as recently as 2012 when the jury of the Pritzker Architecture Prize, considered the profession's equivalent of a Nobel Prize, chose Wang Shu to receive the award, neglecting his wife and the co-founder of their practice, Lu Wenyu. And this happened even though there had been vigorous campaigning to right the Pritzker's wrong to Denise Scott Brown, who was ignored when Robert Venturi, her husband and long-time partner in architecture, received the Pritzker in 1991. It is likely Julia Morgan was the beneficiary of this dust-up, when she was honored by the AIA in 2014.

So if we want to help half of our population to be winners—meaning to inspire them to find ways to have a fulfilling future—it is necessary to keep digging up and broadcasting more realistic facts which will include everyone's history, until no one can honestly claim historical amnesia.

13

Prince: Pain and Dance[1]

While the media is predictably concentrating on Prince's alleged drug addiction and seizing upon another opportunity to shame a Black male celebrity for ratings, only Sheila E. addressed the connection between dance and pain. It is said that all of the survivors of one famous dance troupe are bound to wheelchairs. Why? This stress can cause such injury to the body that dancers might seek relief through chemicals, some of which have bad side effects.

In fact most dancers chose to retire from performing by 35 years of age because of trauma or overuse causing wear and tear on the body. At the time of his death, April 21st at age fifty-seven, Prince Rogers Nelson had been performing for thirty-eight years, following his professional debut in 1978. As reported in a *Rolling Stone* obituary by Kory Grow, early in his performance career, Prince "would sometimes strip down to bikini underpants and do exercise routines onstage." His music videos show Prince enjoying the execution of high kicks and lightning-fast drops to the floor in leg splits. Sheila E. described how he would jump off stages or sound equipment while wearing high heels, a signature trademark of his style.

1. First appeared in *CounterPunch*, 6 May 2016.

Prince, appearing at the Apollo Theater's 75th anniversary gala
June 7, 2009. (Photo courtesy of WENN.)

Repetitive extreme or high impact actions are likely to
cause injury when executed by anyone during the ongoing
practice of dance or athletics. Especially without a careful
regimen of strength training and warm-ups, as hips are the
main axis of all leg movement, they can place intolerable
stress on the joints, often resulting in osteoarthritis. Seventy-
four dancers, athletes, gymnasts, martial artists and yoga
practitioners who required medical treatment to relieve such
conditions appear on www.dancerhips.com, including such
iconic stars as dancers Suzanne Farrell and Bebe Neuwirth,
and athletes Pelé and Jimmy Connors.

According to a 2011 study conducted by Dr. Douglas
Padgett, Chief of Adult Reconstruction and Joint Replacement
at San Diego's Hospital for Special Surgery,

"Professional dancing is a particularly physically demanding occupation with annual injury rates of 67% to 95%, with over 20% of these being hip injuries. 'Hip injury is very common in professional dancers. Many of these individuals tend to be hyper mobile. They are performing very rapid loading and landing activities and an extreme range of motions...'"

There are reports that prior to his death, Prince was seen using a cane when not onstage. Professional dancers, like professional athletes, often resist being sidelined by pain and injury. They ignore the report from the March 2014 annual meeting of the American Academy of Orthopaedic Surgeons that their work makes them vulnerable to hip and knee replacement operations. These are among the most commonly performed operations in the U.S.

Having personally experienced a full hip replacement, I can verify there is incessant pain once a joint deteriorates to bone on bone. However, even that level of pain may not seem as difficult as undergoing hip or knee surgery, which is likely to require a minimum of three to six months of recuperation and rehabilitation, depending on the particulars of the operation.

Many testify they do not feel pain while performing, even though in the long run continuing to perform can increase the severity of an injury. This was likely the attitude and situation of Prince, which led to his use of prescription pain-killers. He was once asked in an interview, "Do you think you will ever retire?" He replied, "I don't know what it is. There's always some way to serve. And I never felt like I had a job."

Print specimen of anatomical illustrations of human pelvis
and hip bones by lithographer Augustus Kollner (1813-1905),
Philadelphia. (Library of Congress Prints and Photographs
Division, Washington, D.C.)

14

Purging History: Was Orlando Really the Worst Massacre in US History?[1]

In the rush for headlines in the immediate wake of the tragic killing of forty-nine people and injury to fifty-three others by a lone gunman on Sunday morning, June 12, 2016, in a nightclub in Orlando, Florida, very few in the media called it what it is: "the worst American massacre since 9/11" or perhaps the "worst U.S. massacre in the last thirty years."

Most media texts and commentary did not parse their claims with definitions or limitations, but instead called this the "Worst Massacre in U.S. history" or a drumbeat of similar phrases that were quickly picked up throughout the mass media. Truth be told, although the Orlando massacre was an atrocity worthy of deep lament, it joins a long, sad list of mass killings throughout our nation's history from the start of the colonial era onward.

There is no officially agreed upon definition of mass shootings, but they are generally defined as indiscriminate killing of four or more people (not including the perpetrator) by gun violence. They may be committed by an individual or organization in a public or non-public place. Massacre, as defined by Robert Melson, former president of

1. First appeared in *CounterPunch*, 17 June 2016.

Dr. H. Wesley Evans, Imperial Wizard of the Ku Klux Klan, leading his Knights of the Klan in costume, as he marched in a parade held in Washington, D.C. on September 13, 1926. (Library of Congress Prints and Photographs Division, Washington, D.C.)

the International Association of Genocide Scholars, is "the intentional killing by political actors of a significant number of relatively defenseless people... the motives for massacre need not be rational in order for the killings to be intentional... Mass killings can be carried out for various reasons, including a response to false rumors... political massacre... should be distinguished from criminal or pathological mass killings... as political bodies we of course include the state and its agencies, but also nonstate actors..."

James Alan Fox, a Northeastern professor of criminology, was quoted in a June 15th Reuters article by Carlo Allegri to say that "When we talk about mass killing, we talk about it as criminal homicide....And, generally, killing related to

military operations, wartime, etc., is not criminal homicide. It's homicide, but not criminal homicide." He further stated that "mass murder...has criminal intent not related to the military."

President Obama said, "We know enough to say this was an act of terror and act of hate." The twenty-nine-year-old shooter, Omar Mateen, was a U.S. citizen whose parents immigrated from Afghanistan in the 1980s. He appears to have acted alone. In an interview, one victim held hostage by Mateen in a bathroom during the rampage, described how she heard Mateen, during a 911 telephone call, explain his assault was in reaction to U.S. actions in Afghanistan. Police officials reported Mateen pledged allegiance to ISIS during this call. The large number of fatalities and injuries in Orlando are directly linked to Mateen's main weapon of choice, the Sig Sauer MCX, which was originally designed for U.S. Special Operations forces and is a descendant of the M16 rifle, the standard issue U.S. weapon of war whose high velocity bullets are designed to kill the greatest number of people in the fastest amount of time. If we are in a "war on terror," as another media drumbeat has drilled into us since 9/11, does it not become more questionable as to whether this can be defined as a criminal act or an act of war?

Without question, an accurate investigation of mass killings of this magnitude quickly reveals this was by far not the worst massacre ever to occur on U.S. soil. I first published a list of massacres in May 2007 in the *San Francisco Chronicle*, which was reprinted in *CounterPunch*, in reference to the same claim being made about another mass shooting, when thirty-three students were fatally shot and at least fifteen injured on the Virginia Tech campus in Blacksburg, Virginia. Then too, mass media coverage was punctuated by claims such as in *The New York Times*, which called it the "Worst U.S. Gun Rampage" and CNN, which called it the "Deadliest Killing Spree in U.S. history." This was followed by San Francisco

Fox affiliate KTVU Channel 2's claim that it was "the worst massacre ever in the United States." Monday, June 13, 2016, MSNBC continued to lead their Orlando reports with their variations on the phrase "The worst massacre in U.S. history." *The New York Times'* two-line banner headline concluded with "...50 DEAD IN WORST SHOOTING ON U.S. SOIL." The title on a front-page centered graphic announced in bold: **"Deadliest Mass Shootings in American History,"** where the earliest example detailed twenty-one killed in San Ysidro, California, in 1984; followed by twenty-three killed in Killeen Texas, in 1991; thirty-two killed at Virginia Tech in 2007; and twenty-seven killed in Newtown, Connecticut, in 2012. NPR posted a list of mass shootings beginning in 1966, which perhaps is what is meant by some claims this was the worst in "modern" U.S. history.

Here are just some of the massacres or mass shootings that also took place on mainland U.S. soil in the nineteenth and twentieth centuries, which involved guns and where more than thirty-three people were known to be killed. This list includes massacres conducted by military or para-military groups, but all were clearly actions outside of the U.S. military's acceptable rules of engagement:

–In 1832, Bad Axe, the junction of the Bad Axe and Mississippi Rivers, was the site of the mass murder of at least 300 Sauk (also known as Sac) men, women and children, and twenty Whites. This incident was one of the last battles occurring during the treaty disputes known as the "Black Hawk War," when federal troops under General Samuel Whiteside and the Illinois state militia, including Lieutenant Jefferson Davis, Captain Abraham Lincoln, and Colonel Zachary Taylor, were determined to remove the Sauks and other Plains Indians from their ancestral lands. This massacre occurred on land ceded to the U.S. in 1787 that became part of the Northwest Territory, until Illinois had entered the Union in 1818 and Wisconsin in 1848.

- In 1860, Bret Harte, a well-known California writer, had just begun his career, working as a local newspaper reporter in Arcata, California (a town then known as Union). Harte was expelled from Humboldt County because he recorded the Gunther Island Massacre of Wiyot Indians, committed on February 26, 1860, when a small group of White men murdered between sixty to 200 Wiyot men, women, and children. The massacre was encouraged by a local newspaper. Extermination was once the official policy of the California government toward Native Americans, as Governor Peter H. Burnett stated in 1851: "That a war of extermination will continue to be waged between the two races until the Indian race becomes extinct, must be expected..."

- On April 12, 1864, at Fort Pillow, near Memphis, Tennessee, Confederate troops under General Nathan Forrest massacred 227 Black and White Union troops with such ferocity that an eyewitness Confederate soldier said, "blood, human blood, stood about in pools and brains could have been gathered up in any quantity...General Forrest ordered them shot down like dogs and the carnage continued. Finally our men became sick of blood and the firing ceased."

- July 30, 1866, the White mayor of New Orleans organized and led a mob of ex-Confederates, White supremacists, and members of the city's police force. They opened gunfire on a meeting of the Louisiana Constitutional Convention, in session because the Louisiana State Legislature had recently passed Black Codes, which contrary to the federal Reconstruction laws, restricted rights of Blacks including not allowing Black men the right to vote. The killing rampage spilled out into the streets, and by its conclusion 238 people were killed and forty-five wounded, including 200 Black Union veterans of the Civil War, forty of whom were delegates to the convention. This

event was immortalized in Thomas Nast's cartoon, "The Massacre of the Innocents."

• On April 13, 1873, 350 miles northwest of New Orleans in Colfax, Grand Parish, Louisiana, 280 Blacks were victims of a group of armed White men that included members of the White League and the Ku Klux Klan. Known as the Colfax Massacre, it was said to have been sparked by contested local elections, although more generally its cause was, as in New Orleans in 1866, White opposition to Reconstruction, which in 1875 resulted in *United States v. Cruikshank*, an important basis of future gun control legislation, because it allows that "the federal government had no power to protect citizens against private action (not committed by federal or state government authorities) that deprived them of their constitutional rights under the 14th Amendment." (Quote from "The Racist Origins of US Gun Control" by Steve Ekwall.)

• In the 1880s, when anti-Chinese sentiment was rampant throughout the western United States after the 1882 enactment of the first Chinese Exclusion Act, two massacres of more than thirty Chinese immigrants occurred. In 1885 at Rock Springs, Wyoming, in riots against Chinese coal miners employed by the Union Pacific Railroad, more than forty Chinese Americans were shot, burned or otherwise killed or injured by a mob of White miners, who also burned down their village. The Chinese men had been brought in ten years earlier as strike breakers at the mine. In 1887, at Hells Canyon on the Snake River in Wallowa County, Oregon, a gang of at least seven White horse thieves robbed, shot or otherwise murdered and mutilated at least thirty-four Chinese immigrants who had set up camp to mine gold there. Most of the bodies were found months later by another group of Chinese immigrants who had arrived to mine gold in the area. Although three people were brought to trial, no one

was convicted. In 2005, the area was renamed Chinese Massacre Cove to honor those dead.

• In 1914, during another nationally publicized action known as the Ludlow Massacre, over sixty-six people were killed, including eleven children and two women who were burned alive. Sparked by a strike against the Rockefeller family-owned Colorado Fuel and Iron Corporation by the mostly foreign-born Serb, Greek, and Italian coal miners after one of their union organizers was murdered, it eventually involved the Colorado National Guard, imported strikebreakers, and sympathetic walk-outs by union miners throughout the state. The union never was recognized by the company, and a U.S. Congressional committee investigation failed to result in indictments of any militiaman or mine guard.

• In May and July 1917, between forty and 200 people were killed and 6,000 Black homes and businesses were burned to the ground in the East Saint Louis Riots (aka East Saint Louis Massacre). Considered the nation's worst example of labor violence or race riots, these events occurred during the period known as the Great Migration, when southern Blacks arrived in East St. Louis by the thousands, and were especially provoked when hundreds of Black workers were brought in to replace White workers striking against the Aluminum Ore Works. The employers refused to negotiate with the White workers because so many Blacks were available to take their jobs at lower wages. The National Guard was called in after Whites rode through town shooting indiscriminately at Blacks in their homes, where many were burned alive or shot at as they tried to escape burning buildings. Estimates claim almost half the Black population left East St. Louis, to return to the south, or reside in St. Louis or other nearby towns such as Ferguson, Missouri.

Photo documenting the Ludlow Massacre Ruins in Ludlow,
Colorado in 1914, following a United Mine Workers
of America strike against the Rockefeller family-owned Colorado
Fuel and Iron Corporation. (Library of Congress,
Prints and Photographs Division, Washington, D.C.)

• In 1921, a year when sixty-four lynchings were reported,
the African American Greenwood business district of
Tulsa, Oklahoma, was the site of shooting deaths of at
least forty people, most of whom were Black, although
the actual—but undocumented—death toll is said to be
closer to 300. This site was then known as the "Negro's
Wall Street," and was home to 15,000 people and 191
businesses. The rampage took the form of a riot, and was
caused by economic tensions, particularly sparked by an
article in the *Tulsa Tribune* regarding an alleged rape
incident between a Black shoe shiner and a White eleva-
tor operator. Because of this riot, Tulsa became the first
U.S. city to be bombed from the air, when police dropped
dynamite from private planes to break it up. Whites took
possession of most of the land, and the site now includes
part of Oklahoma State University's Tulsa campus.

The media does a disservice to all Americans when it, in effect, purges our history of the long litany of mass murders we would do well to remember and try to understand. I guess I mistakenly assumed that all American students had at least learned the haunting story of Wounded Knee, when in 1890, between 150 to 300 Lakota Sioux practitioners of the Ghost Dance were shot dead by a detachment of the U.S. 7th Cavalry Regiment. Can it be that ignorance of American history is not only a problem affecting American high school students, but also handicaps even those who graduate from elite graduate journalism programs? A search of the websites of two of the nation's most respected graduate programs in journalism, at Columbia University and the University of California, Berkeley, indicates no history courses are required for graduation from their programs, but they do mention evidence of students' research skills will be expected as part of their application narratives, and that their basic investigative reporting courses teach the investigative process, including the importance and evaluation of documentary evidence. Since the archives of some of our most influential newsrooms extend back to the 1800s, there is no excuse for such historical amnesia on the part of those who have taken upon themselves the serious task of informing the public. Because one sure effect, since the vast majority of these historical shootings were directed against Native Americans and Blacks, is that the take-away could be that even in death, Black and Indian lives don't matter.

Rudolfo Anaya signing his novel, "Albuquerque," in an Albuquerque
restaurant in 2003. (Photo by Ishmael Reed)

The Sorrows of Young Alfonso
by Rudolfo Anaya[1]

A Review

The Sorrows of Young Alfonso
Norman: University of Oklahoma Press, 2016
Volume 15, Chicana & Chicano Visions of the Americas
Series

Rudolfo Anaya's newest book, *The Sorrows of Young Alfonso*, is a hybrid, with a central story embracing an autobiography wrapped in the guise of a biography of a close childhood friend and fellow writer, Alfonso. Identified as fiction on its credits page, it is also an epistolary monologue, addressed to "Dear K," a meditation full of philosophical musings on life, land, religion, myths, nature and the cosmos; a history of the Southwestern United States—especially Albuquerque, the New Mexican lands surrounding it, and the beginnings of the Chicano Movement.

About one quarter of the way into *The Sorrows of Young Alfonso*, the writer, only identified as "I," writes: "K, I'm slow.

1. First appeared in KONCH Magazine, September 2017.

I suddenly realized I've been writing stories. Or something like stories wrapped in letters. I wrote too, you know. Not as well as Fonso, but I wrote. Never published. I used to show my stuff to Fonso. He encouraged me. But no, he was the writer....So here goes, more stories. Bet they never get published. Ha!" This bit of self-irony ignores the lists of Anaya's publications given at the back of this book. With twenty-five volumes of adult literature, eleven children's books, plus the five books for which he served as editor, publication was clearly not an insurmountable problem for Anaya!

The book's title cues its formal inspiration: Johann Wolfgang von Goethe's loosely autobiographical epistolary novel, *The Sorrows of Young Werther*, (1774, 1787). The anonymous writer of *The Sorrows of Young Alfonso* introduces us to his long-time close friend, Alfonso. And thereby hands us another clue: Alfonso is also Rudolfo Anaya's middle name.

We learn how the writer and Alfonso grew up together, and how they shared the experience of life-changing accidents as young teenagers, from which they never fully recovered. Each personally caused by a failed daredevil-feat, the effects of their handicaps continue to influence the paths of their lives: "Trauma kills us or makes us stronger. I think that's why he became a writer, to tell with each story the making of soul."

Goethe wrote *The Sorrows of Young Werther* as a young man (he was twenty-four years old at the time of the first edition's publication), consumed by an unattainable lost love, Lotte. Anaya wrote *The Sorrows of Young Alfonso* as a man in his late seventies, and although he dwells in memories of times Alfonso shared with one youthful true love, Agnes, who accidentally died as a teenager and his deep love of his late wife Patricia (whose story, he tells the reader, he has already written so will not linger on thoughts of her in Alfonso's story), it seems to me the great loss he ponders in

this book is the home of his birth and the life of his Mexican American family and their community, living in harmony with the landscape of the New Mexican llano. September 22, 2016, Anaya was honored with the National Humanities Medal. The White House press release particularly cited his portrayals of the American southwest and depictions of the Chicano experience.

On the llano, Anaya writes:

"The river is in me, he [Alfonso] said. I didn't understand what he meant. 'The llano is in me,' he said. 'The people are in me.' La gente. His soul was made from those things. He made soul from nature and people." (p. 95)

"Sunsets were burned into his memory....Alfonso carried sunset images in his heart. He was forever caught in that time when he stood alone on the llano, shivering from the lingering coolness of the afternoon rain, looking into the fire of the setting sun, becoming one with fire, clouds, light, and color.... The setting sun that day was as spectacular and glorious as any sunset on the llano...It made me think. We humans can only absorb so much beauty. People jump off the edge into the Grand Canyon; others jump off the Golden Gate Bridge. It's more than suicide; I think it's a way of *walking into the sunset and disappearing.* Agape. I wonder if that's the same feeling some get at the end of life. A feeling that you're intimately involved in the earth's consciousness, ready to let go of the body's love for the next day, ready for rapture." (p. 159-161)

On the history of Mexican Americans in the 1940s and 50s:

"The majority of people from that area [of West Texas, where his family had traveled to pick cotton] were poor. Hispanics had been in the state over four hundred years, but except for a few rich families who owned land, the majority remained rural poor. Most had little or no education. Alfonso's mother stressed education to her children. The village school taught only the first few grades. In town, Alfonso and his sisters could

graduate from high school. But work was not easy to come by, especially for their parents, who had only a second-grade education." (p. 93)

"Sons usually followed in their fathers' line of work. A few were breaking the chain and aspiring to something different, college or a move to California for a better-paying job. Change was in the air in the barrios but it came at a cost. Mainstream society had barriers, visible and invisible, and only a trickle could break through. Glass ceilings. Hell, that's nothing new. Study the history of minorities in this country.

"The middle class wasn't a barrio issue. Maybe one or two families made enough money to qualify as middle class. Those who owned the barrio's grocery stores, cafes, gas stations, and furniture stores had money. Those who worked in the railroad shops made fair wages, owned a home and car—a working class that barely rose above the poverty line. Some Nuevo Mexicanos were starting trade businesses that didn't require higher education, and a few were entering professional fields, especially law. In New Mexico, attorneys and politics went hand in hand.....Mostly it was menial work for menial wages. The Hispanic labor force was good for the city, but there was not much of a future for the works.

"....Life was nothing like what was portrayed in the black-and-white television shows of the time. There were no *I Love Lucy* or *Leave It to Beaver* or *Ozzie and Harriet* families in the barrio. Life was difficult. I still look back in anger. So did Alfonso." (pages 166; 173)

On how the anonymous writer, "I," thinks about this book:

"...I put my novel aside and began writing about those years when Alfonso and I were close friends. I know I'm writing memories. Do my memories become a memoir? Am I writing his biography? ...Damn! Is my novel mixed in with these letters? How much of my novel is becoming Alfonso's story? How much of Alfonso is becoming the character in my story?Will my letters reveal Alfonso or my fictional character, who really isn't completely fictional because he is me? But I

gave the character a new name, so he is not me.I guess I've opened Pandora's box, or Alfonso's box, meaning his life is now pouring into my memoir/novel/biography/whatever you wish to call it. How will you decide?" (pages 113-114)

On a philosophy of life:

"I asked her once [referring to the curandera, Agapita, a folk healer who helped bring him into the world and to recover some muscle function after the teenage accident], 'What is the meaning of life?' 'Life is like a river,' she said seriously. My innocent eyes grew wide and I repeated, 'Wow, life is like a river?' She started laughing so loud, it set a nearby covey of doves to flight. Her eyes watered from laughing. Once more she had pulled my leg. When she stopped laughing, she said, 'I don't know the meaning, No one does. Live one day at a time and enjoy. Experience life. Be thankful. The end will come of its own accord, neither predestined nor thought out. It just comes. What you do is all there is. Be kind Alfonso.' I hope I have obeyed her command." (p. 198)

On God:

"So what's real? we poor mortals ask. Let God decide. Or scientists, those who break atoms apart and tell us the resulting subatomic particles are the only reality we know....Anyway, the particle began to be called the God particle. As if God is a particle. I think God is bigger than that. God created the universe, so God *is* the universe, expanding galaxies, a dance and song so wondrous it can kill just to contemplate it." (p. 140)

These are but a few examples of how Rudolfo Anaya successfully cites an old masterwork, using it to apply to his own region and time, and to navigate the line between fiction and memoir.

All quotes are from Rudolfo Anaya, *The Sorrows of Young Alfonso* (Norman: University of Oklahoma Press, 2016). Reprinted by permission of the publisher.

Suzushi Hanayagi (Left) and her sister Suzusetsu Hanayagi (Right)
in a publicity photo taken to promote their tour of classical
Japanese dance in the United States and Europe, circa late 1980s.
(Photographer unknown.)

16

Suzushi Hanayagi at Mulhouse[1]

An unusual pioneer, especially for Japanese women of her pre-World War II generation, the late great choreographer/ dancer Suzushi Hanayagi created and performed dance and theater works based within Japanese performance traditions and from disciplines culled from various cultures and times. She embraced more than three Japanese classical dance forms. She was a master of the Hanayagi School, a traditional Kabuki Theater style founded by a lineage of Kabuki choreographers during Japan's nineteenth century Edo Period. And she practiced in two schools of *Jiuta-mai*, with *mai* being more abstract, intimate salon dance forms which are accompanied to music with slow tempos called *jiuta*. The origin of *Jiuta-mai* can be traced to ancient Shinto practices of incorporating dance into prayers to the gods. And most unusually, she also became an important experimentalist in contemporary performance art forms, and with Robert Wilson, applied all these techniques to the opera, theater, and ballet works he designed and directed. For over fifty years she actively continued to perform, choreograph, and teach classic Japanese and contemporary dance forms in the United States, Europe, and Japan.

1. First appeared in *American Multiculturalism in Context: Views from at Home and Abroad*, Sämi Ludwig, editor (Cambridge Scholars Press, 2017) 239-259.

She was born Mitsuko Kiuchi, in Osaka, August 15, 1928, the youngest child of a successful rice merchant in the Kansai (Osaka-Kyoto) area. At the age of three, she began her dance training in the Hanayagi style by studying with her maternal aunt, Suzukinu Hanayagi. She earned the right to use a professional Hanayagi name at the age of twenty after mastering a repertoire of 100 dances. (Its founders' perspective, as choreographers, is interesting to me in terms of her development, as other sources for the formation of the over 150 present-day schools of Kabuki dance were dancers or actor-dancers or a combination of actor-dancers and choreographers.) While majoring in Japanese literature at Osaka Women's College, she began studying modern dance in Tokyo with Takaya Eguchi, a choreographer who had trained with Mary Wigman, a German modern dance pioneer. Around this time, she also became interested in the more poetic style of Japanese classical dance called *Jiuta-mai*, becoming a student of Takehara Han, a legendary master dancer based in Tokyo, who developed her singular style of *mai* related to those started in the Kansai area during the Edo Period (1603-1868). In the last interview Suzushi Hanayagi gave, published in Japan in 2003 in *Odori Wa Jinsei* (Dance Is Life), she said that because Takehara Han "was from the geisha training school of Soemoncho in Osaka, her art was *odori* and not pure *Jiuta-mai*. She got her basics from *odori* because she studied with Nishikawa *sensei*, the generations of the Fujima family and Onoe *sensei*." (In *Buyo, the Classical Dance*, Masakatsu Gunji writes that distinctions between the terms *odori* and *mai* are not so clear today. *Odori* means "leaping," and dances classified as *odori* characteristically contain rhythmic movement of the feet and more leaping, jumping actions, freer than those called *mai*. They became refined in the process of transferring them to the stage, in connection with the beginning of Kabuki dances early in the 1700s. *Jiuta-mai* techniques, with their rotating or circling

dance patterns, were more related to early court and religious dances and Noh theater, already a distinct form by the fourteenth century. Some forms of *mai* evolved into salon dances so contained in their subtleties and stillness they could exist within the limitation of a space the size of one *tatami* floor mat (in Kyoto that generally would be 0.955 m by 1.91 m), bringing the audience and dancer so close they seemed "to breathe together with some imagination."

Takehara Han remained Ms. Hanayagi's mentor and friend until Ms. Han's death at the age of ninety-five in 1998. And from the late 1960s, Ms. Hanayagi added studies with Yachiyo Inoue IV, headmaster of the Inoue school, a more austere Kyoto based formal salon dance style utilized by geishas that also has its origins in Noh. She continued her lessons in Inoue style until the end of the 1990s, when she ceased performing.

Almost yearly, Ms. Hanayagi presented classical dance performances in Japan, frequently at Tokyo's National Theatre. These were either solo concerts or with her older sister Suzusetsu Hanayagi, as were her classic dance tours in the United States and Europe. She presented her first modern choreography concert in Tokyo in 1957 with music by John Cage and contemporary Japanese and European composers. After seeing exhibitions of works by such artists as Jackson Pollock and Willem de Kooning, and hearing that artists like Robert Rauschenberg were dancing, she became interested in experiencing the new arts scene happening in New York City.

At the beginning of the 1960s, with an introduction from Takehara Han, Suzushi Hanayagi arrived in the United States as a cultural exchange visitor under programs sponsored by the Martha Graham School and Japan Society. Beate Gordon, then director of performing arts at Japan Society, presented her in both traditional and contemporary dance concerts, workshops, and tours of the country's universities and museums, including a national tour with koto player Kimio

Eto under the sponsorship of the Asia Society's Performing Arts Program. In 1962, she presented her U.S. contemporary dance recital debut at Hunter Playhouse consisting of solos set to music by Japanese and European contemporary composers: Kazuo Fukushima, Karlheinz Stockhausen, and Toshiro Mayazumi.

Seeking out American based artists experimenting in dance and performance art, she collaborated with Yoko Ono and Ayo-O, artists creating Fluxus events, and became friends with New York based dancers Simone Forti and Trisha Brown (who said the eighth movement of her dance *Primary Accumulation* represented "a one-second distillation of my love for Suzushi Hanayagi"). She remained a New York resident for most of the decade, where she met and married visual artist Isamu Kawai. They returned to Osaka to be near her family for the birth of their son, Asenda Kiuchi, in 1968. By 1970 she had re-established Osaka as her main residence, to have her family's help raising Asenda after their separation and divorce.

Also during the 1960s, Ms. Hanayagi participated in the performance experiments happening at Anna Halprin's summer workshops in the San Francisco Bay area, where, in 1964, we met. Upon our return to our New York City homes we began to collaborate, meeting in the basement of Judson Memorial Church, in Washington Square, which at the time served as a center of performance innovation known as the Judson Dance Theater Workshop. Over seventeen years we created fourteen works, performed in New York City, Japan and the San Francisco Bay Area in loft spaces, theaters, and museums. These included our 1966 protest work against the War in Vietnam, *Wall St. Journal*, the last work we performed together in New York City. *Work,* a meditation on alchemical philosophy and medieval dance mania forms was partially funded by a 1973 choreography fellowship from the National Endowment for the Arts and performed in a three

city tour of Japan; *Ghost Dance* (1973*)*, further delving into the world history of dance; *The Lost State of Franklin* (1974-1976), a collaboration with Ishmael Reed, in a romanticized version of American history and theater forms around the time of its founding—especially Italian Commedia dell'Arte; and *Trickster Today* (1977), a cross-cultural mix of trickster myths were among our works performed in both California and Japan.

From 1984, following an introduction by Beate Gordon, Ms. Hanayagi served as choreographer in over fifteen seminal productions and projects by renowned stage director and designer Robert Wilson. Their collaborations continued throughout the rest of the 1980s and 1990s, involving more shared works than any of his other close collaborators to date. Mostly large-scale theater and opera productions, they were presented internationally, beginning with *the Knee Plays*, premiered at the Walker Art Center in Minneapolis in 1984 as part of what Wilson envisioned as a multi-sectioned fourteen-hour work, *the CIVIL warS: a tree is best measured when it is down*. Originally subtitled the "American section," Wilson intended the thirteen scenes of *the Knee Plays* to function as "joints," his term for quick transitions between, and introductions to each of the fourteen larger scenes comprising the five acts of *the CIVIL warS*, to function similarly to entr'actes or Kyogen plays, which are short, funny plays performed between the longer, intensely serious content of two Noh dramas. Envisioned for an international audience, the five acts of its global structure were created in Rotterdam, Cologne, Rome, and Minneapolis, plus workshop productions developed in Tokyo and Marseille. Wilson intended all sections to be joined together at an Olympic Arts Festival, to be held concurrently with the 1984 Los Angeles Olympics. But because of lack of funds, that grand plan never came to be. Their other collaborations included *Hamlet Machine*, based on a Heiner Muller text (1986); the four-hour *Death*,

Destruction and Detroit II (1987); *The Forest,* in collaboration with composer David Byrne inspired by the Gilgamesh epic (1987); *Pelleas et Melisande* (1988); *Le Martyre de Saint Sebastien* with the Paris Opera Ballet (1988); Puccini's opera *Madame Butterfly* (1990); *King Lear* (1990); Gertrude Stein's *Dr. Faustus Lights the Lights* (1992); and the 1989 film *La Femme à la Cafetière* inspired by Cézanne's painting of the same title, in the permanent collection of the Musée d'Orsay, Paris. In the interview in *Odori Wa Jinsei* (Dance Is A Life), when asked why she could work with mixed traditions again and again with Robert Wilson, she answered: "Everything I learnt from my teachers became my flesh and blood. ... [and] naturally comes out from those to create works."

In addition, nearly every year from the early 1980s through 1999, she continued to present solo performances of her original work, often at Jean Jean Theatre in Tokyo, and often involving collaborations with other artists, including videographer Katsuhiro Yamaguchi, playwright Heiner Muller, and composers Nettie Simons, David Byrne, Takehisa Kosugi, and Hans Peter Kuhn. Among other artistic collaborations that occurred throughout her career were works directed by filmmaker Molly Davies, choreographer/filmmaker Elaine Summers, and director Julie Taymor, when they mounted a performance of *Oedipus Rex* with the Japan Philharmonic, conducted by Seiji Ozawa in 1988.

In a 1986 interview with Suzushi Hanayagi by Japanese *Dance* magazine editor Roku Hasegawa, republished in Ishmael Reed's *Konch* magazine in a translation by Suzushi with me, she said:

> [My work] is like a diary. My work is to observe myself and to receive outside stimulation or experiences. I compose my thoughts from these sources. When I used to live in New York I felt a conflict in using separate ways, because the people that I worked with were in different worlds. After returning to Japan I started to study classic dance form again. This time I tried a

different way to work. I like it very much. So I feel very natural when I'm doing it. It resolved the conflict. I can use two worlds of dance without mixing. I don't know why I came to admire the conflict. It may be because I become dull or generous. Anyway, I become two worlds with one world. I don't criticize this in myself.

Film producer Hisami Kuroiwa pointed out multiple significances in this statement to me. In saying, "My work] is like a diary," Suzushi was in part referring to how she, in both her own and Wilson's works, connected her knowledge of the postmodern/Judson dance world with a primary tenet of Japanese dance, called *furi*, in which the dancer reconstructs a narrative or indicates an emotional state through a gesture language similar, although more stylized, than those used in daily life. (Hisami Kuroiwa wrote me that "Kabuki Hanayagi tradition is almost like deconstructing *furi* and *mai*. It reminded me of Judson Church's post-modern dance.") Throughout Suzushi's quote is the underlying fact that she had begun to actively practice Zen Buddhism after her return to Japan and was following its guidance to accept that everything will keep changing. (In the "With Water" section of *With Son* (1972), she reenacted a moment of deep insight while doing ablutions during a summer retreat with her Buddhist teacher, her characteristic humor manifesting in her use of her son's wading pool, profusely decorated with his beloved Walt Disney cartoons, to contain the water she splashed over herself.) That Suzushi had made her peace with expressing herself as "two worlds with one world," can also be perceived as a kind of multiculturalism. She was one of the pioneers of the Hip Hop aesthetic, Ishmael Reed observed, in her ability to navigate through many cultures.

However, all Suzushi Hanayagi's creative work had come to a halt by the year 2000, after she became ill with dementia and was residing in a special care facility in her family's home city of Osaka. It was there she participated in what would

Suzushi Hanayagi. A video frame still from the video portrait of
Suzushi Hanayagi, Robert Wilson, 2009. Projected for the stage
production *Kool-Dancing In My Mind*, Robert Wilson, videographer
Richard Rutkowski and Carla Blank, in homage to and in
collaboration with Suzushi Hanayagi (1928-2010) premiering
in the 2009 Works & Process Series of NYC's Guggenheim Museum.
Image courtesy of RW Work LTD.

be her final collaboration with Wilson and me, her artist
friends who were to gather together to create *KOOL-Dancing
in My Mind*, a poetic monument fueled by our wish to help
guarantee her legacy as a great dancer and choreographer.
This live work, in time, would become the basis of Richard
Rutkowski's documentary films, one titled *KOOL-Dancing
in My Mind* and the other, *The Space in Back Of You*.

For me these works took off in 2008, when Robert Wilson
called me out of the blue, and after delicately establishing
that we had both independently solved the mystery as to
why Suzushi had disappeared—asked me to collaborate with
him as choreographer, dramaturge, and archivist on a new
work to honor our mutual dear friend and long-time artistic

collaborator. And he invited Richard Rutkowski to create the visual component of this work that would evolve into *KOOL-Dancing in my Mind*. Richard also had real connections with Suzushi. They had met in 1985 while he was working as Wilson's assistant, during the time she was in residence at the American Repertory Theater in Cambridge, Massachusetts, choreographing Wilson's first production of *Alcestis*.

The live performance of *KOOL-Dancing in my Mind* was set to premiere in the Works & Process series at New York's Guggenheim Museum, April 17-18, 2009, in conjunction with their current exhibit, *The Third Mind: American Arts Contemplate Asia*. As dramaturge, choreographer, and archivist for *KOOL*, the preparatory research required me to revisit over forty years of our letter exchanges and the films, photographs, programs, rehearsal notations, etc., documenting our fourteen collaborations, besides other memorabilia Suzushi Hanayagi had entrusted to my possession. In addition, it gave me access to study the same kinds of documentation of Robert Wilson's fifteen collaborations with Ms. Hanayagi, maintained at Watermill, the laboratory for performance founded by Wilson in Water Mill, New York. I also researched the Japanese classical dance theater forms she practiced. What became clear was that Suzushi Hanayagi's achievements, as an innovative, even radical, Japanese dancer and choreographer, had uniquely bridged East and West in multicultural work that expanded what classical or modern dance is and could be.

Nonetheless, I had long recognized her name and legacy were in danger of disappearing from the history of performing arts, especially after illness caused her retirement from actively performing and choreographing. In my other hat, as a writer of histories, I have learned that this fate is not uncommon, because the established historical artistic record routinely perpetuates the fame of a few individuals and will forever ignore or omit many who have made truly

major contributions, unless they are championed by someone with the clout of a highly respected critic or scholar, or in this case an internationally lauded artist, as is Robert Wilson. In the United States, this practice is especially true if the person ignored is not American-born, male, and White. I had already experienced this lack of interest because my efforts to elevate Suzushi Hanayagi's legacy through a proposed book about her life and work had failed to interest any American publisher, even among those who had a sterling record of releasing books about practitioners of experimental dance. I found out her obscurity was consistently maintained in publications about Judson Dance Theater Workshop, now considered a major influence in the evolution of "post-modern dance," as it has become a hothouse or source of ideas routinely plumbed by contemporary choreographers of today. Even though this early 1960s "institution" aspired to be democratic and non-hierarchal and was where Suzushi Hanayagi and I were offered space to create and perform some of our first collaborations, her name is not listed among those scholars associated with its history, although I have found some Americans listed who had a more tangential connection to Judson's heyday than she.

Her legacy was obscure to the general public in Japan also. Crossing between schools of traditional classical dance, as Suzushi Hanayagi did, was highly unusual, even frowned upon in Japan, where unquestioned loyalty to one's school has long been the rule. Complicating matters was what could be perceived as the arcane subjects of much of her own contemporary experimental work.

When an interviewer asked the cinematographer Richard Rutkowski why he made this film about a dancer who is not known to the general public he replied, "That seemed a good reason to make the film."

The live performance of *KOOL-Dancing in My Mind* was realized by six wonderful dancers, some long-time practi-

tioners and some still early in their careers. They included
Jonah Bokaer, a young but already highly-honored inter-
national choreographer, media artist, and performer who
served as dance captain and choreographer of two solos he
performed; CC Chang, a Taiwanese-born dancer/choreog-
rapher who has appeared with many experimental dance
companies based in New York; Sally Gross, the late, great
dancer/choreographer and longtime friend of both Hanayagi
and myself, since Judson days; Illenk Gentille, a dancer from
Sulawesi, Indonesia, who performed his own solo section,
"Pakarena," an ancient traditional dance from Bugis, an
area of South Sulawesi, and who incorporated another trad-
itional dance, "Badoyo/Bedoyo," associated with the royal
palace of Java or Jogjkarta, into a *KOOL* section performed
simultaneously with one of Jonah's solos as inspired by the
"Two Face Dance" score from *Work*, a duet originally per-
formed in 1973 by Hanayagi and me; Meg Harper, who has
had a distinguished career performing in the companies of
Merce Cunningham, Lucinda Childs, and Wilson; and Yuki
Kawahisa, a Japanese-born multidisciplinary performance
artist who participated in the Watermill workshop meetings
of Wilson, Rutkowski, and me, in August, 2008.

At this Watermill workshop, many ideas were put on
the table as possible elements of the performance. Wilson
created a three-part structure to have a running time of one
hour, with each part consisting of two distinct A/B segments.
This continued to organize how the elements finally chosen
would be slotted into the work, although some ideas even-
tually proved too expensive or difficult to achieve within the
particulars of the Guggenheim's theater space.

For funding and planning purposes, Wilson routinely
creates a Project Book. His staff asked me to quickly provide
various kinds of information, which I itemized in lists. For
the choreography list, I set about selecting excerpts from
dances Suzushi had choreographed with me (between 1964-

1980) and Wilson (between 1984-1999), which I thought were possible to reconstruct as they required minimum hand props and no set to execute. Other lists consisted of: historical research gleaned from archival publicity materials, programs, published interviews and reviews; people who could be interviewed about their relationship with Suzushi; possible current sources of video projections—locations important to Suzushi's family and professional life, and sources for images from still photographs, films or video documentation of works. I also transcribed excerpts from her letters to me, for Wilson to read.

As a way to include Suzushi Hanayagi herself in this work, our next meeting was in October 2008, when Wilson, Rutkowski, Hisami Kuroiwa (who was to become a producer of both films), a small film crew, and I visited her in the Osaka special care facility. There, Rutkowski shot HD portraits of Suzushi's head, hands, and feet, "masked" with white make-up, as directed by Wilson. In describing this later, Rutkowski said he felt the choice of focus "maintained a stylistic consistency, as her hands, face and feet had been the only parts of her body revealed when she was dressed to perform classical Japanese theater dances." (Whitening the face and hands and wearing white tabi socks are familiar conventions of classical Japanese dance. In his work, Wilson frequently has all performers wear white makeup to cover any exposed skin, as he did in *KOOL*.)

Back in the U.S., over the next few months we all communicated by email, creating this memoir/retrospective by refining selections for the four basic elements. The final movement selection included Wilson/Hanayagi dance segments to be reconstructed from documentation videos of *the Knee Plays*, the first collaboration of Suzushi with Bob Wilson—mainly stage crosses that had served as transitions between *the Knee Plays'* sections, and the entire "Knee Play I" *from The Forest* (inspired by plates published in

1700 in Gregorio Lambranzi's *New and Curious School of Theatrical Dancing*, a text we had used in *Shadow Dance, Crowd*, and *The Lost State of Franklin*), and excerpts to be reinterpreted from scores of Blank/Hanayagi collaborations: the large white ball duet from *Wall St. Journal*'s "Part I" and the improvisation score, consisting of an arrangement of nine months of 1966 news photograph clippings during a build-up in the Vietnam War effort, from "Part III" of *Wall St. Journal*; "The Philosopher's Stone" from *With Son*; and a duet performed in crouched position, "Phony Original Men," from *The Lost State of Franklin*. And because she loved props we incorporated one of Suzushi's favorites: wooden sticks of about six to eight feet in length. Sticks had appeared in our collaborations, her collaborations with Wilson and Molly Davies, and her solo works. Usually they were gathered together and tossed or dropped, thereby creating a considerable racket while falling to the floor in random patterns. So sticks became a *KOOL* motif. Wilson had three or four painted white sticks permanently arranged in a stack so far downstage they slightly protruded into the audience's space from the time they entered the theater. At the end of the six sections, each of the six dancers performed unique actions with three other painted white sticks. These particular actions came from a solo, "Cat Woman w/Sticks," inspired by manifestations of a female Egyptian cat-headed god—Hathor/Sekhmet—attributed to be a god of dance, which I choreographed for my 1972 version of *Work*. (After we left New York, Suzushi and I often created the concepts for our works through letters, drawings, shared research sources, and occasional meetings. We would then realize the scores or scripts in separate performances, hers in Japan and mine in the United States, subsequently sharing what occurred via photos and video documentation.) In *KOOL*, for me the sticks functioned like punctuation. For arts reviewer Susan Yung who wrote about *KOOL* in her PBS blog, the "Wooden

slats served as metaphors for life, for sanity. A short stack sat downstage with some slats askance. The performers manipulated three other slats, letting them drop, scattering them violently, restacking them, or trying to gather them up neatly, as one might a life's detritus."

Otherwise, the sound was recorded music, mostly David Byrne's original compositions for *the Knee Plays*. Jonah and Illenk's duet was performed to the Prelude from Bach's "Toccata and Fugue in B Minor" for organ; Jonah's solo was performed to an excerpt from Lou Reed's *Metal Machine Music*, and Illenk's solo music came from *I La Galigo*, a Wilson directed work inspired by a South Sulawesi creation myth. Because she could no longer speak, scripted voiceovers were read by Richard Rutkowski, of quotes gleaned from Suzushi's published interviews and her letters to me.

The rear of the stage was covered floor to ceiling by a white cyc, a curtain which Wilson saturated with his signature treatments of light, or which became the screen where projections of the HD portraits and archival and recently filmed images floated in and out. In one interview, Richard described how, "we sometimes put her onscreen twice: one side of the screen in a modern piece, and on the other, a more traditional piece. So that comparison can be viewed very directly."

In January 2009 we held our first studio meeting with the dancers, organized under the watchful eye of the late Sue Jane Stoker, Wilson's assistant director/stage manager extraordinaire, who kept track of our choreographic decisions. When we met again in the two weeks preceding the Guggenheim premiere, the dances were further refined after showing them to Wilson, who arrived following the premiere of another work he had been directing in Berlin. In the final week when we had access to the Guggenheim's Peter B. Lewis Theater, rehearsals of the dances continued as Wilson set his lighting design in coordination with the projections and

sound elements, the all-white uniform costumes were sewn, and hand props assembled. Technical aspects continued to be tweaked almost to curtain time. The work was further developed, especially involving a choreographic addition to the ending, in August 2009, for its next performance at Guild Hall in East Hampton, New York, when all the dancers appeared onstage, each entrance "steered" by a stick manipulated like the oar of a boat, and after facing forward while holding the sticks horizontal to the stage floor, they were dropped one by one until the last stick clattered into silence. Subsequently, *KOOL* was given its international premiere at Berlin's Academy of the Arts in September 2010, and its last live performance to date occurred when Wilson chose *KOOL* to represent his work at his Jerome Robbins Award ceremony at New York's Baryshnikov Arts Center, December 9, 2010.

Following the Guggenheim premiere, Rutkowski created the twenty-six-minute film using the same title and incorporating the projections and his documentation of the Guggenheim rehearsals and premiere. It was first shown at the Guild Hall performance. To me, it felt mysterious, like a poem. Later he expanded this footage into the sixty-eight-minute film seen in Mulhouse, *The Space In Back of You.* Hisami Kuroiwa explained in a letter to me, that the motivation for her and Richard, to undertake making the longer version was "Because *KOOL-Dancing in my Mind* is more about Robert Wilson's visiting Suzushi in her sad state, and reconstruction of her pieces, but both of us felt who Suzushi Hanayagi was, was not explained enough. That is why I went to raise money to make a longer piece."

For me, this longer version works more like a story through its interviews, which provide a narrative of Suzushi Hanayagi's biography and clarify many of her artistic connections with Robert Wilson and myself, in addition to other American, European, and Japanese artists, both contemporary and traditional, with whom she worked and whose

life she touched. One artistic connection in both films had particular resonance for the Mulhouse conference: via a documentary film clip, Suzushi performs her solo choreographed to Cab Calloway's classic, "Minnie the Moocher," as sung a capella by Ishmael Reed on *Conjure I: Music to the Texts of Ishmael Reed* (American Clavé 1984), an album Ms. Hanayagi used in its entirety for *Americium/ E.M.*, one of her last Tokyo concerts, in 1997.

In another example, Robert Wilson speaks words to the effect that although audiences thought they saw an influence from the aesthetics of Japanese performing arts in his work, he knew nothing about traditional Japanese dance and theater before he met Suzushi Hanayagi. Through various moments in the film's documentation of their collaborations, and particularly as he demonstrates how he wants the *KOOL* dancers to perform an abstract hand gesture sequence, viewers can see how Wilson, who publicly referred to Suzushi Hanayagi as "my teacher," came to translate essentially Japanese dance styles such as *furi*, the hand gesture language, and the posture and dynamics of *mai* and *odori* into his own famously time-expanding non-realistic style. Jeff Janisheski quotes Robert Wilson in a 1986 interview:

> Maybe the most difficult thing to do is to stand on a stage. How do you stand on a stage? How do you walk on a stage? The Japanese believe that the gods are beneath the floor when you make contact with the floor. But you learn to stand by standing. You learn to walk by walking. There's no such thing as no movement; there's always movement.

In *KOOL's* Guggenheim performance, Suzushi Hanayagi's use of *suriashi*, one of the key practices from Noh theater, is immediately apparent in a sequence reconstructed from her choreography for Wilson's *the Knee Plays*, as all six dancers first enter massed in group formation and progress across the stage. The documentation of this opening sequence is

included in both films. *Suriashi* requires the dancer to walk with smoothly sliding footsteps while maintaining a low center of gravity and a secure, upright position in the torso and head. Translated to English, *Suriashi* means you walk through the earth. It is a basic skill all students of Japanese dance must master, and is also used in martial arts including Sumo, Aikido, Kendo, and even for walking at a tea ceremony. In footage recorded by Hisami Kuroiwa in the Kyoto studio of Inoue Yachiyo, viewers can observe her teaching a young girl how to walk by mastering *suriashi*.

Suriashi is a clear example of how the origins of Japanese culture, which evolved from a predominately farming culture and Shintoism with its many gods from Nature, profoundly influenced Japanese dance forms. Some scholars have theorized that Japanese dance developed in essentially opposite dynamics to those of Western dance traditions because in Western cultures, hunting predominated. And as in scholar S. Ito's theory, in Japan "the gods came down to earth, whereas in the West the gods are imagined to be in heaven, above the sky." In his book *Buyo*, Masakatsu Gunji explains:

> The English word 'dance' derives from the Old High German word *danson*. Its original meaning was 'to stretch the body.'[and] in Western dance...there are many leaps and bounds.... In order to apply this definition to Japanese dance, one must invert it. Japanese dance has a great affinity for the earth, above which it hovers. Its purpose is to confirm the existence of the earth itself. Thus basically Western dance aspires toward the heavens while Eastern dance shows great love for the earth. It is from this basic difference that different kinds of movement were born, Western dance movement being radiant or extensive and that of Eastern dance being intensive...and closely related to everyday life....Nowhere is the intimacy between dance and life itself more clearly expressed in Japan than in the rituals of rice cultivation...The planting festival, *taue*, is one of the sources of all Japanese performing arts.

(I believe Ito and Gunji were thinking about ballet when they described "Western dance," rather than the folk-dance forms, which can be quite grounded, or modern dance, as one early and vociferous critical charge against the modern dance pioneers, both American and German, was that they were too floor bound. Even to this day, the ritual practices of many modern dance techniques begin on the floor, meaning the dancers are actually sitting or lying on the floor while doing their exercises. In fact, entire dances have been choreographed on the floor, such as Mary Wigman's solo *Hexentanz* (Witch Dance, 1926), or most of a dance as in Alvin Ailey's solo, "I Wanna be Ready," from *Revelations* (1960), or seated as in Martha Graham's solo, *Lamentation* (1930). So could it be, this was one of the reasons Suzushi was attracted to modern dance?)

The Space In Back of You demonstrates how Suzushi Hanayagi's complex blending of Japanese classical traditions with modern and post-modern dance continues to influence Robert Wilson's work (and, although not explicitly stated, how in turn, their work has influenced the look of many international companies' opera productions). A Robert Wilson quote from *Portrait, Still Life, Landscape*, a 1993 exhibition catalogue of his work, reveals just how far Wilson had come from knowing nothing about Japanese dance traditions:

'I hate naturalism. I think to be natural on stage is to lie. That is why I like formalism. In theatre I am much more related to the eastern tradition than to the western one. To Noh or Kabuki or Bunraku more than Tennessee Williams or whatever we have done in the last two or three hundred years in western theatre.'

As the Guggenheim's *KOOL* program notes explained, Wilson

...discovered, from working with Hanayagi, that abstract movement can generate meaning and that movement can be

a counterpoint to language. Hanayagi helped him open up the vocabulary of the gesture and opened Wilson's eyes to the importance of feet and the connection of the body to the ground, impacting the ways Wilson's actors stand and move through space, using their entire bodies to convey meaning. Without her influence, he would not have been able to master the literary texts and operatic pieces that have become such a focus of the latter part of his career.

Richard Rutkowski said "Suzushi's legacy is in the work she did and [is] powerfully visible in any image of her incredible presence on stage. She truly understood the power of stillness and the universal language of movement." In another interview he further explained, "What I most enjoyed... was seeing the interchange between the modern and the ancient, how she could make the old dance look new and embue [sic] new work with the great weight and timelessness of her traditional background."

Fortunately, her artistry can continue to be communicated through showings of Rutkowski's films. *Kool-Dancing in My Mind* appeared on ARTE TV in France and Germany and was shown at Sundance and the IFC Center, a New York City cinema featuring independent films. *The Space in Back of You*, the documentary film directed by Richard Rutkowski between 2010-2011, premiered at Lincoln Center's Dance on Camera festival in New York in 2012, was shown at CinemaAsia on the Public Broadcasting Service (PBS) in the US and at international film and dance festivals in San Francisco, Berlin, Tokyo, Thessaloniki, and Toronto.

Another opportunity to show *The Space in Back of You* took place the evening of March 26th, 2015, when participants in the Université Haute-Alsace's international conference, "American Multiculturalism in Context / Le Multiculturalisme Américain en Contexte," gathered with their guests at the Hôtel de Ville, the Old Town Hall of Mulhouse, in the Alsace region of France, close to the Swiss

and German border. Originally constructed in 1553 and known in Alsatian as the *Rothüs* (*Rathaus* in German), the Old Town Hall is famous for its pink and red façade, decorated with trompe l'œil allegorical paintings representing the vices and virtues.

The Hall offered a fitting setting for a meeting between ancient (exterior) and modern (interior) cultural aesthetics when, after an opening reception, the conference participants and their guests watched *The Space in Back of You.* Sämi Ludwig, the conference's primary organizer, arranged for this viewing at the beginning of the conference because he saw it as an opportunity to bring attention to the inherent "issue of variety in multiculturalism":

> Multiculturalism means variety, also of the means of expression! We don't just want to have dry and abstract academic ruminations (I am not a deconstructive semiotician!). Life is much more complicated than our representations of it, thus showing dance to our literary critics, political sociologists, etc. was important to me. Dance is a different medium, and so is film. I was very happy to get these two additional dimensions into my conference! ... I also think that multiculturalism does not just move forward in the sense of modernizing experience or progressing knowledge. There are too many branches on that tree to give its growth a clear direction. The development is simply a matter of richness. ...
>
> Finally, a public viewing also opened up our gathering to a wider audience. In France this is called *vulgarisation*—meaning that the complex academic shoptalk should be translated to the wider public. The idea is to bring the ivory tower of academia closer to the general public. It didn't work out perfectly in our case, but at least we were gathering in the Hôtel de Ville. The viewing did good work for the group feelings at the conference! It made each one of us think beyond our own narrow patch of expertise!

I led the Q & A that followed the showing and shared some background about the film and my relationship to it.

How Suzushi Hanayagi and I were life-long friends from the time of our meeting at Anna Halprin's summer dance workshop session in the Kentfield woods of Marin County, California, during the summer of 1964. For me, the experience underlined how, when you are so close to someone, it can be difficult to fully communicate their significance to others, the impact of their work on their times and even the world.

I did not know how the Mulhouse audience would respond to the film. So I was especially touched by the warmth of people's feelings, as expressed to me after the showing. One person said she had never looked at dance before; another said this film surprised her with an exciting new experience. Others offered sympathy for our loss of such a great artist's presence. As explained by the youngest conference participant, Julia Ludwig, a high school student who had recently published her first novel:

> I can remember feeling touched by Hanayagi's words, something only a true artist would do; very awe-inspiring for me personally because I was somehow able to relate, and it made me feel sad that she could not practice her art with her entire body anymore. It was all the more inspiring to see that she was able to create a similar compelling ambience with but the movements of her fingers and toes. I believe I got a better understanding of how important space is and what it means to be moving through space and within your own space. The film generally left me with a warm feeling of tranquility and yet very much inspired me to produce my own art.

Poet and journalist Yuri Kageyama sensitively expressed the complex emotions I still experience watching and presenting this film, in her AP article celebrating the premiere of *KOOL* at the Guggenheim Museum: "One of the most moving aspects of 'KOOL' is to catch a glimpse into the vision and emotions that bond artists, how they overcome cultural differences, the passage of time and the hardships of

sickness. The piece is also about how artists can see beyond what is there, to get others to see beyond what is there. It is about how life, artistic productivity and our time with our loved ones must end—and about how they never really end."

Partial Annotated Bibliography

Articles and Books:

Anderson, Jack. "Life Through A Glass, Darkly," a review of "Arrivals and Departures," a collaboration with filmmaker and director Molly Davies. *The New York Times*, May 10, 1988.

Banes, Sally. *Terpsichore in Sneakers: Post Modern Dance*. Boston: Houghton Mifflin, 1980, rpt. with a new introduction by Wesleyan UP, 1987, 2011. See page 83 for Trisha Brown's explanation for choosing the eighth movement in her 1972 dance "Primary Accumulation."

Bernheimer, Martin. "Robert Wilson Stages an Abstract Vision of 'Alceste' in Chicago." *The Los Angeles Times*, September 17, 1990.

Blank, Carla. "Suzushi Hanayagi (1928-2010)," *Dance Magazine*, August 08, 2012.

Dunning, Jennifer. "Experiment With Mirrors and a Dancing Camera," a review of "Bitwin: Dance in Media," a collaboration with videographer Katsuhiro Yamaguchi. *The New York Times*, June 18, 1988.

—. "Exploring the Art of the Solo in 2 Forms From Japan." *The New York Times*, November 23, 1989.

—. "2 Worlds of Dance of Suzushi Hanayagi." *The New York Times*, November (day unknown), 1978.

Fairbrother, Trevor. *Robert Wilson's Vision*. Boston and New York: Museum of Fine Arts, Boston, with Harry N. Abrams, Inc., Publishers, 1991.

Gunji, Masakatsu. *Buyo: The Classical Dance*. Translation by Don Kenny. New York & Tokyo: A Weatherhill book by Weatherhill/Tankosha, 1970.

Hasegawa, Roku. "Suzushi Hanayagi: An Interview." *Dance Work* #35, Summer 1986 as translated by Suzushi Hanayagi and Carla Blank for *Konch* (1.1).

Janisheski, Jeff. "Empire of Stillness: The Six Essential aspects of Japanese Noh." *The Conversation*, June 18, 2014.

Jowitt, Deborah. "Robert Wilson Pays Homage to Suzushi Hanayagi at the Guggenheim." A review of the Guggenheim Museum premiere

performance of *KOOL-Dancing in My Mind*. *The Village Voice*, April 22, 2009.

Kageyama, Yuri. "Wilson pays 'last' homage to ill Japanese Dancer," a review of the Guggenheim Museum premiere performance of *KOOL-Dancing in My Mind*," *The Japan Times*: Friday, July 24, 2009.

La Rocco, Claudia. "Choreographers Reveal A 'Last Collaboration'." *The New York Times*, April 21, 2009. This reviewer somehow did not understand that the majority of the choreography included in this work was either remounted, based on archives of works by Ms. Hanayagi created in collaboration with either Blank or Wilson, or reinterpretations by the cast of scores provided by Blank.

Levine, Marianna. "Robert Wilson's Dance for a Friend." *The Sag Harbor Express*, posted August 7, 2009.

Mee, Erin, interviewer. "Laurie Anderson and Suzushi Hanayagi: Modernists with Classical Roots." *The A.R.T. News* VI.3 (March 1986).

Okamoto, Taiyo and Joseph Reid. "To Embrace the Space in Back of You." *COOL, a Bilingual Art Magazine*. January 29, 2012. This interview with Richard Rutkowski originally appeared on the web site for *The Space In Back of You*, which is no longer available online.

Reed, Ishmael. "Tilting Toward A Masterpiece, Take 23." Blog posted on sfgate May 8, 2009.

Richards, David. "Singular Rhythms of 'the Knee Plays'," review of the first collaboration by Hanayagi with Wilson in *The Washington Post*, November 20, 1986.

Rockwell, John. "Robert Wilson Updates A Babylonian Epic," a review of "The Forest," a Hanayagi collaboration with Wilson. *The New York Times*, December 4, 1988.

—. "Pageant: Portion of Robert Wilson's 'Civil Wars'." *The New York Times*, April 27, 1984.

Stein, Bonnie Sue, interviewer, *Dance Magazine*, May 1988, page 38-39.

Tuohy, William. "Robert Wilson: The Theater of Timelessness," a review of the opera "Alceste." *Los Angeles Times*, December 21, 1986. Another Wilson/Hanayagi collaboration.

Tsurumi, Kazuko, with Senrei Nishikawa and Suzushi Hanayagi. *Odori Wa Jinsei* (Dance Is Life). Tokyo: Fujiwara-Shoten, 2003. (English translations in this article by Yuri Kageyama and Hisami Kuroiwa.)

Weiler, Christel. "Japanese Traces in Robert Wilson's Productions." *The Intercultural Performance Reader*, ed. Patrice Pavis. London: Routledge, 1996. Pages 105-113.

Weinreich, Regina. "Turning Japanese: Tennessee Williams and Robert Wilson." *Huffington Post*, August 11, 2009.

Wilson, Robert. *Portrait, Still Life, Landscape*. Rotterdam, Netherlands: Museum Boijmans Van Beuningen, 1993. Out of print.

Yang, Chi-Hui. "The Space in Back of You: A Conversation with Director Richard Rutkowski." Posted August 25, 2013 in *Cinema Asian America Xfinity on Demand*.

Yung, Susan. "Robert Wilson: Mastering Time." Blog posted on thirteen. org 04/21/09.

Zieda, Margarita. "Dancing in My Mind." *Studija*, Visual Art magazine. June 2010.

Film:

The Art of Make-Up for the Japanese classical dance; [and] Classical Dance (1975). Directed by Don MacLennan. 2 hour VHS documentary produced by Beate Gordon and Don MacLennan. Suzushi Hanayagi and her sister, Suzusetsu Hanayagi on *Jiuta-mai* technique, repertoire, make-up and dressing, with commentary by Beate Gordon. Available in the Performing Arts Research Collection-Dance of New York Public Library at Lincoln Center.

It's Clean, It Just Looks Dirty. (1986) Film by John Giorno that includes excerpts from documentation of Suzushi Hanayagi choreographing and performing, in 1984, in rehearsals and performance of *the Knee Plays* at the Walker Art Center, Minneapolis, MN.

La Femme à la Cafétière. (1989) 6 minutes. Directed by Robert Wilson with Ms. Hanayagi as featured performer. Inspired by a Paul Cézanne painting of the same name, currently in the collection of the Musée d'Orsay.

KOOL-Dancing in My Mind. (2009) 30 minutes. Short Documentary. Directed by Richard Rutkowski and Robert Wilson. Produced by Jorn Weisbrodt, Richard Rutkowski and Hisami Kuroiwa. Co-produced by: ARTE/France and INA. Editing by Keiko Deguchi and Brendan Russell. Researcher, archivist: Carla Blank.

The Space in Back of You. (2011) 68 minutes. Documentary. Directed and with principal cinematography by Richard Rutkowski. Produced by Hisami Kuroiwa and Richard Rutkowski. Principal film editor, Keiku Deguchi. Researcher, archivist: Carla Blank. Includes interviews with David Byrne, musician; Molly Davies, filmmaker; Anna Halprin, choreographer; Simone Forti, choreographer; Hans Peter Kuhn, composer; Yoshio Yabara, designer; Yachiyo Inoue V, the granddaughter of Ms. Hanayagi's

master teacher, Yachiyo Inoue IV, and Carla Blank, choreographer and dramaturge.

CD/DVD:

Byrne, David. *The Knee Plays*. Nonesuch303228-2. Contains *Music for the Knee Plays by Robert Wilson and David Byrne from Robert Wilson's the CIVIL warS*: and sequential photographs by JoAnn Verburg, taken at the Walker Art Center premiere performance in Minneapolis in 1984.

Archives:

Suzushi Hanayagi's archives that are currently held by the Kiuchi family in Osaka, Japan, and by Carla Blank in Oakland, California, consist of letters, photographs, scores and rehearsal notations, programs, films, and video documentation. New York City's Performing Arts Library at Lincoln Center also holds videos and archival materials. Robert Wilson's documentation of his collaborations with Suzushi Hanayagi are housed by his company, RW Work LTD., 115 W 29 St, 10 fl., New York, NY 10001. Research requests can also be sent to www.robertwilson.com.

Dancer / choreographer Isadora Duncan (1877-1927), dancing.
A lantern slide by Arnold Genthe (1869-1942).
(Genthe photograph collection, Library of Congress,
Prints and Photographs Division, Washington, D.C.)

"L'arte è per 1% ispirazione e per il 99% duro lavoro, / Art is 1% Inspiration and 99% Perspiration"

An Interview by Corinne Bergamini with Carla Blank[1]

Dear Mrs. Blank,

I am Corinne Bergamini and I am a Ca' Foscari University student in Venice.

Some other students and I are taking an exam about poetry and music.

I obtained your email address from Mr. Alessandro Scarsella, a Literature teacher of Ca' Foscari University and the [person] responsible for the event in which Mr. Ishmael Reed will be protagonist in May.

As you and your family are all artists and work everyday with both the disciplines, poetry and music, we decided to choose you as cornerstone of our research. Would you be so kind to answer some questions before the event "2016 A.D.A. INTERNATIONAL PRIZE" on May 19th?

1. First appeared in *Una bussola per l'infostera*, edited by Giorgio Rimondi and Nicola Paladin. Milan: Agenzia X, 2017, 89-96.

Dear Mrs. Blank,

1. You are a performer, director, dramaturge and teacher of dance and theater for over 40 years. Why do you do what you do? How did you approach to the world of art? What is your background?

From early on, the arts were completely integrated into my daily life. I was lucky in that although my family was poor, because many of my parents' closest friends were artists, I was able to get an early start as an artist. Since I loved dancing to any music as a very young child—I began my first lessons from five years of age—in what was then called "contemporary dance" or "modern dance," with the technique I was taught basically centered on Martha Graham's technique and philosophy, with some Humphrey-Weidman and other modern dance pioneers' ideas mixed in. The modern dance mantra— with roots going back to Isadora Duncan—was that this form was unique in that it was your "individual expression," and I believed this until I recognized the implications in the fact that, although I was choreographing and performing my own work frequently, the technique classes that supported it were conducted in a very regimented manner, with all the dancers placed in lines, facing mirrors or a wall, imitating each movement the teacher demonstrated as exactly as possible.

The way I was trained to perform and choreograph was very similar to the way actors are trained in the Stanislavsky system, or what is known in the U.S. as Method acting, in which the performer seeks their emotional truth behind every word and action. As translated to dance, every movement needed my justification. By my early twenties, I no longer practiced the Graham style. At Judson Church workshops in New York City and Anna Halprin's summer workshops in Marin County, California, I experimented with improvisation and chance methods, which did not require any justification, but which like a game, provided rules or directions to follow. But in fact, that earlier training would prove to be a helpful bridge into teaching and directing theater, which became a major focus of mine as I grew older.

Another major influence occurred from fourth grade through eighth grade, when I attended a private experimental elementary school connected to the University of Pittsburgh. There I spent much of my time collaborating with the music teacher and fellow students on musical productions where I was one of the writers, the choreographer, and a performer. I loved these collaborations, and as it turns out, have continued to participate in them throughout my professional life.

I also took piano lessons from five years of age, and then switched to violin by fourth grade, playing in youth orchestras, besides going folk dancing with my family on weekends, folk singing, and later learning how to accompany myself playing the guitar.

I started teaching very young also—teaching folk dancing to eight-year-olds when I was twelve years old at a local Y in Pittsburgh, Pennsylvania, where I was born. And I apprenticed with my modern dance teachers, so that by sixteen years of age I was teaching children's classes for them. As dance is a notoriously low paying profession in the U.S., this was very fortuitous as it gave me a way to earn an income.

Had I grown up in the New York City area, which starting in the 1950s was being called the center of the art world, I might not have been given these opportunities so young—as the lessons were all on scholarship—and the competition for teaching jobs not so intense.

As for the writing—my other hat—it may be that it was my escape from the performing arts world, as it can be done alone, with just the simplest of tools—at that time a typewriter and some paper. Sometimes it was to create scripts, other times journals and poetry, and later on, as my teaching assignments led me into it, historical essays.

2. Your husband Ishmael Scott Reed is a poet, novelist, essayist, songwriter, playwright, editor, and publisher. How can you blend music with literature? What's integral to the work of an artist that does so many different things?

Working in a multidisciplinary way seems completely neces-sary—by their very nature dance and theater are multidisci-

plinary forms—even if you know how to do all the technical work, often you cannot do everything, e.g: if you are not working in natural light, you need a lighting designer, and depending on the needs of the project you may need a set designer, costume designer, music director or environmental sound designer, stage crew, performers, and on and on.

Art is one of those jobs that you cannot leave at the office—projects take over your life, and if you are performing, you must keep on training like professional athletes must do or you lose too much time getting back into shape.

We have to learn to "round robin" the jobs—some creative process time in the studio, some time at the computer (keeping the documentation, the business of the business and publicity going), some time doing the research to feed the creative juices, besides fitting in daily life chores.

Another thing is to learn not to take personally all the "nos" you will inevitably receive—this is a hard one for many, as some of the most creative people I met along the way could not ignore the negativity that probably results in large part because the arts provide such a small pie and so many people are fighting over who gets a piece.

3. What art do you most identify with?

Can't decide—I love them all. Visual arts, music, performance, literature. I enjoy being able to switch back and forth between them.

4. What work do you most enjoying doing?

Working with a group of people to make an original performance from scratch. Actually some of my most exciting experiences have been with people who had little or no training as artists. I work with them in basically the same ways I would with any professional artist.

5. Reed's work has often sought to represent neglected African and African American perspectives. Describe a real-life situation that inspired you.

The cast and crew of *News from Fukushima: Meditation on an Under-Reported Catastrophe by a Poet* gather outside of the Club at La Mama after September 2015 premiere performances. Left to Right: Stage manager Rome Neal, musician Hirokazu Suyama, technician Hao Bai, musician Sumie Kaneko, playwright Yuri Kageyama, musician Kaoru Watanabe, musician Melvin Gibbs, actor/dancer Shigeko Suga, actor/dancer Takemi Kitamura, actor/dancer Monisha Shiva, director Carla Blank. (Photo by Tennessee Reed)

In 1965-66, when the United States' role in what became the Vietnam War was just heating up, I created an hour-long performance work with Suzushi Hanayagi, called "Wall St. Journal." We were against the war, and at times in the piece, consciously used our different appearances—she as an Asian and me as an American. For Part One, we went to Wall Street and improvised inside and outside of its skyscrapers, and then back in the studio used ladders to recreate that sense of space while in performance, a tape played the radio's erratic stock market reports of the day. In the second section we manipulated a series of found objects such as a baby doll, multiple eyeglasses, a window frame—the images functioned like a list of "headlines," or poetic puzzles. The score for the third

section was created by cutting images out of newspapers and magazines during the nine months we were creating the piece, and after these months of improvising, organizing them into a final order we performed while wearing chest high fishermen's rubber suits, which helped us slosh around like the clowns we felt us humans are to go to war.

More recently, I was dramaturge and director for Tokyo based writer Yuri Kageyama's *News From Fukushima: Meditation On An Under-Reported Catastrophe By A Poet*, where dance, poetry and music were performed by a collaborating international cast of actor-dancers and musicians. The title announces the real-life situation.

6. You serve as editorial director of the Ishmael Reed Publishing Company, supervising its poetry and prose projects. Do you enjoy working with your husband?

Ishmael and I believe in helping other artists, in this case writers, and this is the best way we can, by getting them published. Especially now, when it is very hard to get a mainstream publisher to take on new work, or even publish work by long established artists who may not have a history of selling a lot of books, but who are fine writers. He has a great eye, so it is very helpful to get his feedback while editing other people's work, and framing how to present it in press materials and so forth.

7. Ishmael Reed and Tennessee Reed are both artists. How is it living in a family of writers?

It is wonderful to have the complete support of each other's work. And because we are all working artists, we understand how important it is to give each other the space to do the work.

For my own writing work, as with editing other people's work, it is very helpful to get Ishmael's insights as an editor. And as a source of reference materials, he is endlessly helpful.

Tennessee has been documenting my work with her photography and videography, something very important to do when working "live," but was one detail I would sometimes not think to take care of until too late.

8. What is your dream project?

Working with a group of people to make an original perform-
ance from scratch. (Never know what you will end up with.)

9. Professionally, what's your goal?

To keep working, trying new things. To finish my chronological
history of the U.S., 1775-1899 on which I have been working, on
and off, since completing *Rediscovering America, the Making
of Multicultural America 1900-2000* in 2003.

10. What's the best piece of advice you've been given?
Art is 1% inspiration and 99% perspiration.
Or
Edit!

Thanks a lot,

Best regards

Corinne Bergamini

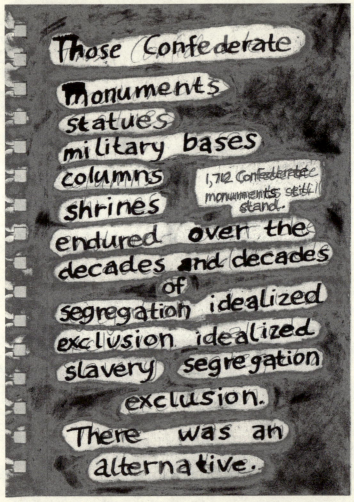

Those Confederate monuments statues military bases columns shrines endured over the decades and decades of segregation idealized exclusion idealized slavery segregation exclusion. There was an alternative.

1,712 Confederate monuments still stand.

From Slavery to Freedom by Nell Painter, page 10. 2020. Series of 15 drawings each 8.5" x 5.5", ink and collage on paper, digitally manipulated. Commissioned by Emma Wilcox for Aferro Gallery in Newark.

Old in Art School:
A Memoir of Starting Over[1]

by Nell Painter

Review

Old in Art School
Berkeley, California
Counterpoint Press
2018, 331 pages

At the age of sixty-four, with a distinguished academic and publishing career as a historian, Nell Painter decided to fulfill her long-time dream to become a professional visual artist.

Before launching her career as an artist, she was a professor at Princeton University. Recognizing that her "history writing tugged me toward art over the years," she follows through this change of field by going back to school, earning a BFA at the Mason Gross School of the Arts at Rutgers University, and an MFA in painting at the Rhode Island School of Design. She chooses this difficult and expensive route, which she calls a "pursuit of pleasure," because she

1. First appeared in *Konch*, Fall 2018.

wants to experience evaluations of her work by other artists. Another aim is networking, in order to realize a professional career. She did not want to end up as "a *mere* Sunday painter," (italics author's).

Nell Painter chronicles her day-by-day experiences as an art student. She is well aware of most pitfalls that could be ahead, having been a long-time participant in the ways of the academe. She enjoys learning with and from the young art students who surround her. However, she is still subject to painful self-doubts. Some come because of reactions to the fact that she is still a rarity in art school—a person much older than the other students, who is also a Black woman. Others are occasioned by criticisms from fellow students and some teachers who adhere to inflexible training traditions, which include belittling students. Such taunts as, "You'll never be an artist"—which she sees as "a way to take me down a peg—knock me off my high horse…" These admonishments which are more suitable for training Marines are transferred to the classroom, based on the belief they prepare students to survive in the competitive art world.

Making it is, however, an essential part of her goal, and so she soldiers on with plain old persistence, using lifelong skills honed through disciplined research and writing. Her basic solution to bumps in the road: do lots of work, because, for her, progress comes from her "old standbys: education and hard work." Her accumulating knowledge of current techniques and technologies of the art trade are useful to anyone wanting to become an artist in the twenty-first century. They reveal not only her own processes—how she applies paint to paper or canvas, how she mixes multiple colors to depict Black skin and its reflectiveness—but also classic and contemporary techniques of the trade. She writes: "Process was becoming more important to me, how work looked as well as what it meant politically. Now I could concentrate more fully on how artists worked."

Over these years as a student, Painter asks the questions: "What counts as art? Who is an artist? Who decides?" She has her favorite artists, and through her classes and travels, learns more, realizing: "It took me years in art school to recognize my twentieth-century eyes as my major handicap as an artist, the real way I was old in art school. My eyes hindered me perhaps more than my sex and race. I say perhaps, because I can't disentangle old eyes from woman and black, and because I don't want to dwell on my disadvantages. I did come to know that art is fundamentally about taste, and tastes vary; tastes change. My lying twentieth-century eyes favored craft, clarity, skill, narrative, and meaning. My twenty-first-century classmates and teachers preferred normal subject matter, the do-it-yourself (DIY) aesthetic, appropriation, and the visible marks of facture: drips, smudges, and what in the twentieth century would have been considered mistakes needing to be cleaned up."

Painter knows that artists who are not White males have long been given short shrift by the establishment art world, so she is careful to highlight many artists whose names may not be familiar to many readers, too many to list here but particularly she cites her "idol" Robert Colescott, who is a fellow Bay area friend; Faith Ringgold, who employs history and text in her works; Mary Lovelace O'Neal, an abstract artist she wrote about, also from the Bay Area; and Barkley L. Hendricks, working unrecognized in the 1960s and 70s for his life-sized portraits. Among the women who inspire her are Howardena Pindell; Alison Saar, whose sculpture of Harriet Tubman she mentions more than once; Maira Kalman, another artist incorporating text with image; and Kara Walker, who, she recounts, being called upon to champion after the Newark public questions the appropriateness of one of Walker's donated silhouette works being hung in a public library—Painter is elated when they decide to keep it. She also finds inspiration from the subject matter or processes found

in African antiquities and miscellaneous "art world notables" as Romare Bearden, Richard Diebenkorn, Alice Neel, Max Beckmann, Gerhard Richter, Andy Warhol, and long-gone historical figures such as the spectacular technique of Lucas Cranach, the Elder.

Coinciding with the torrent of questions and works she produces, she also includes how she finds time to finish and promote what becomes a *New York Times* listed bestseller, *The History of White People*. Plus, ever self-aware, she even reveals how she pays attention to every day "costuming" choices of the artists and teachers around her, changing her own style by straightening her hair and letting it go gray. She finds time to be with her husband (who is clearly supportive of her choices, except to ask to be mostly left out of this book), her increasingly frail parents and later her widowed father, sharing what starts with her daily long distance phone calls to him in her childhood hometown of Oakland, California, to support and comfort him through the last years of his life. Additionally, although not stated, it is likely she at least kept a running journal during these years, in order to write this book.

She admits to still dealing with moments of self-doubt—a very common energy drag experienced by most artists—but now as an independent artist, feels free to work her own ways. In some sense, Painter's years of art school brought her back full circle, incorporating her love of history, but moving "beyond straight history." She concludes: "Now what history means to me in images is freedom from coherence, clarity, and collective representation. My images carry their own visual meaning, which may or may not explicate history usefully or unequivocally. For me now, image works as particularity, not as generalization. That is how art school changed my thinking about history and how visual art set me free."

Actually, the preceding quote is one of the most stylistically "academic" moments in the book, because Painter rolls

out her deepest thoughts and feelings with great clarity and energy as she travels through these years. And in doing so, she offers a primer that could be useful to anyone of any age who is considering becoming an artist, especially if going the art school route, but also it could give others courage to begin the process of reinventing themselves.

Another bonus of this book, thanks to her publisher— it is a pleasure to hold a book printed on quality paper. And because they have included many color prints of Nell Painter's art works, readers can more fully understand the evolving processes she describes in her text.

Aimee Semple McPherson, "Glamour Shot" (1938). (Photographer unknown.) (Reprint permission by Steve Zeleny, Archives Team Lead of the International Church of the Foursquare Gospel.)

The Resurrection of Sister Aimee[1]

Bleached-blond hair carefully wreathes her face. A pure-white cape, pinned with a corsage, drapes her shoulders. A cross adorns the front of her white dress. She is flanked by her congregants: women uniformly attired in white dresses with dark capes, men wearing suits and stiff white shirts. Though looking a bit wan, she manages to smile as movie cameras record the scene. The woman assures her followers: "Angelus Temple will carry on and we shall win many thousands of souls if we all pull together." Then, with some of her faithful playing stringed and brass instruments, she leads everyone in a children's song: "If we all pull together how happy we'll be!" The crowd joins her in pulling on imaginary ropes and clapping hands to punctuate each syllable of "how happy we'll be." This was evangelist Sister Aimee Semple McPherson after being cleared of charges in a 1926 case that had threatened to destroy her and her ministry.

Recently, characters inspired by McPherson appeared on two TV series: *Penny Dreadful: City of Angels* (Showtime) and *Perry Mason* (HBO). Perhaps this coincidence—each including a female evangelist—is evidence of the current zeitgeist. In both programs, the McPherson-like character is

1. First appeared in *Alta Journal*, Issue 14, 15 March 2021.

variously depicted as a ditzy, conflicted bleached blond and an alluring radio preacher and healer not above tricking her followers with headline-grabbing stunts. In *Penny Dreadful: City of Angels,* Kerry Bishé portrays Sister Molly Finnister, who finds respite from the responsibilities of her ministry in an affair with the Los Angeles Police Department's first Chicano detective (Daniel Zovatto). Meanwhile, the city struggles with corrupt police, the Zoot Suit Riots, illegitimate land grabs, and Nazi plots. In *Perry Mason,* an origin story for the legal drama that aired from 1957 to 1966, Tatiana Maslany plays Sister Alice McKeegan, who fakes the faith healing of a worshipper in a wheelchair and attempts to resurrect a murdered baby. Lili Taylor plays her controlling mother and manager. Like their real-life counterpart, the evangelists in these series are enigmatic figures whose messages resonate during the troubled 1930s setting of the shows—and who are in sync with the charged climate of today.

The gift of tongues

A Canadian farm girl born in 1890 to devout parents Mildred and James Kennedy in Salford, Ontario, Sister Aimee—as she was often later addressed—was brought up with one foot in the Methodist church of her father and one foot in the Salvation Army, where her mother was a Sunday school superintendent. As a teenager, Aimee felt called to God after witnessing people speaking in tongues at a service led by a handsome Irish Pentecostal missionary named Robert Semple. "It was the voice of God thundering into my soul awful words of conviction and condemnation...though the message was spoken in 39 tongues," she recalled in her first autobiographical work, 1919's *This Is That: The Experiences, Sermons and Writings of Aimee Semple McPherson.* "From the moment I heard that young man speak with tongues to this day I have never doubted for the shadow of a second

that there was a God." Semple, she wrote, became her Bible school. Soon thereafter, Aimee was born again, spoke in tongues, and claimed to have been baptized in the Holy Spirit. In 1908, the seventeen-year-old married Semple. They left Canada as self-appointed missionaries bound for China, with a stopover in England and Ireland to visit Semple's family. In London, Aimee delivered a sermon at the Royal Albert Hall, a great success in which, she said, she felt as though she were speaking in tongues, although it came out as English.

They arrived in Hong Kong in 1910, knowing little of the language and culture. The two quickly contracted malaria in Macao and were taken back to Hong Kong for treatment. Semple also got dysentery and succumbed; Aimee survived and gave birth to a daughter. Three months later, the young widow returned home.

She got married again in 1912, this time to Harold McPherson, an accountant, and set up home in Providence, Rhode Island. A year later, she gave birth to a son. Though she had never heard of women preaching, McPherson felt called to deliver the gospel. During a visit to her hometown in Canada, she found that she could attract worshippers by standing on a chair placed curbside on a main street and remaining still and silent in prayer for perhaps twenty minutes, until enough curious passersby had gathered. Then she would call out, "Follow me," and run them into a mission space she had rented. After one follower reminded her to pass the hat, she used the donated $65 to purchase her first tent.

By 1915, McPherson was conducting revival meetings in tent shows, parks, cotton fields, and borrowed auditoriums. In 1916, she began what became a seven-year campaign in which she crisscrossed the continent six times—and twice drove from New England to Key West and back—in a Packard convertible "Gospel Car." This was a feat, given the largely unpaved roads of the era. Her grassroots preaching

style, laced with humor based in down-home farm girl and motherhood stories, and, especially, her seemingly miraculous faith healings were a huge draw. Explaining their attraction, she wrote, "Right there at the first there was borne upon me the realization that the popular methods of that day were too archaic, too lifeless to capture the interest of the throngs." At her stops, she routinely turned an initial crowd of a handful into one of hundreds or even thousands over a few days or weeks.

McPherson maintained that miracles, including divine healings, had not ceased after the death of Jesus and that they were dependent only on recipients' belief in him. She said she was merely the conduit.

Her first experience with faith healing came in 1909, when, with prayer, she claimed to have healed her own broken ankle overnight. Her next healing happened in 1916, at the start of her cross-country campaign, when she was invited to preach in Corona, New York. McPherson called on all those present to help her pray for Louise Messnick, a young woman so crippled by rheumatoid arthritis that even though she used crutches, she required others to help her to the altar. As McPherson and the others prayed, Messnick said she felt a warm surge of energy pass throughout her body, and she left the meeting walking upright, without needing her crutches. Over the years, tens of thousands who suffered from goiters or were deaf, blind, or paralyzed would ask to be healed through McPherson's invocations. In 1921, the American Medical Association confirmed that many of her healings had indeed taken place. That same year, during a service in San Diego's Balboa Park, a crowd of 30,000 rushed the stage for healing, and nearby police and U.S. Marines, who had volunteered to help out during the event, succeeded in restoring order. Eventually, McPherson all but ceased this part of her ministry, training others to continue the work instead.

Preaching as performance

In the meantime, she had upgraded her old Gospel Car to a new Oldsmobile 8 with "Jesus Is Coming Soon—Get Ready" painted in gold on its side and had driven west. Just before Christmas 1918, McPherson, her children, and her mother arrived in Los Angeles, where McPherson had decided to set down roots. There, she learned much about publicity from the nascent movie industry—Louis B. Mayer's film studio and United Artists were startups. Her friend and adviser Charlie Chaplin told her, "Half your success is due to your magnetic appeal, and half due to the props and lights. Whether you like it or not, you're an actress."

McPherson dressed the part. Her preaching attire had been born of poverty, when all she had were two white nurse uniforms, which she partially covered with a military cape. A beauty, she embellished her image with camera-ready makeup and fine clothes and abandoned her long, dark tresses for a bobbed, marcelled, and bleached-blond look.

She would later serve as the inspiration for Cole Porter's evangelist Reno Sweeney in his musical *Anything Goes*, for Rose Carlton's impersonation of evangelist Sister Annie Alden in the Mae West film *Klondike Annie*, and for Sinclair Lewis's Sharon Falconer in his book *Elmer Gantry*. In a connection to a later generation of entertainment stars, McPherson baptized Marilyn Monroe's grandmother, who brought up her granddaughter with Pentecostal teachings.

Much the way she recognized the importance of performance in her sermons, McPherson was fast to see the value of promotion. During her early tours, she'd drive the car while her husband used a megaphone to attract worshippers. Photographs show them standing next to hand-painted signs inviting people to attend her meetings and "Get Right with God." By 1917, she'd begun marketing to larger audiences by editing a Christian newspaper, *The Bridal Call,*

which she soon transformed into a monthly sixteen-page magazine. The issues carried her sermons, pictures from her campaigns, news, and other articles. "Now I could keep in touch across the miles with many of the people to whom I ministered in different parts of the country," she wrote. Two years later, she published her autobiography *This is That*. To advertise upcoming services, she took out ads in newspapers' theater sections and, for the Balboa Park revivals, dropped 15,000 leaflets over San Diego during her first airplane ride. In 1924, just four years after Westinghouse received the first radio broadcasting license, McPherson raised funds for a station of her own: KFSG, its last three call letters an abbreviation for the denomination she'd named Foursquare Gospel.

Her mix of old-time conservative Christian identity, faith healing, and American patriotism was dispensed with compassion—and not the hellfire-and-brimstone warnings common to other evangelicals. So welcome was her message during the Great Depression that McPherson "drew more than one million people in the last half of 1933 to see her in person," says Foursquare Church archivist Steve Zeleny.

Sanctuary as stage

In 1923, after raising more than $300,000 in donations, McPherson finished construction on her 5,300-seat Angelus Temple in Echo Park. Its interior looked more like a movie palace—an orchestra pit was situated at the foot of a stage—than a church. Outside, an electrified marquee hung above the main entrance, and a revolving neon cross stood on the roof, visible from fifty miles away. A year later, the cross was joined by a radio tower to broadcast KFSG. Angelus was then the nation's largest church—for comparison's sake, St. Patrick's Cathedral in New York City seats 3,000 people.

Overflowing crowds showed up for two services each weekday and for four services on Sundays. McPherson would

enter the sanctuary by walking down a long ramp to the pulpit—with the dramatic flair of a Kabuki actor—wearing a silky, shape-revealing white gown and a military cape and carrying a huge bouquet of roses. The packed house would erupt in applause.

Sunday evenings were especially popular, attracting Hollywood stars and other luminaries. These services featured spectacular allegories, pageants, and operas—what McPherson called illustrated sermons. One of them, "Arrested for Speeding," was inspired by a traffic violation. Dressed as a police officer, McPherson rode in on a motorcycle, alighted, and gestured with a white-gloved hand while calling out, "Stop! You're speeding to hell." Author Carey McWilliams, a friend of McPherson's, wrote, "I have seen her drive an ugly Devil around the platform with a pitchfork, enact the drama of Valley Forge in George Washington's uniform, and take the lead in a dramatized sermon called 'Sodom and Gomorrah.'"

"It was quite simply the best show in town," as Zeleny proclaimed to the BBC in 2014. And the show was open to all. Then, as now, most churches were segregated, but all races were welcome at Angelus Temple, even if a majority of the attendees were Caucasian. Among those who worshipped were local Roma, who called McPherson their queen, and members of the Ku Klux Klan, who once removed their hoods and stayed to pray after McPherson preached against their ways. Throughout the Depression, Angelus's commissary was a reliable source of food, bedding, clothing, and other necessities. Mexican American actor Anthony Quinn once recounted in a television interview that "the one human being that never asked what your nationality was, what you believed in and so forth, was Aimee Semple McPherson." He continued, "All you had to do was pick up the phone and say, 'I'm hungry,' and within an hour there'd be a food basket there for you. She literally kept most of that Mexican community alive for many years."

Yet her fame wasn't without scandal. An international media furor ignited when, in 1926, she mysteriously disappeared while swimming at a beach in Santa Monica. She was thought to have drowned until a ransom note signed by "the avengers" was found. The kidnappers wrote: "We took her for two reasons: First to wreck that damned Temple and second: to collect a tiny half million."

She resurfaced more than 600 miles away and five weeks later in the Mexican border town Agua Prieta, claiming to have escaped her captors. Owing to alleged sightings of her while she was missing, McPherson was suspected of creating a ruse to cover up an affair with a married KFSG radio engineer. The grand jury inquiry that followed was shut down for lack of evidence, and no charges were filed. Famed journalist H.L. Mencken, a staunch Darwinist critical of McPherson's campaigns to place Bibles in every Los Angeles public school classroom and to remove evolution from the curriculum, covered the case. He deemed the attempt to uncover wrongdoing by McPherson a conspiracy by the city's other religious leaders. "I think it's a shame the way they are prosecuting her," he wrote. "It's a dirty shame." In the years that followed, the press covered every hint of scandal, from a third marriage that ended in a messy divorce to unfounded claims that McPherson had mismanaged Angelus's finances—she had little involvement in church business affairs, and at the end of her life, her estate was worth less than $10,000.

End of days

Just as it did then, McPherson's larger-than-life story makes for great entertainment now. At the outset, the *Perry Mason* and *Penny Dreadful: City of Angels* series accurately portray their evangelist characters as extraordinarily charismatic women, as senior pastors of large L.A. churches, and as having problematic mothers as their business man-

agers. However—spoiler alert—the final segments of both series divert from the historical record when their fictional evangelists desert their ministries. In *Perry Mason*'s season 1, Sister Alice goes missing and is found by Perry Mason (Matthew Rhys) hiding out in Carmel, working as a waitress, her blond hair dyed dark brown. In *Penny Dreadful: City of Angels*, Sister Molly finds herself trapped, afraid of her murderous mother, and escapes the only way she can—by slitting her own wrists.

The darkness of *Penny Dreadful: City of Angels*, says writer and executive producer John Logan, can be traced to the 2016 presidential election, which led him to revive *Penny Dreadful* four years after it had finished a three-season run. His one-season reboot is set in 1938 Los Angeles, where the Sister Molly character plays a central role in what was a tumultuous time in the city's history. "There are so many shocking parallels to me about what was going on then and what's going on now," Logan told *TV Guide*.

Bishé says her role "owes a whole lot to Aimee Semple McPherson," whom she credits "as one of the pillars in the invention of a city," adding, "I think there's this broader trend of people finally being interested in the untold stories of history."

Meanwhile, Ron Fitzgerald, who developed and wrote *Perry Mason* with Rolin Jones, offers a disclaimer about the show's Sister Alice. "We made up 99 percent of this stuff. Here's this church, and here's this woman, and she's a fascinating person. I mean, the combination of Hollywood and religion—she was a showman," he says. "We used her as a jumping-off point and created our own character."

Yet there's always the chance that artistic license will effectively rewrite history. Zeleny cautions, "These characters are fictitious, and the shows do not claim that they are intended to be accurate representations of Aimee Semple McPherson. The audience doesn't know what Aimee was

like, so they don't know that these portrayals don't match reality—and so they don't turn to the person next to them and say, 'That's absurd,' or 'That's silly.'"

In September 1944, the real McPherson, fifty-three years old, traveled to Oakland to dedicate a new church. On the day of a scheduled appearance at the Oakland Auditorium, her son, Rolf, found her unconscious in her Leamington Hotel room, and she died shortly afterward. The cause of death was an accidental overdose of a barbiturate, compounded by kidney failure. Rolf McPherson assumed leadership of what then consisted of 410 churches in North America, 200 mission stations, and about 29,000 members. Since then, the mission McPherson founded—now known as the International Church of the Foursquare Gospel—has grown to more than 8.4 million members and 87,000 churches in 147 nations.

The once-grand Spanish-style Leamington Hotel today stands shrouded in scaffolding and dark netting as it's transformed into a coworking space. It was built in 1926, and its storied past includes Amelia Earhart setting up an office while preparing for her tragic attempt to circumnavigate the globe. Around the time McPherson stayed there, the Leamington was still considered one of Oakland's most fashionable spots for dining and dancing. Today, like Sister Aimee Semple McPherson, it is being resurrected.

A Grande Dame of Dance[1]

As she inches her way across the wood-paneled wall of her dance studio to the sounds of Meredith Monk singing "Gotham Lullaby," ninety-six-year-old Anna Halprin appears to be mourning her losses. Her face expresses despair; her torso and long arms curve inward or tenaciously unwind. But there are also joyful moments during this four-minute video when she pauses with uplifted arms and rises on her forefeet as if in elation, before gently falling back against the wall, clinging to and leaning against it as she continues to inch along, her fragile, gingerly steps reflecting her life journey. The clip ends with several seconds of her standing still, eyes closed, at peace.

Such was the grace and brilliance of Halprin that she was able to convey both the sweetness and the pathos of life in this remarkable footage filmed five years ago at her Mountain Home Studio, in Kentfield, California. The iconoclastic dancer, choreographer, educator, and movement philosopher, who died in May at the age of 100 at her nearby home, created more than 150 works during her seventy-plus-year career, and her artistic journey was often the subject of negative assessments by dance critics and the dance establishment. But

1. First appeared in *Alta Journal*, Issue 17, 27 September 2021.

Anna Halprin at ninety-nine. (Rick Chapman
Permission courtesy of Tamalpa Institute.)

despite this, she earned the respect of artists and non-artists
who studied and worked with her, and today her legacy is
deservedly celebrated.

Halprin's pioneering body of work, recognized as a major
influence on what became known as postmodern dance,
was uniquely Californian, confronting vexing issues with a
creativity that could only have blossomed beyond the reach
of dance's traditional institutions.

I first heard about Halprin (she was known as Ann until
she changed her first name to Anna in 1972, after surviving
cancer) from the visual artist Charles Ross almost fifty-five
years ago. I had just moved to New York City after graduating

from Sarah Lawrence College. Set on launching my profes-
sional life in dance, I supported myself by teaching children's
dance classes and joined the last choreography workshop led
by musician Robert Dunn at Judson Memorial Church, in
Greenwich Village. Dunn's workshops, which had started at
Merce Cunningham's studio in 1960, moved to the church
in 1962, when the pastors there offered to house them free
of charge. Importantly, the offer included space to present
concerts of experiments developed in the workshops, also at
no cost to the participants. For poor artists like me, Judson's
support was crucial to New York's becoming, during the
period of 1962 to 1966, the East Coast seat of postmodern
dance. Known as the Judson Dance Theater, these workshops
were the subject of a retrospective at the Museum of Modern
Art in 2018–19.

Like Ross, who had been creating sets in collaborations
with Halprin in California before coming to New York in
1963, many of Judson's dancers had worked with Halprin in
the late 1950s and early '60s. Their choreographic inventive-
ness underlined for me the positive effects of her influence.
But I think it was mostly Ross's description of Halprin's dance
deck, jutting out over a Marin County forest of redwoods,
that beckoned me to California. Created by her husband,
architect Lawrence Halprin, with the scenic designer Arch
Lauterer, it had been built from the wood of madrone and
coast redwood trees in 1954. The deck was located down
a steeply graded stairway from the Halprins' modernist
home. It had been constructed after the birth of their second
daughter, Rana.

There was no question that I would find a way to experi-
ence Halprin's teaching once I learned that she held summer
workshops. The opportunity to dance outdoors under an open
California sky, surrounded by forest, sun, and wind instead
of enduring a sweaty Manhattan summer and taking classes
confined within studio boxes, was irresistible. An added

attraction was visiting the Golden State, where my sister and brother-in-law were U.C. Berkeley graduate students, for the first time. I even accepted the offer of a $35 nonstop, three-day cross-country automobile ride with a group of college boys— previously strangers to me—to get there. The summer proved to be a wonderful gift. The example of Ann Halprin's ongoing search for new ideas and her generosity, encouraging everyone to explore their own ways, strengthened my resolve to move on from my early training. Generations of international performance, music, literary, and design artists would in turn decide to make this journey.

A dancer's steps

Born Hannah Dorothy Schuman in 1920 and raised on Chicago's North Shore, in Wilmette, Halprin was a natural dancer. Her training began with ballet lessons at the age of four. Ballet didn't work for her, but as a six-year-old she enjoyed classes based on the practice of everyday motor skills: walking, running, skipping, hopping, jumping—the basic technical vocabulary of Isadora Duncan, a founding mother of modern dance. Duncan said that "the finest inheritance you can give a child is to allow it to make its own way, completely on its own feet."

As a young adult dancer taking classes that emphasized the techniques associated with pioneers like Martha Graham, Doris Humphrey, Charles Weidman, and Hanya Holm, Halprin encountered a glaring inconsistency in the traditional modern dance philosophy. Modern dance is supposed to be about each individual's expression; if you view classes in most studios, where lines of dancers stare into a mirror while imitating a teacher or following their directions, you quickly spot the contradiction.

In 1938, as a student at the University of Wisconsin, Halprin was introduced to the theories of Margaret

H'Doubler, a kinesiologist and the director of the dance major program. She gave Halprin a key to changing how she analyzed movement, different from the motor skills lessons she'd absorbed as a young child. Instead of leading a series of warm-up exercises at the beginning of Halprin's first technique class on campus, H'Doubler asked the students to gather around a suspended human skeleton. Halprin went on to study physiology and even spent a year dissecting cadavers. This experience provided the basis for an anatomical approach to movement throughout her career as a teacher and a performer, during which she routinely referred to a skeleton and charts of musculature. (Later in Halprin's professional life, when her primary focus shifted from trained dancers to people of all ages and medical conditions, H'Doubler's influence would become ever more essential. The curriculum of Tamalpa Institute, the nonprofit educational and research center Halprin founded with her daughter Daria in 1978, includes anatomy and kinesiology.)

Halprin—then known as Ann Schuman—met horticulture graduate student Larry Halprin in 1939 through their association with the University of Wisconsin's Hillel Foundation. They married in 1940. A visit to Frank Lloyd Wright's nearby estate, Taliesin, inspired Larry to change his career path to architecture; the couple decided he should enter Harvard's design program while Halprin completed her senior year in Wisconsin. When she joined him in Cambridge, Massachusetts, for his last three years, she audited lectures, and they both found inspiration in the transplanted Bauhaus philosophies being taught there. Halprin's ability to teach children's dance classes proved doubly useful, as a means of support and as a challenging way to test her fledgling ideas about dance.

Larry enlisted in the navy in December 1943 and, after completing his degree, was shipped out to the Pacific. Meanwhile, Halprin decided to navigate New York City as a

professional dancer. Her performances included a Broadway show, *Sing Out, Sweet Land*, starring Burl Ives and with choreography by Doris Humphrey and Charles Weidman. After Larry was almost killed by a torpedo attack on his ship, *USS Morris VII*, he was sent to San Francisco on survivor's leave. When he was discharged there in 1945, Ann joined him. She excitedly wrote to a college friend:

> *I'm glad I'm going to California—I want to be left alone, live a normal resourceful life with a connection to the soil and to the common pulse of ordinary people. I'm not interested in acclaim—I'm only interested in creating out of the soil and the people a healthy fresh dance that is alive and vital. I'm getting sick and tired of New York dance—it's neurotic, eccentric, and in many cases stale and in most cases uninspired. I'm not being smug—I don't say I can do better—but I do say* New York *itself breeds a warped kind of dance.*

She commented very differently after she arrived: "Compared to New York it was like coming into the boons. I thought my career was ended."

Home on the mountain

Upon arrival on the West Coast, Halprin continued working within traditional modern dance styles, forming a partnership with dancer Welland Lathrop in 1946. They presented joint concerts and formed the Halprin-Lathrop School, offering classes for children and adults. Ten years later, during a trip to New York to participate in the American National Theatre and Academy's American Season of Dance, Halprin felt tremendously disconnected from the works being shown by the modern dance establishment. After returning to California, she dissolved her partnership with Lathrop and resolved to transform her creative process. Improvisation and the dance deck her husband had built in the woods below their home, later named the Mountain Home Studio,

became her gateways to discovering new material. Besides experimenting with her dancers and students, she sought out visual artists, architects, writers, actors, filmmakers, designers, physiologists, and, later, psychologists in an effort to resist old habits and remain open to new ideas. Meanwhile, back in New York City, the studio training I received in the 1950s and '60s, including Merce Cunningham's and Alwin Nikolais's modern techniques, had indeed evolved into set and predictable rituals. I understood why Halprin wanted to release herself from habits formed by these schools of dance as well as those who had revolted against them—to find her own ways to move.

Initially, Halprin's improvisations were not set, but after a while, she felt the need to devise a structure or guidelines, which she called a score, to be followed similarly to the way musicians read a music score. A dance score might consist of tasks, might be like a recipe or a map to follow or drawings to interpret. And when her improvisations became repetitious, she developed a more focused process she called dance explorations.

The premiere of *Birds of America or Garden Without Walls* (1960) gave her a chance to test this idea. The performers in the piece—dancer A.A. Leath and actor John Graham (both now deceased); Halprin's two daughters, Daria and Rana; and her company, the Dancers' Workshop—would become her longtime collaborators. Before the performance, Halprin passed out ten-foot bamboo poles, nearly twice as tall as everyone, and told the performers to execute the work's score as rehearsed, except to always keep the poles in hand. I remember being blown away by the extraordinarily powerful photographs documenting that work, which she shared during one of the summer workshops I attended.

Mornings in those summer sessions typically began with Halprin's warm-up ritual that included standing and floor exercises. After that, we worked on individual or group

improvisation assignments that varied every day. At the end of each session, Halprin gave participants a booklet of scores by everyone in the workshop. During the 1964 summer session, I was fortunate enough to be present while Halprin was working on the score of *Parades and Changes*, one of her most well-known performance works. In her 2007 biography, *Anna Halprin: Experience as Dance*, Janice Ross related my recollection of participating in rehearsals of two units of a score that eventually consisted of six improvised units: "Ann divided the dancers into two groups and asked one to travel around the circumference of the room on a small ledge three or four feet off the ground. The other group, which Blank performed with, walked parallel lines on an imaginary grid on the floor of the studio, with instructions to change lines only at the beginning or end of each imaginary parallel line. As they traveled they could pick up or discard objects or clothing within their reach. In the process, Blank said, they went through moments of nudity." In another unit of the piece, the performers tore mountainous sheets of butcher paper, only to gather them up and disappear from the audience's view.

Parades and Changes continued to be reinvented in each location where it was performed, including Berkeley, San Francisco, Los Angeles, New York, Stockholm, and Tel Aviv, from 1965 to 2015. The onstage nudity caused a scandal, and the ensuing court cases, according to Charles L. Reinhart, director emeritus of the American Dance Festival, eventually resulted in the repeal of New York State's blue laws.

In late 1964 or early 1965, after I'd returned to New York City from my first summer experience on Halprin's dance deck in Kentfield, a friend suggested I join her in trying out for a modern dance company that was to tour the country. The audition judges included such luminaries of the dance establishment as Lucas Hoving, Anna Sokolow, May O'Donnell, and Donald McKayle—all stellar inheritors of

the Graham, Humphrey, and Weidman schools of classical modern dance.

The judges' choreography was to be performed by this company. At the audition's start, all the dancers were asked to walk across the open space. I quickly stood up and proceeded to walk my most straightforward personal, everyday walk. I was the only person to do so. As I looked around, I could see that every other dancer had chosen to perform the "dancer's walk," a modern dance convention that requires the legs to move from a full turnout in the hips, with a pointed toe-ball-heel, heel-ball-toe action of the foot, while the arms alternate a lift through the center of the body to overhead and then are lowered to the side within four-count measures.

Although I had been well schooled in the dancer's walk and had become completely competent in its execution, it no longer occurred to me that this particular walk defined what a walk was. That was how much I had changed.

An RSVP with change

In 1963, Halprin started renting a training and rehearsal space she named the San Francisco Dancers' Workshop—her translation of the German *bauhaus,* or "workhouse"—located adjacent to the city's Haight-Ashbury district. Soon, her husband pushed her to acknowledge the social issues and turmoil taking place right outside her new studio. In 1968, after Larry saw the excessive emphasis critics and audiences put on the nudity in his wife's work, he shared his plan for a feedback loop—a formula he was working on to help realize design projects. Named RSVP Cycles, it involved "four components: assessment of resources (R), the formulation of a plan or score (S), an evaluation (V) and a performance (P)."

From 1968 onward, Halprin's focus shifted toward performance works conceived with a healing or social mission related to individuals, communities, or the environment. She

continued to apply the RSVP Cycles to develop new scores and make revisions after analyzing audience reactions.

Ceremony of Us, a 1969 collaboration choreographed and performed by Halprin with the all-White San Francisco Dancers' Workshop and Los Angeles's all-Black Studio Watts School of the Arts, confronted issues of race. Another piece, *White Placard Dance*, was inspired by 1970s protests. Performers paraded through city streets carrying empty white placards, and viewers were asked what causes they would like written on the placards. Their requests were read at the end of the march.

Many of this period's communal events, rooted in Halprin's research and observations of community ritual traditions throughout the world, consumed much of the rest of her life. Her long-standing bond with the Pomo nation, her neighbors near her family's second home at Sea Ranch, gave her an opportunity to invite some members to participate in her work. (Her husband was central to the development and design, in 1963, of the planned community on the Sonoma County coastline. During the second workshop I attended, Halprin used the undeveloped site as a place for us to explore the possibilities of a different environment. This practice continued during the years she led Tamalpa Institute trainings.)

In the early 1970s, Halprin experienced a eureka moment through a process of visualization in the form of two self-portraits. In the first, she drew a circular gray mass in her pelvic area. That drawing coincided with a diagnosis of cancer. Surgery and chemo treatments left her feeling weak and depleted, and when it seemed as if the cancer had returned, she drew another self-portrait expressing her rage. After creating a dance in response to this image and performing it before a private audience of family and friends, she came to believe that she had healed herself because her cancer went into remission.

The collaborations with Indigenous people and Black dancers, her community actions, and her battle with cancer

were central to the last phase of her career, when she resolved to make "transformative rituals" rather than performances. In a 2000 documentary video, *Artists in Exile*, she explained her change of heart: "We've opened up all these boundaries, we've redefined—I had at least, and it had some influence—the body, redefined who dances, redefined how we can dance, redefined what is theater. But for what?"

"It became very vital to me that we deal with people's feelings, [that] we deal with the differences that we have. And that started this whole idea for me of healing.... I wasn't willing to continue devoting my life and using my energy unless it was going to be useful."

For Halprin, this meant that each piece had to have a purpose, and it had to be inclusive, meaning that anybody could perform it. "I started questioning what dance could be about and I started making dances that had to do with my life and the lives of the people who dance them."

Over the next forty years, Halprin's career became a quest to answer her own questions about how dance could heal anyone, serve the environment, or promote peace in our country and among nations. Many of her works involved participatory events, where observers often functioned as witnesses instead of being passive viewers.

In and on the Mountain (1981), a two-day performance work that would evolve into *Planetary Dance* starting in 1987, was created in the wake of the unsolved murders of seven women on Mount Tamalpais, also the site of the Halprins' Kentfield home. In response to the crimes, the mountain's trails had been closed for two years. Dancers from Tamalpa Institute—the core performers—joined witnesses at the College of Marin.

Overnight, performers and witnesses slept in a circle with their feet positioned toward the center in a mandala-like formation. The next morning, performers and witnesses participated in a walk on some of the mountain trails, starting

with a sunrise ceremony. Along the way, offerings were left at the site of each murder. Soon after the performance occurred, the killer was apprehended and brought to justice.

Never claiming that his arrest had resulted from their event, Halprin felt it was most relevant for its effect on the participants. She said, "When enough people move together in a common pulse with a common purpose, an amazing force takes over—a power that can renew, inspire, teach, create and heal."

Circle the Earth: Dancing with Life on the Line (1989-) started as a communal mythmaking healing ritual centered on the theme of life and death and was first performed in Marin County in 1985 as *Circle the Mountain*. Undergirding this work was Halprin's belief in the power of myths, whose original meaning, she said, embodied "a personal or collective vision of how we experience ourselves and the world." The piece was developed in workshops by a core group of one hundred participants, some of whom had AIDS, cancer, or another life-threatening illness, along with their caregivers and friends, facilitators, and Tamalpa dancers. Halprin then shaped the performance score to follow "Five Stages of Healing: identification, confrontation, release and restoration, change, and assimilation." Subsequent performances were staged in New York City's United Nations Plaza and Central Park, Los Angeles, San Diego, and several international locations. The people involved at each site re-create the score in their own way, based on their own myths.

A most beautiful dance

Halprin and I continued to cross paths over the years. The last times I visited with her were in Kentfield in 2010, when we were interviewed together on the dance deck for *The Space In Back of You*, Richard Rutkowski and Robert Wilson's film about the late Japanese choreographer Suzushi Hanayagi,

and in 2012, for a get-together to honor Meredith Monk on the occasion of one of her Bay Area performances. (Hanayagi and Monk also attended Halprin's summer workshops in the early 1960s. This was how I met Hanayagi, and upon our return to New York, we began a lifelong collaboration. Monk, my friend since college days, joined the 1965 workshop after listening to my stories about experiences there.)

Every advance in the arts is infiltrated by traditionalists who wish to maintain the status quo, and often these are former leaders of the avant-garde themselves. So the question remains: Will the systems Halprin developed succumb to this cycle? Will people simply follow the detailed instructions Halprin left and re-create her work, or will Halprin's instructions become launchpads for reinterpretations and reinventions?

Regardless of the answer, one enduring contribution to the world of dance is Halprin's steadfast belief that "everyday movement can take on an awareness of a dance *if* you bring your consciousness and awareness to your experience and into your body: the body moving becomes a dance expression."

Throughout her long career, Halprin never forgot her paternal grandfather ecstatically dancing in prayer at an Orthodox Jewish synagogue. He was a driving inspiration behind her artistic journey. The sight of this Yiddish-speaking immigrant, a tailor from outside Odessa, Russia, with his head thrown back, uplifted arms, and a flowing white beard, made her believe that he "was God and that God was a dancer."

In 2019, close to the end of her life, Anna Halprin opened the introduction to her last book, *Making Dances That Matter: Resources for Community Creativity*, by recalling childhood memories of her grandfather. She wrote, "I [could] never live like him, or do his dance with the kind of authenticity and devotion, but I have been driven to find a dance that moves me and the communities I work with as much as his dance moved him."

The interior of Laura Keene's new theater, Laura Keene's Varieties,
which opened November 18, 1856, at 622 Broadway, only
to close due to bankruptcy during the Panic of 1857. Reopened
under new management as the Winter Garden Theater,
it burned down on March 23, 1867. (Library of Congress
Prints and Photographs Division, Washington, D.C.)

Is Broadway about Dollars and Cents?[1]

In a 2019 interview with *The Daily Beast*, Tony Award-winning *Hadestown* star André de Shields explained, "The Great White Way is not called that for racial reasons, but because many years ago it was electrified and it appeared as if it were daylight all the time. But it's a marvelous metaphor if you want to discuss racism, because for so many generations we of color have been taught this is an inhospitable environment."[2]

To understand how completely inhospitable to diversity the Broadway environment has been and continues to be, one only has to examine the statistics of the business of Broadway: who produces the shows; who is hired to write the scripts and compose the music; who gets hired to perform as actors, singers, dancers, and musicians; who is hired to design, build and maintain the stage sets, costumes, lighting, hand props; who is hired to work backstage as the stage

1. First appeared in *Bigotry on Broadway*, An Anthology Edited by Ishmael Reed and Carla Blank, Montreal. Baraka Books 2021, pp. 24-43.
2. Teeman, Tom. "See Us, Trust Us, Employ Us: Broadway's Women of Color on Confronting Racism and Reshaping Theater." *The Daily Beast* updated 30 August 2019.

managers and tech crews; and who buys the tickets, etc.
Luckily, because of increasing pressure within the indus-
try in recent years, a few studies have been published that
back up de Shields' assertion with unambiguous figures. In
addition, they reveal that there have been other consistent
Broadway biases that also extend throughout the rest of the
American theater industry. These are the long-entrenched
gender biases, against women and the LGBT community.
And, like systemic discrimination patterns grounded in race
and ethnicity, Broadway's patterns of discrimination based
on gender or disabilities are revealed in both employment
patterns and payment patterns.

Charlotte St. Martin, president of The Broadway League,
the trade association of the Broadway theater industry, when
interviewed about the state of Broadway in early 2020, said,
"There are 97,000 jobs attached to Broadway for both the
people we employ or cause to be employed."[3] Therefore,
considering that in 2018, New York City's population was
recorded at 8.399 million or that New York's metropolitan
area was recorded to have a total population of 20.3 millon
in 2017, this industry makes a considerable contribution to
the economic health of the region even though the home
residence of any production's hires may be located outside
of New York City. Just to give you some way to assess how
Broadway's hiring practices align with the diversity of its
hometown population, according to New York City's deci-
mal census for 2010, the city's residents were recorded to
be 26 percent Black, 13 percent Asian, 26 percent Hispanic,
33 percent White and 4.9 percent other.[4]"

3. *Spectrum News* NY1, 9 October 2020.
4. The Changing Racial and Ethnic Makeup of New York City Neigh-
 borhoods, Furman Center for Real Estate and Urban Policy, 2011.
 The U.S. Census Bureau estimated that the U.S. population as of
 July 1, 2019 was 328,239,523. Their "Race and Hispanic origin" count
 breaks down into the following percentages: White alone, 76.3%;

No statistics were available for the 2019-2020 Broadway season, reflecting the fact that Broadway theaters have been closed since March 12, 2020, after Mayor Bill DeBlasio declared a state of emergency due to the Covid-19 pandemic. As of Fall 2020, Broadway and Off-Broadway theaters are projected to remain closed at least through May 30, 2021. At the time of the emergency closure, Ms. St. Martin told Spectrum News that "31 productions were running, including eight new shows in previews. Eight additional productions were in rehearsals that were preparing to open this past spring. It'll be up to each individual show when they reopen after May 30, but according to sources, the long-running 'The Phantom of the Opera' and 'The Lion King' will most likely not reopen until the fall of 2021."[5]

Therefore, this essay's discussion will be based on statistics gathered no later than the 2018-2019 season by various organizations in the industry, including two surveys from Actors' Equity, the powerful union for performers and stage managers, and two coalitions of theater artists of color. (The union that represents operatic, choral and dance artists is the American Guild of Musical Artists. No recent surveys of hiring or pay practices appear to have been made public by this union.)

Actors' Equity published a study of hiring biases in the Spring 2017 issue of *Equity News*, the first such study in their 104-year history. Across the board, their findings reveal that the Broadway industry has been more than slow to change its ways. Their statistics, reflecting seasons from

Black or African American alone:13.4%; American Indian and Alaska Native alone: 1.3%; Asian alone; 5.9%; Native Hawaiian and other Pacific Islander alone: 0.2%; Two or more races: 2.8%; Hispanic or Latino 18.5%; White alone, not Hispanic or Latino: 60.1%; Foreign born persons (2014-18): 13.5%. And the percentage of the population identifying as female was 50.8%.

5. Op cit.

2013- 2015, include data gathered not only from casts of new Broadway productions, but also from productions located Off-Broadway, in regional theaters and touring companies. They confirm that besides there being fewer work opportunities for women and members of color, they often draw lower salaries when they do find work. In summary there are "stark and pervasive barriers to employment in our industry for women and people of color—across all Equity contracts."[6]

Job categories covered by Actors' Equity are those of principal, chorus, and stage managers. In considering the following data, keep in mind that members of Actors' Equity worked an average of seventeen weeks in the 2018-19 season, a figure which did not vary significantly over the previous four seasons. Of course, as in all averages, some union members worked far more weeks than the average and some probably didn't find work at all or worked for only a few weeks. Although stars generally receive salaries well above Equity's minimum requirements, imagine adding this limited window of employment opportunities to the other employment factors that many theater artists and technicians have learned to deal with year after year. Most routinely take jobs outside of the industry, such as teaching, when they cannot rely on earning a living wage in their chosen profession, or keep a side job with arrangeable hours to supplement their income, such as going the "classic" waiter or waitress route, working the midnight shift as a copy editor, or becoming a fitness trainer. It is a wonder how generations of people have continued to persevere in this industry, knowing these conditions, even including White male artists and technicians who, as the following statistics overwhelmingly show, are the most likely to be hired and

6. *Equity News.* Spring 2017, Data Compiled by Russell Lehrer | Graphics by Nick DeSantis |Special thanks to Doug Beebe, Tom Kaub and Sherry Xu.

most likely to receive higher pay. For example, the Actors' Equity Spring 2017 report stated:

… we have learned that nationally over the course of 2013 to 2015, most principal contracts went to Caucasian members, accounting for 71 percent. Asian Americans: barely 2 percent. African Americans: 7.56 percent … these numbers are consistent with other contracts and opportunities offered to our members.

Equally troubling is the appearance of hiring bias when it comes to gender: Our membership is evenly divided between women and men. Consistently across all the on-stage contracts examined in this study, men were offered close to 60 percent of the on-stage contracts. For example men were offered 61 percent of national principal contracts.

This study also shows that the problem goes beyond the stage and extends into the booth. The overwhelming majority (74 percent) of national stage management contracts went to Caucasians. In fact, stage management was the least ethnically diverse cohort in Equity's employment categories.

While women were more likely than men to receive stage manager contracts, they reported lower earnings. Women were employed on agreements with lower minimums, negotiated lower over scales and earned lower average contractual salaries than men.[7]

Another study, "The Visibility Report: Racial Representation on NYC Stages," from the Asian American Performers Action Coalition, extends these findings by their analysis of the 2017-18 season, in which they looked at eighteen of the largest nonprofit theaters in addition to companies performing on Broadway in New York City.

Over 61 percent of all roles on New York City stages went to White actors, a rate double the population of White people in New York City (32.1 percent of residents). According to the study, 23.2 percent of roles went to Black actors, 6.9 percent to Asian American actors, and 6.1 percent to Latino actors.

7. Ibid

That represents a slight improvement from the previous season, which had 67 percent White actors, 18.6 percent Black actors, 7.3 percent Asian actors, and 5 percent Latino actors.

> "Overall, nearly 80% of Broadway and off-Broadway shows' writers were white and 85.5% of directors during the 2017-18 season. Last year's report —on the 2016-17 season—found that 86.8% of all Broadway and off-Broadway shows were from white playwrights and 87.1% of all directors hired were white."[8]

The Asian American Performers Action Coalition's study also found that 95 percent of all plays and musicals were both written and directed by White artists. And as reported in *Playbill*, March 5, 2019, that season: "African-American playwrights were represented at 4.1 percent and MENA playwrights at 1.4 percent. According to the survey, the Broadway season featured no plays or musicals by Latinx, Asian-American, or American Indian/Native/First Nation playwrights, nor playwrights with disabilities."

The *Playbill* article reports that the Coalition's survey found that in their previous season's study, of all playwrights engaged in New York's 2016-17 season, 75.4 percent were male and 24.6 percent female. "Eighty-nine percent of playwrights produced on Broadway were male and 11 percent female. Female directors fared only slightly better than female playwrights, representing 31.1 percent. Only 0.8 percent of directors included in the survey were non-binary."[9]

Another study, conducted in 2018 by Women of Color on Broadway, a non-profit organization advocating for African American, Asian American, and Latinx women in theater, found "that between 2008 and 2015 people of color

8. Kennedy, Mark. "Report Finds New York Writers, Stages Remain Extremely White" AP, 1 October, 2020.
9. Clement, Olivia. "New AAPAC Report Shows Nearly 90 Percent of Playwrights From 2016–2017 Season White and Mostly Male" *Playbill*, 5 March 2019.

represented less than 25 percent of the theater industry. Last year, 196 individuals were hired as directors, writers, choreographers, and designers for more than 130 Broadway shows. Of that total, only 13 percent of directors, 24 percent of choreographers, and 13 percent of writers were women." [10]

There has been a little progress, according to the 2018 data collected in their first survey from 2011 to 2014, when "just over 3.4 percent of work being produced in American theater was by women of color; that figure almost doubled in the second surveying period, to 6.1 percent."

The Women of Color on Broadway's study also found that

> The number of women of color who were classified as principals in plays, musicals, as members of the chorus, and as stage managers was dramatically lower than any other demographic.
>
> Caucasians made up a majority of all onstage contracts—principal in a play (65 percent of contracts), principal in a musical (66 percent of contracts), and chorus (57 percent of contracts). Caucasians were generally hired with higher contractual salaries. African-American members reported salaries 10 percent lower than the average principal in a play roles, for example.
>
> Seventy-seven percent of stage manager contracts on the Broadway and production tours went to Caucasians. Over three years there were only six contracts given to African-American members.
>
> "Of plays on Broadway, none were by women of color in the 1998-99 season," [playwright, screenwriter, founder, and co-executive director of the Lillys, Julia] Jordan said. It was the same figure in the 2008-09 season, and in the 2018-19 season, of the eight shows by women on Broadway, two were by women of color; "representation within the underrepresented," as Jordan put it, adding that there had been zero female directors of color this season.

10. Teeman, Tom. "See Us, Trust Us, Employ Us: Broadway's Women of Color on Confronting Racism and Reshaping Theater." *The Daily Beast* updated 30 August 2019.

Jordan noted that the U.S. Census estimates that the country is made up of 20 percent women of color; the same figure went for those receiving B.A. degrees in literature, B.A. degrees in performing arts, and new dramatists at the Playwrights Center. "There's no shortage of women of color in the pipeline—until production," said Jordan.[11]

The summary that begins the *Actors' Equity 2018-2019 Theatrical Season Report* by Steven Di Paola shows that American theater, and especially Broadway, experienced a very healthy season, reflecting that the industry had at last recovered from the revenue drop which occurred during the economic recession of 2008, to even surpass earnings and employment of previous years.

The 2018-2019 theatrical season, which began in June 2018 and concluded in May 2019, was a highly successful one for the members of Actors' Equity Association. The number of Active Members continued to grow, a larger number of members worked than ever before, earning the highest amount of money on Equity contracts ever (within sight of a half-billion dollars), and members registered the largest number of work weeks ever. Some contracts, including the Production contract, which provides the financial foundation of the union, had their highest levels of employment since the recession that occurred at the end of the last decade. At the beginning of 2019, thousands of members mobilized for the first major job action in years that led to an agreement with Broadway producers that opened the door for Equity members who participate in the development of future successful Broadway shows to be financially recognized and compensated for their contributions.[12]

The increase in Actors Equity's total earnings reflected the increased number of members employed in 2018-19. However, as an Equity spokesperson noted, in non-Equity

11. Teeman, Tom, Op cit.
12. DiPaola, Steven. Actors' Equity 2018-2019 Theatrical Season Report: An analysis of Employment, Earnings, Membership and Finance.

houses wage earnings are likely "more stark," as performers and stage managers do not have the advantage of Equity's representation and bargaining power.

At the conclusion of the 2018-19 season, Equity's active membership totaled almost 52,000, which was almost equally divided between females (49.99 percent) and males (49.81 percent) with the balance of the membership preferring either not to identify their gender or to self-describe, or to identify as either no gender or non-binary third gender.

Of course, statistics for the 2019-20 season, because theaters were closed in mid-March due to the Covid-19 pandemic, will reveal a significant revenue drop across the board. As happened after the drop in earnings following the 2008 recession, the 2021-22 season is expected to reflect the beginning of a slow recovery also. Chris Heyward, executive vice president of NYC and Company, the destination marketing organization for the five boroughs, predicts that international tourism levels will not return to their pre-pandemic highs until 2025, although domestic tourism is likely to do so in three years.[13]

But Covid-19-related losses aside, why is Broadway so slow to reflect the diverse population of its home metropolis and the nation as well? The Broadway League provides clues to the economic dynamics often cited to justify Broadway's near exclusion of plays created by people of color besides the resistance to hiring Black, Latinx, or Asian Americans to perform or work other jobs in Broadway productions. The statistics in their 2018-2019 demographic survey reveal that there has been hardly any change in the source of ticket buying income within the industry, as Caucasians have long constituted the majority of the ticket buying public. During the 2017-2018 season, the Broadway League reported

13. Sanchez, Hazel. "Tourism Expert Says it could take NYC 3 to 5 Years to Recover." CBS2, 17 November 2020.

that Whites comprised almost three quarters of Broadway audiences. "The average ticket buyer is a 44-year-old White woman, and almost 80% of all buyers are White."[14]

The average admission paid for the following Broadway musicals, during the week ending 02/23/2020 was:

Aladdin	$113.55	with audience capacity reaching	98.85%
Hadestown	$151.89	"	101.51%
Hamilton	$257.03	"	101.51%
The Book of Mormon	$122.71	"	100.82%
The Lion King	$140.55	"	96.54%
West Side Story	$110.67	"	100.00%

Of course, should someone want the best seats in the house, such as in the center of the orchestra section, those tickets will carry a considerably higher price tag than the average prices listed above.

These prices actually reflect the rise in ticket prices that has occurred since the 2013-14 season, when for the first time, the average cost of admission to a musical passed $100.00, although again, the best seats had been going well above $100 for many years. So, unless someone is able to secure one of the limited number of discounted seats available through some theater's same-day lotteries or through such services as TKTS, it is clear that significant potential audiences are routinely excluded because of the cost. Broadway relies on New York's domestic and international tourists to comprise the majority of ticket buyers, as they are likely expecting to have to splurge on a Broadway show, because in fact, Broadway is one of the city's biggest attractions. But for many locals, attending a Broadway show remains a rare special event at best, especially when compared to the cost of seeing a film in a movie theater.

14. Seymour, Lee. "Why Broadway Is So White, Part 1: Real Estate, Nepotism And David Mamet." *Forbes*, April 7, 2016.

The biggest roadblocks to change are the high cost of producing a show on Broadway and the fact that most Broadway producers and theater owners are White men. Their tastes and knowledge are likely to exclude underwriting new works or revivals with subjects or styles with which they are not familiar or comfortable. Theater owners, such as the Shubert and Nederlander organizations and the Jujamcyn, who between them own thirty-one of Broadway's theaters, can exercise the power to decide what shows they will house, what tickets will cost, and when those shows can open and close. Producers and theater owners want to invest in productions that promise market success, because they take a real risk.

Just to develop a Broadway production, from scratch through rehearsals to the beginning of previews, costs upwards of $3-$6 million for a play and $8-$12 million for a musical in 2016, with costs increasing by the year. Once a show opens, its weekly operating budget must be met by filling the seats. Again in 2016, the running expenses for all Broadway shows averaged $455,000 per week, with the most elaborate musicals likely to cost upwards of $750,000 per week. These expenses include performers and technicians' salaries, theater operating expenses, equipment rentals, advertising, and royalty guarantees to the author, director, choreographer, designers, orchestrator, producer and co-producers, ahead of additional royalties due to investors, which may also be required to be paid out weekly.

According to the Broadway League "only one in five Broadway shows breaks even, and those that do take an average of two years to show a profit.... Twenty-five years ago, it took an average of six months for a hit show to recoup its cost." And because producers and theater owners control the money, their influence in choices of writers, directors, and performers can be huge.

That is why most Broadway shows are built around stars whose big-name recognition is most likely to attract audiences.

In his article, "Why Broadway Is So White, Part I," *Forbes'* senior contributor Lee Seymour found that "… Broadway's decision-makers simply don't prioritize racial equality. Several producers and ad execs—who asked not to be named for this piece—told me that 'green is the only color that matters….'" Seymour concluded: "Another hurdle is our own innate bias as humans. We are predisposed to building communities around our own ethnicity, and as Broadway is mostly white, it builds on that. Again, some could argue this is racism. I would call it inertia. Producers and theater owners are not actively shunning minorities—they just don't see an incentive to reach out."

Although not a new phenomenon, another example of that inertia, and a major contributor to the consistent lack of productions by playwrights of color is how many recent Broadway musicals are already familiar commodities rather than original works. *Kiss of the Spiderwoman, Hadestown, The Scottsboro Boys, Avenue Q.,* and *Urinetown,* are among the few completely new shows that appeared on Broadway during the late twentieth and twenty-first centuries. Many productions are reworkings of films, like *The Color Purple, Billy Elliot, An American in Paris,* and *Kinky Boots,* and the Disney Theatrical Group's juggernaut of screen-to-Broadway productions of *The Lion King, Beauty and the Beast, Aladdin, Mary Poppins, Frozen, The Little Mermaid,* and *Newsies.* This practice is sure to be continued, as of this writing, Disney is reported to have projects in various stages of pre-production development. Among those mentioned are *Hercules, Bedknobs and Broomsticks, The Princess Bride, Alice in Wonderland, The Jungle Book,* and *Father of the Bride.* Broadway producers' idea of another sure bet is to revive classic plays and musicals, such as the recent productions of the musicals *Oklahoma, Kiss Me Kate, Carousel, West Side Story,* and *Porgy and Bess,* the George and Ira Gershwin/ Dubose and Dorothy Heyward "folk opera." These revivals generally have involved more diverse casts than appeared

in the original productions, (except in the case of *Porgy and Bess*, whose original all-Black cast refused to perform in front of Whites-only audiences, causing some Southern theaters to desegregate for the first time). When significant changes are made to original plots, dialogues, and scores, these adaptations can be called "revisals." Of course, changes to iconic works generate controversy. People will have opinions when you start messing with a classic. Such was the case in the adaptation of *Porgy and Bess*, renamed *The Gershwins' Porgy and Bess*, which was produced in agreement with the Heyward and Gershwin estates. The revisions to the book were done by African-American playwright Suzan-Lori Parks, with musical adaptations by Deirdre Murray, who is African American, and direction by Harvard's American Repertory Theater-based director Diane Paulus, where the previews occurred in 2011. At the start of the rehearsal process, Paulus, who is not African American, explained her idea to the cast, "that the original libretto would be fleshed out—or 'mined,' as she says—to make the update more like a piece of musical theatre, or a play, than an opera." When transferred to Broadway, amid considerable controversy, it won a 2012 Tony award for Best Revival of a Musical. In an interview, Parks explained her process:

> So many of my ideas come from deepening the characters and their character's relationships, and deepen their truth in the plot, are really achieved by the music. The epic scope of the music, the beautiful recurring motifs, as I listened and listened, and relistened to the music I allowed it to inform the adaptation that I did with the book.... And this is where people get it wrong, not to make it 'right, or make it politically correct.'.... Come on, give us a break already. We wanted to make it better. Better... A more perfect union ... (she sings joyously, as her voice trails off). Hello. Like amending the constitution, we want a better country. It's not politically correct... so the people get all the hair on the back of their neck up. It's not

about that. It's about making it better. The music is Sooo great.
Let us make the story just as great, if we possibly can.

Racial and gender diversity has been slow in coming to
Broadway, in spite of the revelations in studies by organ-
izations such as those mentioned in this article (the Asian
American Performers Action Coalition, Women of Color on
Broadway, The Lillys, and Actors Equity), and besides the fact
that in recent years, mass media outlets have been quick to
call out the small number of awards bestowed upon people
of color, women in general, LGBT, and disabled artists in all
categories of the industry. This status quo, justified by the
need to appeal to majority White audiences who have been
the successful market for Broadway's expensive tickets, has
been combined with little outreach to develop audiences
outside of the typically over seventy and White ticket-buy-
ing crowd. But now theater makers who are not White have
organized to call out the traditional modes of doing business
on Broadway.

In June 2020, following police killings of George Floyd,
Breonna Taylor, Ahmaud Arbery, Daniel Prude, and Rayshard
Brooks, to list the most publicized cases involving African
Americans who did not deserve to die that year, 300 the-
ater-makers who are Black, Indigenous, and People of Color
(BIPOC) addressed an open letter to "Dear White American
Theater." Signed as "The Ground We Stand On," it referenced
playwright August Wilson's keynote address, "The Ground
On Which I Stand," delivered at Princeton University on June
26, 1996, during a Theater Communications Group national
conference. Immediately controversial with its advocacy for
the need to develop exclusively Black American theaters and
critics, Wilson said:

> We cannot share a single value system if that value system con-
> sists of the values of white Americans based on their European
> ancestors. We reject that as Cultural Imperialism. We need a

value system that includes our contributions as Africans in America. Our agendas are as valid as yours. We may disagree, we may forever be on opposite sides of aesthetics, but we can only share a value system that is inclusive of all Americans and recognizes their unique and valuable contributions. The ground together: We must develop the ground together.

In retaliation for Wilson's manifesto and the following series of exchanges in *American Theatre* magazine with Robert Brustein, then the *New Republic*'s theater critic and director of the American Repertory Theater at Harvard, Broadway's powers-that-be took a five-year break on producing another Wilson play, even though the Broadway production of Wilson's *Seven Guitars* had won the 1996 New York Drama Critics Circle Award for Best Play.

The June 9, 2020 "Dear White American Theater" letter begins:

> We have come together as a community of Black, Indigenous, and People of Color (BIPOC) theatremakers....to let you know exactly what ground we stand on in the wake of our nation's civic unrest.
> We see you. We have always seen you. We have watched you pretend not to see us.

And closes with:

> And now you will see us....
> This ends TODAY.
> We are about to introduce you...to yourself.

The complete letter, which can be found in this book's Appendix, had 300 signatories including Cynthia Erivo, Viola Davis, Suzan-Lori Parks, Lynn Nottage, Lin-Manuel Miranda, Lauren Yee, Leslie Odom Jr., Lindsay Mendez, Leah C. Gardiner, Katori Hall, Eden Espinosa, Ruthie Ann Miles, Issa Rae, Jacob Padrón, and Liesl Tommy.

In December 2020, June's "Dear White American Theater" letter was followed up by a thirty-one-page manifesto by BIPOC theater makers, a work-in-progress list of demands for "…..accountability to anti-racism" in American theaters' hiring practices, working conditions, unions, and academic and professional training programs.

There appears to have been some progress in the virtual world which became the go-to venue for many theater artists and organizations after the Covid-19 pandemic caused the shutdown of live performances. Perhaps this happened because of what we hope were embarrassing mass media disclosures of the surveys within the industry and the BIPOC theater makers' demands. Or perhaps it was because the internet offers anyone the possibility of bypassing the need for sponsorship by an established venue and can be less expensive than mounting a live theatrical production, pluses that many believe will continue to make the internet an important showcase for all after the pandemic subsides. We will have to wait for Broadway's curtains to go up again to know if any further, lasting significant changes will happen on their stages.

2024 Update: Counting Together, a new national coalition of American theater artists and service professionals, offers an ongoing, evolving research tool from multiple perspectives that provides access to data available since 2019 on theater community practices through studies of race, gender and/or disabilities as gathered and experienced among its members. The data tracks and analyzes information about performers, playwrights, directors, designers, musicians, technicians, dramaturgs, stage managers, and administrators.

22

The Profound Public Art
of Mildred Howard[1]

Some artists want their works to appear behind the velvet ropes of a museum where guards keep an eye on visitors' every move. Mildred Howard wants her work to be in places where everybody can see it. Her largest public art piece, *Frame* (2015), a 22-by-20-foot rococo bronze structure, is situated in San Francisco's Hunters Point Naval Shipyard. The empty rectangle draws the eye to *Refrain* (2015), a cluster of vertical steel rods created by Walter Hood that stand as if in conversation with Howard's work. Breathtaking views of Hunters Point, other parts of the city, Treasure Island, the East Bay, and even the South Bay lie both within and beyond *Frame*, depending on one's vantage point. The piece highlights the shipyard's central role in "migrations from the southern part of the United States," Howard wrote in a catalog for the Fred Jones Jr. Museum of Art at the University of Oklahoma. "People came out to the West Coast to find employment.... A lot of them worked in that shipyard. I wanted to frame those who walk through the frame. You are the art. You are part of what makes this place what it is."

1. First appeared in *Alta Journal*, Issue 20, 29 June 2022.

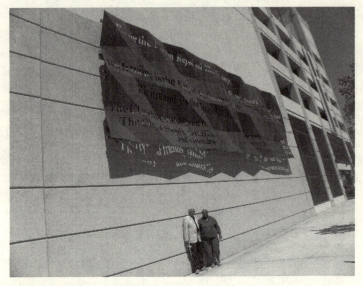

During the unveiling ceremony for their mixed-media collaboration, "Moving Richmond," artist Mildred Howard stands with poet Ishmael Reed under one of its two 12' x 40' Corten steel billboards that are placed on the exterior of a parking garage in Richmond, California's mass-transit hub complex. The poem recalls the industrial and ship-building heritage of the area's factories.
(Photo by Tennessee Reed)

During an interview for the Berkeley Art Center, Howard said, "I'm always trying to bring in the African American experience because I don't think it gets done enough." And while Howard does not set out to produce socially or politically themed work, she has come to realize that those meanings will likely be found by spectators and by her, too, once a piece is assembled.

Creating public art is not an easy choice for anyone, but it makes sense for Howard, even though she took an indirect path to the field. She was born in San Francisco in 1945, the tenth child of Black parents, Mable and Rolly Howard, who had migrated to the San Francisco Bay Area from Galveston,

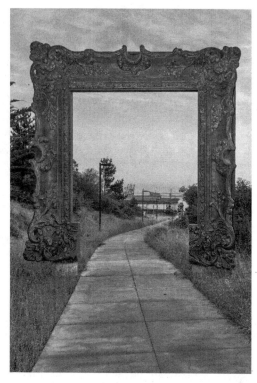

Howard's rococo bronze *Frame* (2015), with Walter Reed's steel
Refrain (2015) in the distance, at Hunters Point Naval Shipyard in San
Francisco. (Photo by Christie Hemm Klok)

Texas. Her mother sold antiques, and her father was a long-
shoreman. Growing up in Berkeley, she was surrounded
by antiques and learned to evaluate the quality of their
materials—knowledge that she applies when making mixed
media assemblages and sculptural installations. Howard
explains, "I've always been trying to figure out how I can
take something that's ordinary and make it into something
extraordinary."

Question everything

Howard lives in West Oakland in a building that was previously a factory where awnings were made and sold. Her loft space is filled with her own art—a prototype for *Frame* hangs on a living room wall—and works by her husband, John Moore; her grandchildren; and artist friends as well as objects and antiques from Africa and the Americas, and it could be one of those dazzling interiors displayed in *Architectural Digest*. Yet Howard lives on San Pablo Avenue in a district that a former White mayor once referred to as "Botswana." It's not lost on Howard that the powerful influence of her parents serves as a bulwark to counter such a hateful remark. Their roles as community leaders and union activists and their involvement in political causes not only shaped her worldview but also taught her patience and persistence.

To secure a public art commission, one must navigate a bureaucratic labyrinth. For starters, such projects can be sponsored by city, county, or state organizations; at the federal level, by the National Endowment for the Arts or the U.S. General Services Administration's Art in Architecture Program, which requires that one half of 1 percent of the budget for any federal-building construction or remodel be designated for a public art commission; or by similar programs for privately owned buildings. To have their work considered, an artist must respond to a call for proposals, draw up a project plan, and then submit it to an appointed panel of judges.

The competition can be fierce. Berkeley's Civic Arts Program has commissioned about 100 public artworks since its inception in 1967, selecting one or two per year from a field of twenty to fifty applicants; Oakland's Percent for Art program has commissioned about one hundred artworks since its creation in 1989 and receives between twenty-five

and 150 applications per commission, of which there are one to five each year.

Once chosen, the artist enters into negotiations with urban planners and other government officials about the materials and assembly methods to be used, in order to meet safety and other construction requirements. The winning artist also participates in meetings with residents of the sited community to explain how the work will represent something meaningful to the place and its inhabitants.

It wasn't until Howard was about forty that, as a graduate art student with young children, she first responded to a call for public art proposals. "I started seeing all these White men get a lot of public art projects, and I thought, I want to do this," she recalls.

Ironically, the site for the work was Marin County's Mill Valley, one of the wealthiest and Whitest enclaves in the Bay Area. Her winning proposal, a temporary installation with performances, called *The Gospel and the Storefront Church* (1984), was set in the town's then-post office, which also functioned as a community center. These were performances by, among others, the Marin City Choir, singing gospel music, and Bishop Norman Williams, who at the time was with the Saint John Coltrane Church, named after the late tenor saxophonist. The work served as a jumping-off point for the larger projects Howard does today, although sixteen years passed before she was commissioned to create a permanent public work.

During this time, in addition to pursuing her art, she worked and raised her two kids. For eleven years, Howard held various positions at San Francisco's Exploratorium, a museum of science, technology, and the arts. She took the museum's inquiry-based approach to thinking and making and adapted it to her art. "I had no idea of the connection between art and science," she admits. "Scientists question things, and they go on this journey of investigation and exploration. Through that journey, you learn and discover

other ways of seeing and doing. I realized that artists do the same thing. Artists, like scientists, question their way of working and thinking. They are curious about the world. It is the 'what if?' that is interesting to me as an artist. You can go in one direction or another, and maybe even both directions simultaneously. Everything I do now, whether it's obvious within the context of the work or not, I'm always thinking about that. I'm always trying to learn something new, even if I've been doing it for years."

Howard's first large permanent public art project, *Salty Peanuts* (2000), an homage to the Bay Area's rich jazz history, can be found inside the San Francisco International Airport. Much like Howard's career, the work evolved over time.

"I decided I had to collect saxophones. I think 130," she says. "All kinds of saxophones and had them shipped to my studio. At one time my studio was filled with saxophones. First I had wanted to use trumpets, but trumpets are played at funerals. So I said, 'No, I'm going to use saxophones.' Even before that, I had wanted to use a wall of suitcases, but [the commissioners] said 'Oh no, it's too much like a plane crash.' I wasn't even thinking about that. I was thinking about the migration of people. Dizzy Gillespie was on the radio playing 'Salt Peanuts.' I had the first four bars of Gillespie's composition cut out in powder-coat steel and the saxophones mounted to the steel on the wall."

Another work, *Moving Richmond* (2014), shows the importance of collaboration in public art. The project, commissioned by the city of Richmond, involved Howard as lead artist; my husband, Ishmael Reed, as poet; and Hugh Hynes as architect. Howard's vision: "If you take a piece of paper and fold it into various shapes, that's how the poem was laser cut into two 12-feet-by-40-feet corten steel sculptures." In his poem, Reed tried to capture the essence of the city as understood from numerous meetings with Richmond residents. Hynes executed the weathered-steel pieces, which echo the

area's industrial roots, and mounted them on a parking garage exterior wall at Richmond's mass-transit hub.

Howard attributes her use of cut-out letters to science and the history of race in the United States. "The reason why I had the poem in negative space goes back to my work at the Exploratorium. Because during the course of the day, the shadows of the words move across the floor, depending on the light and the season. And you can think about that also as a metaphor of Black folks moving from the South, hopefully to find a better way of life. Yet although somewhat better, racism exists. It just takes on a different form and shows itself in many ways—education, employment, housing, food deserts, to name a few."

Unlocked meaning

Over her forty-year career, Howard has received commissions for a half dozen temporary installations and sixteen permanent public art projects. Her honors include a pair of Rockefeller Foundation residencies and a National Endowment for the Arts fellowship in visual arts; her work is in the collections of the San Francisco Museum of Modern Art, the DeYoung Museum, the Oakland Museum of California, and the Los Angeles County Museum of Art.

Yet winning commissions never gets easy, particularly if the artist is a Black woman in her late seventies, no matter her reputation. The art world itself and many higher centers of learning—which often oversee public art commissions— remain hindered by racism. Still, Howard fights for grants and commissions that will allow her to work full-time as an artist: "Public art helps me make money. It pays my rent."

Howard is excited for her next potential project, *Falling Dominoes*, even if one commission panel has already passed on it. Her plan consists of seven eight-foot-tall dominoes, rendered in bronze, suspended while falling from vertical to

horizontal, as if in a chain reaction. For Howard, the piece would acknowledge how cultures influence one another. Undeterred by the initial rejection, she will propose it elsewhere.

In the meantime, she has three large-scale public art pieces in progress. One is a redo of her *Locks and Keys for Harry Bridges*, originally designed in 2001 for the half-block stretch of San Francisco's Stevenson Street that now dead ends at the valet parking entrance of a Four Seasons hotel. The work features large, upright bronze keys set in locks in the sidewalks on both sides of the alleyway, and it honors Bridges, the founder and, for forty years, the leader of the International Longshore and Warehouse Union in San Francisco, who opened doors.

Another, presently untitled work is scheduled to be installed in May or June at the Southeast Community Center in the Bayview district of San Francisco. Inspired by West African currency, Howard has cast 14-, 16-, and 18-foot-tall boat shapes in bronze. In her proposal, she wrote that this "universal, iconic shape calls to mind the perpetual movement of immigrants and the hard-fought wealth—both economic and intangible—needed to build their communities, standing tall as a proud and dignified reminder that we all ultimately arrived in this country from somewhere else."

Howard's third project, a variation on the West African-currency design, is planned for Berkeley's Ashby BART station. "I'm going to put it in Berkeley if I can ever get through the paperwork," she says. "I'm thinking of naming it after my mother. She led a suit against BART, and that is the reason it is underground in Berkeley."

23

Finding Nature
in a Built Environment[1]

Most of us travel through environments—either built or what we call "natural"—without realizing how much they have been altered over time or understanding why these changes happened. Readers of *Changing the Commons: Stories About Placemaking* (ORO Editions, available January 2023) by landscape architect John Northmore Roberts will come away with a new appreciation of the importance of landscape architecture to society, a profession whose title is often mistaken as a synonym for gardening. They will also become more aware of how, since the 1970s, movements toward social justice and ecological stewardship have been playing out in our physical environment.

You cannot get more iconic than Yosemite National Park. In three Yosemite Valley projects for the National Park Service (NPS), Roberts was tasked with restoring the balance between the ecological and built environments, as what we usually think of as urban issues had developed with the ever-increasing public use of the park's wildlands. A tall order, as the improvements to visitor accommodations requested by the NPS also needed to protect the Merced

1. First appeared in *CounterPunch*, 23 December 2022.

River, wetlands, granite cliffs, meadows, and forests while increasing ease of access to those grand views. Two of the locations were the Yosemite Village Day Use Area, the primary destination location for visitors and the park's center of operations, and Yosemite Lodge, built in the 1950s as a destination motel near Yosemite Falls. Roberts was directed to find ways to relieve traffic congestion, realign dangerous road crossings, reposition and expand parking lots, install adequate signage, build new restrooms, and provide a pleasant arrival plaza with orientation and interpretive displays which Roberts situated so as to screen the parking area from visitors' view. And at the third Yosemite site, Bridalveil Fall, where waters cascading down 600 feet of granite rock make it a favorite first stop for park visitors, many similar restoration requirements had to be addressed. Here the project team was also tasked with constructing new boardwalks to discourage visitors from treading off established trails, thereby disturbing the surrounding wetlands. Another intention was to make it safe for everyone to access the upper overlook at the Fall's base, as the existing trail's steep incline was difficult for many people to navigate, especially anyone with mobility issues. Roberts' team proposed an ecologically responsible solution as it would not require heavy equipment to install and would thus minimize intrusion on the wetlands. He describes this structure as an elevated "self-supporting metal bridging system, tied to boulders for support, to climb at a gentle, accessible gradient." The Yosemite Conservancy, a partner of the NPS, and NPS trails staff ruled against accepting this plan, considering the technology too radical a departure from park traditions. They eventually settled on what Roberts describes as "an intermediate-level lookout offering a good photo opportunity." Roberts says the decision was made despite "a years-long consensus-based design process." It exemplifies how differing concerns within communities can play a significant part in shaping environments.

Most landscape architects would regard these Yosemite projects as the pinnacle of their career, but for John Northmore Roberts, they are among many highlights of his ongoing professional history. For over fifty years, he has been active as a practitioner and college educator in the field of landscape architecture. A long-time resident of the San Francisco Bay area, Roberts' landscape architecture work has been centered in Northern California. Roberts seeks ways to live with nature rather than dominating it. He addresses our ever-more pressing need to conserve the earth's urban and rural communities and all their life forms, finding creative solutions to serve the twenty-first century and beyond. He takes full advantage of technological advances not available to Frederick Law Olmsted, widely considered the founder of American landscape architecture.

Changing the Commons includes twenty-five sites from the built environment of cityscapes to watersheds into the Pacific. Located in San Francisco, Alameda, Marin, Napa, Sonoma, Mariposa, and Humboldt counties, these projects demonstrate how it is possible to sustain California's ecological and environmental health by adapting "existing conditions to a new set of circumstances." Roberts describes projects that span private and public sectors, including "parks (national, state, regional and local), schools, libraries, institutional and industrial campuses, streetscapes and urban plazas, museums, housing and historic restorations." While some of these sites are not as well-known as Yosemite National Park, Roberts' designs have touched other iconic California places. They include Muir Woods and Muir Beach in Marin County, Crissy Field and Strybing Arboretum in Golden Gate Park in San Francisco, and his home city of Berkeley's popular 4th Street Paseo and its Central Library Gardens.

The standards and methodology Roberts details in *Changing the Commons* could be adapted to restore any

environment. Their holistic approach necessitated collaborations outside of Roberts and associates in his office. Depending on the design needs of each site, Roberts variously functioned as the project lead or as a sub-contractor to the principal architects, engineers, or urban and environmental planners. His collaborators have also included other landscape design colleagues or firms, hydrologists, biologists, federal and regional regulators, politicians, citizen and technical advisory committees, sculptors, artists, and skilled crafts workers, besides owners and residents within affected communities.

The patience and long hours devoted to understanding the unique ingredients and multiple requirements underlying the path toward the transformation of each project become quickly apparent. Roberts generally begins by paying attention to the history and culture of each place, considering its functional needs and those of the humans, animals, and plants that formerly or already inhabit the space or are projected to be its future inhabitants. He explains he tries to understand each place's unique "physical, sensual, emotional, and cultural implications" to achieve what Roberts calls "placemaking." When looking to work on public spaces, the next step is to draw up a proposal for review by a government or private governing board. If approval is won, the following steps involve meetings and negotiations with the community and officials or agencies who will be affected by any changes to a site. Roberts practices inclusive and democratic ways to progress, involving the locals in what he calls "Community Design" solutions rather than continuing those that would be exclusive and reflective of the "interests and values of the powerful." Often these discussions involve compromises and revisions to the original proposal, but once agreements at this stage of development are reached, projects move toward completion.

Roberts began his professional career working in the landscape architecture firm of Royston, Hanamoto, Beck,

& Abey, where his first assignment was to transform Fort Mason, which functioned as a U.S. Army base from the 1850s through World War II, into an urban park. Now under the National Park Service's Golden Gate National Recreation Area, it also houses its headquarters in addition to almost two dozen non-profit arts and culture organizations who are permanent residents. Fort Mason's location presents panoramic views of the San Francisco Bay, the Marin Headlands, and the Golden Gate Bridge. The plan required selecting which structures should be removed and which should be preserved, along with burying old concrete foundations, sidewalks, and slabs to reveal the full scenic glories of the site. Because Fort Mason is registered on the National Register of Historic Places, it was not immediately apparent that he could satisfy the neighborhood's request to keep their beloved community garden. But Roberts learned that in the nineteenth century, military housed in one of the barracks had cultivated a vegetable garden. That provided the needed precedent for Roberts to get approval to create the Fort Mason Community Garden on a 2.5-acre segment of the land. Roberts is proud to report it continues to function, yielding a profuse combination of fruits, vegetables, and flowers every year. During the five years devoted to this project, Roberts eventually became the project manager. It is high testimony to the quality of Roberts' ways of working that the NPS has continued to employ him on projects throughout his career.

Roberts observes:

"A protected bay, a fertile river valley, a waterfall on a granite face, or towering trees may give iconic identity to a specific place. But in each case, the underlying ecological systems and natural processes that sustain the life of a place are what create the conditions for such iconic features to reveal themselves, and are what interest me. From long experience I have found that water is the key to unlocking the secrets of such under-

lying natural systems. Nature and the built environment are in a continuous dynamic balance with each other, adjusting as conditions change. Water is at the heart of it and its treatment is the seminal consideration for the design of most places in this book. By following the water we can discover how to sustain the balance. Of course, in the end, nature will prevail. Entire civilizations have collapsed by neglecting the underlying ecological support systems for their built environments and it is often the water systems that fail. It is imperative for our survival and for the health of the planet that the places we construct and nurture the long-term sustained ecological health of their settings and water is the key."

This belief guided what Roberts calls a "...landscape-scale change...for the 6.5 mile, 800-acre river corridor through the center of Petaluma." Historically, the town's origins ten thousand years ago were related to the waters the indigenous Miwok people called Petaluma Creek. By the mid-nineteenth century, it had developed into a thriving port, serving the agricultural areas of west Marin and southern Sonoma counties. Its downtown thrived around the need for supporting commercial functions. But as railroads, roadways, and trucking systems developed, the river had ceased serving as a commercial hub by the end of World War II. Roberts says it became "a smelly, dirty drainage channel." Increased flooding episodes had resulted from development along its watershed, while the downtown lands adjacent to the river had also deteriorated. Recognizing "the importance of the entire riparian system—from fresh to salt water," Roberts' office reintegrated the Petaluma River into the life of the city, establishing "pathways and open spaces, recreational connections to the river, and restored riverfront vegetation." Roberts says that for more than two decades, the community has accepted these guidelines to maintain a balance between the ecological system and urban life while developing "the Petaluma riverfront into one of the San Francisco

Bay Area's most popular residential, tourist and commercial destinations."

The city of Berkeley's over sixty-foot high, 92-acre municipal garbage dump provided Roberts with one of his most frustrating and significant learning experiences. It turned out that the solution his design team offered was so ahead of its time that it failed to be adopted by the Berkeley City Council. Now known as Cesar Chavez Park, the former garbage dump is among the thousands of acres of flatlands created from the late nineteenth century until the 1960s by dumping garbage and soil from development sites onto the shallow San Francisco Bayfront's mud flats, marshes, and beaches. The new land, above the garbage and next to the Bayshore freeways, was an ecological disaster because the landfill gases and leachate pollute air and water quality. Roberts enlisted a special team of collaborators to develop a plan for an "ecologically sustainable place directly connected to its natural setting." Landscape architect Richard Haag who designed Seattle's Gas Works Park on the site of a former gasification plant, chemical engineer Richard Brooks who is an innovative bioremediation expert, and other scientific experts in greenhouse gases and methane consumption, worked on finding solutions. They reasoned that it would be best to clean the site of methane rather than continue using the common methane flare systems, which burn off landfill gases and are a major source of greenhouse gas pollution. Instead, Roberts writes, they "imagined opening the landfill, grinding and composting its organic matter, blending it with the clay cap to create healthy new soils, and then regrading the site. In this way the soil itself might provide the active medium for cleaning the landfill of gas and water pollutants—not just for growing plants.... The ideas we proposed are fascinating and achievable. Indeed, they are now being adapted at other contaminated sites." So although one community unfortunately passed on this proposal, its ideas are

Poco Way, San Jose, before and after renovation.
(Photos courtesy of John Northmore Roberts Associates.)

serving other communities and, by extension, the general health of the planet.

The City of San Jose's decision to close Poco Way, a short through-street at McCreery Avenue north of Story Road and turn it into a cul-de-sac helped transform a neighborhood plagued by decayed housing and violent crime into a place so pleasant that there is a waiting list to obtain a rental with the San Jose Housing Authority. The design team, which included the architectural firm of Herman Stoller Colliver besides Roberts, gained input from the street's various ethnic communities through workshop meetings. Central and South American, Cambodian, and Vietnamese immigrant families were among the neighbors who described traditional ways of living they would like to have supported by the new design, in addition to creating a safe environment. Destroyed structures were vacated and removed, and other existing housing was redesigned or renovated, with new

units built in clusters. Dead-end pathways were eliminated where gangs used to gather and criminals sold drugs. This particular reconfiguration was a relief for women who had previously been targeted by assailants when each building cluster's communal laundry was situated at the back of these dead-ends, now rendered safer by their highly visible central locations. The landscaping elements also included one of the community's first requests, to plant fruit trees. A new community center and play areas fulfilled other popular requests. And all were placed around lush courtyard gardens and well-planted pathways opening onto a public street/ promenade, narrowed to discourage unwanted traffic, and generously lined with trees. While proud of this transformation, Roberts cautions that although life on Poco Way was changed for the better, it will take vigilant city and resident cooperation to maintain it.

Many of the public landscape projects in *Changing the Commons* were initiated with goals to address pressing urban problems such as those described in Poco Way and Berkeley's Cesar Chavez Park. The Library Terrace Garden in Golden Gate Park's Strybing Arboretum offered Roberts a different focus. This site allowed him to enhance what he believes to be a great and necessary human service: a beautiful environment where visitors can benefit from calm contemplation, relaxation, or other healing gifts of time out of time. In the Library Terrace Garden, it was Roberts' pleasure to find a way to integrate a cache of medieval stones dumped in Strybing Arboretum into his garden design. Carved by medieval stonemasons for a twelfth-century Cistercian monastery of Santa Maria de Ovila in Spain, publisher William Randolph Hearst had eleven ships bring them to the Bay area in 1931. But the Great Depression made it financially unadvisable to reconstruct the monastery as Hearst had planned. Although many of the plainer stone blocks had been taken for use on projects here and there, Roberts described finding a master

stonemason's fluted column bases and keystones for vaulted arches remained, among other "irregular and astonishing shapes." A local sculptor, Edwin Hamilton, reconfigured these treasures into a unique wall incorporating seating. It surrounds the perimeter of an outdoor terrace featuring plants from the arboretum's Asian plant collection. While primarily functioning as an entrance courtyard to the Helen Crocker Russell Library of Horticulture, the terrace garden's combination of cultures old and new also provides a distinctive space to stage public events besides facilitating individual enjoyment.

Roberts wrote *Changing the Commons* with his grandchildren in mind, which likely helped his writing maintain a straightforward, jargon-free, reader-friendly style. A handsomely designed volume, all of the project descriptions are accompanied by a generous offering of impressive color photographs, charts, maps, and graphs showing sites before/during/and after a project's completion. Their inclusion makes it even more likely that readers of *Changing the Commons* will find their expanded understanding of the terms "built environment" and "natural environment" has changed the way they view and experience the world. And as Roberts wrote in the close of his dedication to his grandchildren "That may trigger questions about how other places, more familiar to you, have been made and empower you to think about how you can affect changes in your own environments. I would like that."

A Jew in Ramallah[1]

Part I

As I write this, it is exactly one week since Saturday, October 7th, 2023, when Hamas executed their orchestrated surprise attack killing 1,200 festival celebrants, soldiers, and kibbutz inhabitants, besides capturing over 150 hostages, including workers from various countries.

Every succeeding day has brought more violence on both sides. Many neighborhoods in Gaza City have been pulverized into rubble by Israeli airstrikes. It appears inevitable that more unspeakable suffering lies ahead for Palestinians and Israelis. The Israeli Defense Forces say they are determined to eliminate Hamas, the terrorist group that is estimated to be 10 percent of the Gazan population of 2.3 million people. The other 90 percent of Palestinians have nowhere to go because there is no exit out of Gaza. The blockaded borders surrounding the 140-square-mile Gaza Strip are Israel on the East and North, and Egypt on the Southwest. I have never heard mention of the Mediterranean Sea border on

1. Part 1 first appeared in *CounterPunch*, 16 October 2024 and a revised edition appeared in *Konch*, Fall 2023. Part II, email correspondence is published for the first time.

Graffiti on a partition wall near Ramallah. (Photo by Carla Blank)

the West as an escape option, so I assume blockades or other deterrents are in place there also.

At present more than twenty-four hours have passed since the Israeli government warned Palestinians living anywhere from the northern Gaza town of Beit Hanoun to evacuate their homes and move twenty miles south to the town of Khan Yunis. My daughter Tennessee Reed calls it "the 2023 Trail of Tears." They claim they do not want to harm the other 90 percent of Gazans, Americans, and other foreign nationals including UN and other humanitarian workers, who live and serve in the Gaza Strip. Thankfully, it appears this twenty-four-hour deadline was extended after international pressure by the UN and other governments and diplomats convinced the Israelis it would be a war crime to start bombing at the original deadline, as twenty-four hours is not enough time for more than one million Palestinians, including children, disabled, hospitalized, and the aged to

arrive in the South. And although the Israelis just bowed to U.S. pressure and will allow water to be distributed to Gazans in the South, since the Israelis have cut off essential sources of electricity, fuel, food, water, and medicine throughout the Gaza Strip—which has the misfortune of bearing the oft-repeated description of being the world's largest open-air prison—the situation remains dire, whether people chose to flee their homes or stay in place.

Today, one week later, mass demonstrations are happening worldwide, supporting either the Israeli or Palestinian causes. Even in Israel thousands of demonstrators are demonstrating, both for returning the hostages and in support of the Palestinians, asking whether the fight to stop Hamas necessitates collective punishment and demanding the government negotiate a cease-fire.

I have never lived in or visited the Gaza Strip. But I have visited Israel four times, the first time at the beginning of the 2000 Intifada and the most recent in 2013, when I lived in the West Bank city of Ramallah, for a ten-week residency.

This experience was set in motion in February 2013, while I was in New York City helping cast *The Final Version*, a play by my partner Ishmael Reed. I got a surprise phone call from George Ibrahim, the founder and director of Al-Kasaba Theatre and Cinematheque in Ramallah. He offered me the job of directing his theater's planned production of American playwright Philip Barry's 1928 play, *Holiday*, in Arabic. This project was set up in partnership with the American Consulate General in Jerusalem, with the requirement that it would be directed by an American. George Ibrahim told me the American he had arranged to direct this production had unexpectedly withdrawn, due to a cancer diagnosis, and he needed an immediate replacement as rehearsals were to begin shortly.

The Consulate had given him my name and contact information, I think because when I was their guest in September

The Hospital Street front entrance to Al Kasaba
Theatre & Cinematheque, a Palestinian specialized cultural
non-governmental organization located in Ramallah since
June 2000. (Photo by Carla Blank)

2012, directing theater workshops with Palestinian elemen-
tary and secondary students in East Jerusalem, I spoke about
my experiences directing *The Domestic Crusaders*, a play
about a Pakistani American Muslim family by Wajahat Ali.
The cast of this play, which I directed from 2005-2011, were
Pakistani and Indian American actors.

So after checking with the Consulate office and talking
it over with my family, I agreed to the job. I arrived at Tel
Aviv's airport on March 14th, following a fifteen-hour flight.
Once I had passed through customs, George Ibrahim met me
and drove me to Ramallah where I would live for ten weeks,
departing after the Ramallah premiere at the Al-Kasaba
Theatre on May 30th, and the following night's performance.
The company of Palestinian and Syrian actors continued to
perform the play on a tour of five other West Bank cities,

including Nablus, Bethlehem, Hebron, and Tulkarem, closing on June 14 at the Palestinian National Theater in Jerusalem. As stated in *Holiday's* program, the Consulate's ambition for the project was to "introduce audiences in Jerusalem and West Bank to the performing arts of the United States, as well as support the creative expression of talented Palestinian artists who use theater to promote dialogue and raise awareness of important social and cultural issues..., building bridges in English and Arabic, and finding mutually agreeable paths to understand and present ways American and Palestinian culture and history could meet."

George Ibrahim had gathered a distinguished pick-up acting company prior to my arrival. I think three of the supporting actors—Rita Hourani, Firas Abu Sabah, Muayed Abdel Samad—were based in Ramallah. Maisa Abd Elhadi had just wrapped a film project in Israel when she joined the cast a few weeks into rehearsal, as a last-minute replacement for an actor who became ill. Two of the actors, Yussef Abu Warda and Shaden Kanboura, are Arab-Israelis who travelled to Ramallah from their homes in Haifa, where both were active in theater and film. Warda at that time had participated in over 130 TV series, films, and theater productions. One of the actors, Ezat Abu Jabal, had recently relocated from the Syrian Golan and had just graduated from the High Institute of Theatre Arts in Damascus the previous year. Out of the blue he had to miss rehearsals for a few days when he was ordered to return to the Golan Heights to undergo a required interrogation by Israeli intelligence authorities. He said they kept asking him why he had gone to Ramallah, even though he had papers to prove he had been hired to perform in the Al-Kasaba/U.S. Consulate co-production. Another actor, Adeeb Safadi, was born in the Golan's Majdal Shams and before taking up residence in Ramallah, where he was teaching at The Drama Academy, had been a teacher at the Higher Institute of Theatre Arts and the School of Art in

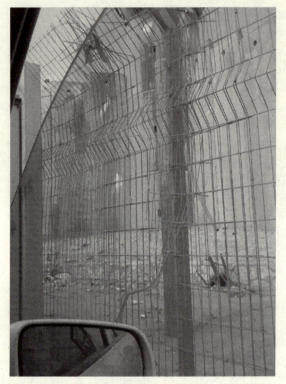

Approach to a checkpoint between Ramallah and Jerusalem.
(Photo by Carla Blank)

Syria. Sami Metwasi, a winner of the 2001 UNESCO Ashburg Artist's scholarship placed in India, who played the leading male character (Cary Grant in the 1938 movie), had been living in Jordan where he was directing a musical. Amira Habash, who played the leading female character (Katherine Hepburn in the 1938 movie version), lived in Jerusalem. One day, she matter-of-factly related how, while driving to rehearsal through a checkpoint with her then about eighteen-month-old son, a bullet grazed her car.

Almost everyone in the pick-up acting company, the production crew, and the theater's administration were at

least bilingual, if not trilingual. Sami Metwasi and the actor who left the cast due to illness, had performed together in Shakespeare's *King Richard II* at London's Globe Theatre. The script the company was using was an Egyptian scholar's Arabic translation of Barry's original text. This became a source of much discussion as I was working from the original English version and assumed the actors' Arabic translation was a close facsimile, only to find out their version did not include some of the text I was referring to when discussing their characters' possible back stories and motivations, or reasons for actions. Although I learned a few Arabic words and phrases by the end of my stay, I was not able to understand spoken Arabic, so when rehearsal discussions were conducted in Arabic, actors often took it upon themselves to translate for me.

Compared to the Gaza Strip, Ramallah, in the occupied West Bank, is a safe place to live. It is home to many international non-governmental organizations. Importantly, it is the seat of the Palestinian Authority, which rejects Hamas, considered a terrorist organization. Before October 7, 2023, according to many reports, Prime Minister Netanyahu had been accused of favoring Hamas and of diminishing the power of the Palestinian Authority—in what is probably a classic divide to conquer strategy. But even so, I observed the Palestinians who live in Ramallah experience daily indignities and hardships that Palestinians throughout the occupied territories routinely endure, ranging from the merely irritating and time-consuming to harassment, such as those occurring to people in this production during those weeks I was in Ramallah, and also during my short visit to East Jerusalem six months earlier.

Like everyone else, my drivers, who were Palestinians, and I had to show our ID papers every time we travelled from anywhere in Israel to or from the West Bank. I learned to recognize we were close to the Qalandia checkpoint, the

one most frequented between the border of East Jerusalem and the West Bank, when we began to pass by a long corridor of twenty-feet high graffiti decorated cement barriers. Surveillance cameras positioned on watchtowers were evident as we reached the checkpoint's gateway, topped with barbed wire and guarded by visibly heavily armed, very young-looking Israeli soldiers. Imagine negotiating going to work every day with a soldier, often barely past teenage, who is carrying an assault rifle besides at least another gun attached on his or her hip.

According to the United Nations Office for the Coordination of Humanitarian Affairs things have only gotten worse since then:

- In early 2023, OCHA documented 565 movement obstacles in the West Bank, including East Jerusalem and excluding H2. These include 49 checkpoints constantly staffed by Israeli forces or private security companies, 139 occasionally staffed checkpoints, 304 roadblocks, earthmounds and road gates, and 73 earth walls, road barriers and trenches.
- Additionally, 80 obstacles, including 28 constantly staffed checkpoints, segregate part of the Israeli-controlled area of Hebron (H2) from the remainder of the city; many checkpoints are fortified with metal detectors, surveillance cameras and face recognition technology, and with facilities for detention and interrogation.
- Combined, there are 645 physical obstacles, an increase of about 8% compared with the 593 obstacles recorded in the previous OCHA closure survey in January-February 2020.
- Specifically, the number of occasionally staffed checkpoints has increased by 35% and that of road gates by 8%. While these remain open most of the time, they can be closed at any moment. In 2022 there were 1,032 instan-

ces (or 293 days) where nonpermanent checkpoints were staffed across the West Bank.

♦ Over half of the obstacles (339 out of 645) have been assessed by OCHA to have a severe impact on Palestinians by preventing or restricting access and movement to main roads, urban centres, services, and agricultural areas.

♦ In 2022, Israeli forces also deployed an average of four ad hoc 'flying' checkpoints each week along West Bank roads.

♦ In addition, the 712 kilometre-long Israeli Barrier (65% of which is built) runs mostly inside the West Bank. Most Palestinian farmers with land isolated by the Barrier can access their groves through 69 gates; however, most of the time, the Israeli authorities keep these gates shut.

♦ Palestinians holding West Bank IDs require permits from the Israeli authorities to enter East Jerusalem through three designated checkpoints, except for men over 55 and women over 50.

♦ In 2022, 15% of permit applications by West Bank patients seeking care in East Jerusalem or Israeli health facilities and 20% of permit applications for their companions were not approved by the time of the scheduled appointment. Also in 2022, 93% of ambulance transfers to East Jerusalem were delayed due to the 'back-to-back' procedure, where patients are transferred from a Palestinian to an Israeli-licensed ambulance at checkpoints due to restrictions imposed by Israeli authorities.[2]

These boundaries make Palestine, and especially the Gaza strip, one of the most densely populated areas in the world. I better understood how people have learned to adapt their

2. https://reliefweb.int/report/occupied-palestinian-territory/fact-sheet-movement-and-access-west-bank-august-2023#:~:text=These%20include%2049%20checkpoints%20constantly,walls%2C%20or%20road%20barriers%20and%20trenches.

lives within these limitations one Sunday afternoon when I joined George Ibrahim and his family on their stroll after enjoying a sweet treat at a local ice cream parlor in Ramallah. We walked a few blocks along one side of the street, and then crossed the street to return to where our walk began. George's daughter, wheeling her baby in a stroller, laughed as she told me that this was how they have learned to create a feeling of variety in their daily recreation.

While driving around Jerusalem, it was clear to me that in West Jerusalem, the Jewish section of the city, citizens received far more of what we in the United States consider basic government services than those living in East Jerusalem, where Palestinian Israelis are concentrated. The streets were clean in West Jerusalem, with no garbage littering the sidewalks waiting to be picked up, as was the case in many of the Eastern streets of the city. And the roads were wider and better maintained in the West than in the Eastern sector, where once off the main thoroughfares, many neighborhoods were without cement sidewalks—just dirt separating the street from the buildings. I heard stories of incessant demands on property owners to file for permits to do even the most minor of upkeep jobs, like a plumbing repair, let alone for major improvements to property as we are required to report in the U.S. These permits routinely involve unusually long waits to obtain in order to begin the job, and then to gain approval documents once the job is completed. One day George Ibrahim spent the better part of his day at a government office in order to pay some theater property-related fees. He said the due date had slipped up on him; I understood that the fines for being late would be considerable.

Generally, this conflict is presented in a bifurcated religious framework between Muslims and Jews, but actually this part of the world is far more complex in its makeup, with many denominations of Christians and other religions with

"Holiday" set and costume designer Fairouze Fawzy Nastas (left) and George Ibrahim, founder and director of Al Kasaba Theatre and Cinematheque (right). (Photo by Carla Blank)

long ties to the land also present in significant numbers. As I recall, George Ibraḥam, the owner/producer/director of Al-Kasaba Theatre, belongs to the Greek Orthodox Christian Church. We had a day off the weekend of their Easter holiday celebration. The cast and crew included a mixture of Christians, Druze, and Muslims. None of the women wore hijabs, and there were no other overt signs of religion-based strictures inside the theater. Outside the theater, the dress ranged from very contemporary international styles to traditional Palestinian as people traveled around the streets full of markets and shops.

The theater arranged for me to stay at the Royal Court Suites Hotel on Jaffa Street. Their ever-gracious staff served a buffet style breakfast which kept me well prepared to last through the daily eight-hour rehearsals. Out of the many offerings, I usually selected a hardboiled egg, toast or pita

bread with hummus or labneh, and some fruit and tea. From there it was just a ten-minute walk up the hill to the theater. I would also walk about the city by myself in both day and evening hours, and never felt in danger.

I also never felt that anyone at the theater was put off when they learned of my Jewish heritage. I was raised in a Reform Jewish family but have been non-practicing throughout my adult life. My father was a Zionist at heart; my mother was definitely the opposite. Their opposing views personified the fifty-six-year-old controversial history that has brought us to this epic tragedy, rooted in a colonial past brokered into law in 1948 by the British. One thing I had experienced on other trips to countries in the Middle East that was especially common among older generations of Arabic men was related to my being a woman: they would not look at me while in conversation, a rule of their etiquette regarding respectful behavior toward all women outside of their own family, regardless of religion. This custom took me a while to understand and get used to, as at first it felt hostile to me. I do not remember this happening in interchanges with those I met in the context of the Al-Kasaba theater community, regardless of anyone's age, perhaps because they were almost all artists.

In contrast, during the second performance I viewed at Al-Kasaba Theatre, I saw how strongly conservative beliefs can rule behavior when a large part of the audience who had been bused into Ramallah from surrounding village communities loudly streamed out of the theater during the first act. Later, George explained to me they were offended by women appearing onstage with bare arms, and stage business by the actors pouring themselves drinks of alcohol, which of course was actually tea or juice.

I was aware of two large political demonstrations during my stay in Ramallah. One happened on May 14, the anniversary of the day after Israel Independence Day in 1948. Palestinians call this day the Nakba (Arabic for catastrophe

or cataclysm). It serves as a symbol for Palestinians' permanent displacement from their homes and lands from that date and the subsequent seventy-five years of Israeli occupation in the Gazan and West Bank territories. A crowd of maybe several hundred stood outside in Yasser Arafat Square, located near the theater, at the top of Jaffa Street, where loudly amplified speakers addressed the crowd from behind a podium set up on a stage constructed for the occasion. The other demonstration I saw looked similar in arrangement and happened in the same square. As I understood, it was organized because a Palestinian man had died of an untreated cancer while imprisoned in Israel for thirteen years. In both demonstrations the crowds appeared to be male only, and even after they had dispersed from the square, I heard car horns honking for hours, as the passengers waved banners and flags, and shouted slogans from bull horns. Neither demonstration was violent—just felt very intense as I skirted around the perimeter of the crowd to return to the hotel after rehearsal.

During the time I was in Ramallah, hostilities between Syria and Israel were beginning to seriously heat up. The consensus among the actors was that it would be better to leave Bashar al-Assad in control of Syria, even though he was running a police-controlled dictatorship. I think they felt the devil you know is better than the chaos to come, as they cited the example of what happened in Iraq, after Saddam Hussein was toppled.

The set and costume designer, Fairouze Fawzy Nastas, let me know she had to miss some rehearsals in order to travel to Jordan to get a visa because she wanted to join a puppetry workshop in the Czech Republic. She was very stoic about all the hoops required to travel outside the occupied territory, probably because she had previously participated in workshops in playwriting, scenography, and puppet theater in Tunisia, Egypt, Britain, France, and Portugal. She was going

to Jordan because she could not obtain a visa in Jerusalem—let alone in Ramallah—as she is a Palestinian.

Conversely, in looking through my directing notebook's papers I found my draft for the text of the *Holiday* program. It contained edits by the Israeli Consulate staff, who had final approval rights. Wherever the word "Occupied" appeared it was crossed out.

Now we watch the extermination of Gaza by airstrikes and ground assault, with many lives lost or changed forever. Will Israeli's decapitation by air be considered more elegant than decapitation on the ground, as Hamas is rumored to have done? Because communication, dependent upon internet and phone connections, will be intermittent at best, we may not know what is happening except to know that Gaza will be unfit for human habitation for many years to come.

Part II

During my time in Ramallah, I maintained a diary by email, a record of my day-to-day experiences while preparing to mount their production of *Holiday*, a Philip Barry play, at Al-Kasaba Theatre & Cinematheque.

March 14, 2013

Leaving on time from NYC

Carla

I am in Ramallah, which is a hill town. Will go to dinner with George Ibrahim, the producer. Full plane to Tel Aviv. No aisle seat. Were already boarding when arrived at JFK.

All is well. Customs was easy. Hotel is fine. Might see Noga [Tarnopolsky, a journalist based in Israel] Sunday as she will be in Ramallah.

Love

C

Had a lovely breakfast at my hotel with Noga yesterday morning. She has been writing a piece about cooperation between Palestinian and Israeli authorities using as an example a case of a man who stole something like a million dollars' worth of bras. She comes to Ramallah by taxi. She said she was in the room where Obama spoke with the university students and is impressed, although she believes he did poorly during his first term.

I didn't celebrate Passover. Not a word about it here in Ramallah, except with Noga, who invited me to come have a sushi dinner with her friends in Jerusalem. But I will wait until this coming weekend to go there to visit Rachel Heinstein [an Israeli friend who I met many years earlier when she was living in the United States and our children were in the same nursery school in Berkeley, California]. Consulate people will check in on me this Thursday, so while I meet with them for coffee, I arranged for the actors to talk costumes with the costume designer, Fairouze Fawzy Nastas.

Yesterday we went onstage for the first time and got about halfway through Act I. (We had been doing script read-throughs around a table up until now, with discussions around the text.) George decided to stay out of the way, which I was glad about—I think his style is more "actorly" than mine, and I do not think it right for this piece—it needs a light touch.

I think the actors like having a lot of freedom to find their way, although who knows what they really think. But anyway we are moving ahead, and two months is really a generous

amount of time to accomplish something, compared to the time I'm usually given for productions in the states.

My new assistant director is really working out well. He pulled all kinds of pieces of furniture out of nowhere so that we could have something to simulate the set-up that will be our stage set. His wife is having a baby soon. One of the actors just found out he will become a father also.

Learned that we cannot actually have actors kissing onstage in Ramallah—but some serious flirting between the actors they thought was ok. Funny negotiations.

Love,
Carla

Hi Ishmael

George went to Egypt to pick up films to show at Al-Kasaba—which has an ongoing film program he curates—so he is gone for a couple of days.

Went to a show by the guy who was supposed to be my assistant director.

Didn't understand a lot as it was performed in Arabic—it was about a musician's experience under the occupation.

Saw what folks are saying about theater styles used here. The actors used movement a lot to communicate character and atmosphere. And also music was used like it is in movie soundtracks. From the way George was talking, I think they like that too.

Have to think thru plans for tomorrow's rehearsal now,

Carla

Hi Ishmael

Got the afternoon off—lots of actors getting sick—they are infecting each other with some respiratory bug, and it seemed wiser to let them rest after our morning session. We do have a lot of time to put this together.

Last night George took me to meet his old friends, Makram and Wadia Khoury. The husband is one of the most famous actors here—Wadia Khoury has performed in some of Peter Brooks' most famous plays—and his wife Makram is a visual artist—they live in Haifa but have another getaway home outside of Ramallah. Was delicious food and in talking over ways to approach theater work Khoury was very sympathetic to what I was saying—George believes his way is the best and he came down with a heavy hand on the actors last night upsetting everyone, including me, without thinking why he was expecting whatever he is expecting so early in the game. But it did make me shift gears—today we just did improvisations, to find character, and that seems a far better way to work with this crowd. Plus they need a physical warm-up which I hadn't done, and it really should be done.

So regroup—somehow it will be done. Editing George's English translation of his Arabic script, which will become supertitles during performances. Interesting to see an Arabic take on this WASP writing style [of Philip Barry]...funny layers in this process.

Planning to go to Jerusalem, to Rachel Heinstein's on Sunday, and she invited Noga too, so will be another pleasant time. Last night of Passover is another reason to feast! The consulate (who cancelled on tomorrow's meeting again) gave me the name of a Ramallah taxi driver to use, so will get that organized too.

Love, Carla

Dear Folks

Just to let you know that all is well—the work is moving forward bit by bit and no surprise that it is very difficult and intense, with rehearsals 6 days a week for 8 hours a day and prep outside of that, besides the complications of working in two languages, with Arabic being the predominant one of the two. But everyone is very kind. The theater is professional; the actors are well trained. They come from many different places and methods of training which can make for some tricky dynamics about how to proceed with the work because many of them are young and think they know best, but it is beginning to settle out now that we have been together for two weeks.

Tomorrow is my "day off" and I will go to Jerusalem to visit with friends. My long time Israeli friend, Rachel Heinstein, who I met when we were mothers in a Berkeley coop nursery school program, and who moved back to Israel with her American husband when he retired, is cooking a feast for the end of Passover. She is a Moroccan Jew and professional cook, so you know I am going to be eating well. I will ride there with another friend who is a journalist, Noga Tarnopolsky, who is doing an interview in Ramallah tomorrow, so I can take advantage of her arranging for a driver she uses regularly, who will also bring me back to my hotel here when the dinner is over.

The hotel is a very convenient walk up a hill—this is a city of hills—and appears to be full of Europeans visitors and those working for an NGO with offices here. I take the free hotel breakfast and eat a hardboiled egg daily, with a piece of whole wheat toast, some fruit, some hummus or other spread—labneh, made with a yoghurt base, and that keeps me going for quite a while.

Otherwise I have been fully immersed in Palestinian society—which can be Christian and/or Muslim—and have been treated very kindly. I understand Ramallah used to be pre-

dominantly Christian, but since the 21st century hostilities its Muslim population appears to have grown quite sizable, —(I am hearing a call to prayer in the distance right now) and here I am talking from my observances of dress, and how the town largely shuts down on Fridays, and is open on Saturdays, somewhere more in between on Sundays. Tomorrow is Easter here, at least for some Christians, so it will be interesting to see how that is observed. But I know for instance, that the theater will run as usual. George Ibrahim, the director/producer comes from an Arabic Christian family, but he does not practice any religion.

I didn't see anything in the area I live in to indicate Obama's visit here, no signs or demonstrations, although I heard signs were defaced in other parts of the city and there were demonstrations against him. My friend Noga covered him, and she said he got her in his pocket—that he couldn't have handled it better (unlike in the beginning of his first term when she said people here thought he could not have handled it worse).

So do not worry about me. I am being very prudent about my comings and goings. This hotel is very safe. And anyway, I barely have much time to myself.

Please let Mom know that things are working out okay. Much love,

Carla

Hi Ishmael

Things are moving forward here but still find I cannot fully participate because of language block—supposed to get another act in an English translation of Arabic script the actors are actually using today—not a small matter since the original version has been edited and some lines have different meanings. Trying to think how to present the best face on this

to the Consulate people when I meet with them this Friday. Probably the production will be fine as we still have 6 weeks (opening is now set for May 14 and they will tour this area too), and George will be fully involved. Very stressful—as any production—but extra kick because of the language separation. My mind is not coming up with fantastic ideas yet. But little by little, as the motto goes here.

Much love,
Carla

Hi Ishmael

Yes of course. I have to give a positive spin to the Consulate people. This is a little more than usual pre-performance anxiety—I am sure a big piece is the language block but also this is a difficult play to find justification to do today. But slowly, slowly I am making contributions. Probably movement will be a big piece of what I do, and there will be a lot of it throughout, including having the actors serve as their own crew, moving the set pieces between scenes.

After stumbling awhile, today we concentrated on the opening scene of the play—it is starting to make sense in terms of style and approach.

Dear Ishmael

Just waking up here, having Peets coffee from the French press coffee maker the Heinsteins loaned me. Getting picked up at 10:30 to go to the Consulate in East Jerusalem. Will let you know how it goes. Come back here in time for the afternoon rehearsal.

Got a glimpse of the expensive areas of Ramallah last night, that I don't think I had been in before. A Movenpick Hotel here—am told there are lots of Germans in Ramallah.

Drove past the building with Arafat's tomb. There were a few peaceful demonstrations in the main squares, for a man who died while in an Israeli prison—was told he had been there I think 13 years and died of cancer not treated. The party was full of lovely singing, dancing, good food. It turned out to be the birthday party for George's girlfriend. These folks know how to party. A lot of my young cast was there helping to keep the singing going. Discovered one of them, the young woman who stays here at the hotel also, sings American jazz music. Very good voice. Maybe work that into the show. It would fit with her character.

Love,
Carla

Dear Ishmael

Sending you here my first try at Program Notes from the Director—wondering if it is too flat, or says enough. Your advice please.

It has been a great privilege to work with George Ibrahim and the Al-Kasaba production crew and this wonderful group of actors over the past two months. When George invited me to join this Al-Kasaba Theatre production of Philip Barry's 1928 play *Holiday*, he said he chose the play because it is a romantic comedy. Upon reading the script, I was surprised at the choice, as it was centered upon an upper class, extremely wealthy WASP American family living in New York City the year before the Great Depression began—about people we now refer to as members of the 1%. Beginning rehearsals in Ramallah, we agreed to update the play to 2013, but struggled to find a concept to guide our choices for actions until three weeks into rehearsal, when we decided that what made the most sense was to perform the script as Palestinian Americans living in New York. [As the Al-Kasaba program explains, this was consistent

with the fact that "around two hundred thousand Palestinian Americans are living in the United States today and some are very wealthy."] So we have shortened Barry's script a bit to quicken the pace while maintaining all plot developments in the original play, and where we have made adjustments to Barry's text, it has been to keep the characters' biographies believable as Palestinian experiences in America, to bring everything into the present time, to conflate 3 servants into one all-purpose servant, and to find comedic devices in movement, mask and puppetry, to present some of the conflicts that come from being Palestinian and American.

Will write later, as still in the theater—trying to get set design moving forward.

Much love,
Carla

Back at the hotel now. Arranged for one carpenter to build set pieces and another who does upholstery to build the pieces that needed fabric coverings. So the set is really underway at last. Long day.

George arranged for one of his academy staff to do the choreography which I was not coming up with, so that is a big relief. I can be a figurehead in peace now....

Much love,
Carla

Thursday, April 18

Big change of plans in the works here. This has happened because on Monday one of the lead actresses in the play called in that she would have to have major surgery this coming Monday and the recovery would require her to not rejoin the production for a minimum of 3-4 weeks. So this

made it necessary for her to end her contract for the play. Amazingly, another actress who lives in Haifa was found within a couple of hours of this news, via Facebook, who is said to be strong enough and is definitely as beautiful as the part requires, but her prior commitments will not allow her to join this production until April 27. She has been sent the script, so she is to arrive with her lines memorized but of course she has to learn all the blocking [staging] and create/understand her relationships to the other characters in the production, as they see it. As this character is in 80% of the scenes in the play, this is no small matter.

In a snowball effect, although not all new dates on the production timeline are figured out as yet, this means that the opening of the show will probably be pushed until May 30 or at earliest two days before that, due to a prior commitment of another of the lead actors which takes him out of the country for a week. The good news is that this is giving me and everyone a couple of much appreciated breather days in the short run but for me also brings up the as yet unanswered question as to whether I should/will remain in Ramallah or leave as planned on May 18.

Yesterday the Al-Kasaba producer, George Ibrahim, and I met with the U.S. Jerusalem consulate officer who is probably the one responsible for my being here. In talking privately with me at the end of the meeting, he said I should make up my own mind as to what I want to do. Presently, I feel ambivalent—would appreciate seeing how the production turns out but also would like to leave here—although it is interesting to be here in such an important area of the world politically and culturally, truly not in love with Ramallah and of course there is being away from home and family so long—although Ishmael says that even though they miss me, it is up to me, and he and Tennessee can manage. (He also says it is peaceful and quiet there, although [I] hear a somewhat different story from Tennessee....!)

The actors were given 4 days off and tech aspects of the production are continuing to move forward during this time of waiting for the new cast member. Currently the plan is to have all these aspects of the production—coordinating set, costume, sound, translation of the text for supertitles, preparing cue sheets—in place by the beginning of May, although the wife of the assistant director, with whom I will do this, gave birth to a baby daughter yesterday morning so he is naturally concerned with them at the moment.

Was given a break yesterday afternoon—even took a nap—so not up on the latest details.

Otherwise, an international contemporary dance festival, Sareyyet Ramalleh, is going on here this week, with many of the events produced at Al-Kasaba, so it is easy for me to get to some fine evenings of dance. Have been to two evenings so far, with quite a few more to go. Opening night was Maguy Marin Co., from France, doing a new work, "May B," based on the writings of Samuel Beckett. They are an excellent company which I have seen a few times in Berkeley over the past 30 some years they have been creating work—and last night was also quite good, by Athanasia Kanellopoulou, a solo artist from Greece in her work titled "In lo(e)verland," and a puppet/dance theater quartet in "Bobroshkov's Dream," by the Abalino Dance Theatre, which as I understand is based in the UK, but this work's cast is from Norway. Tonight is another company from France and one from Switzerland, all of which I have never seen because as far as I know, most of these groups do not get to tour in the U.S., especially not to the SF Bay area. Actually seeing more international dance companies here than I get to see in the San Francisco Bay Area!

The festival is featuring dance companies that incorporate performers with disabilities—in the opening night ceremonies they showed a video which explained that because this is a war zone, there are many people with "differences," their word, and that this is a natural part of life, and they

want to help people feel they are not excluded from life because of their differences. Will miss a group from Ireland on Friday, as that had been scheduled as a day off and I had already planned to go into Jerusalem for the day, to go to the Israel Museum with my old friends the Heinsteins, to see a show on King Herod that is said to be excellent, and I won't return here until after dinner with them. (This is my long time friend I mentioned in an earlier letter, who is the great Moroccan-style influenced cook.)

Just came back from checking in at the theater. Hardly any of the administration there, so I guess everyone needed a breather, and sounds like schedule planning is still in flux, as I explained above. Will let you know, as soon as I know, how all these changes settle out. Such is theater; such is life.

Love,
Carla

Good evening folks,

The beginning of another day off (well I can pretend it will be a weekend off, but actually going into the theater tomorrow, Sunday, to figure out music selections) so thought you'd like to hear that all is well.

We have now visited a little less than half the scenes in the play—feels like the play is getting longer—and in fact we are beginning to delete some of the repetitive talk.

But of course, much of this feeling is because these actors really like to talk out their actions, their sub-text, and it takes so much time that I am sure it will be a surprise when everything gets run in order for the first time, and we can see how the whole play feels.

The set design has to get settled this week, and that will make a big difference when we really know what kind of

chairs and tables and playing areas we will have. Then a lot of details can be filled in, including the set change transitions between the scenes. Little by little is the motto.

I went into Jerusalem on Friday to meet with the U.S. State Department Consulate people—the ones who got the grant to do this play. They are all people we know: one for many years who will retire from State Department service at the end of May and go off with his wife and motorcycle to live out their dream life on the Big Island of Hawaii; and the other two whom we met in September when we visited East Jerusalem for a week. I assume they are the reason I am here.

So I took them the original American English script by Philip Barry, George's translation into Palestinian Arabic dialect of a classic Arabic translation, and his daughter's translation into English of his Palestinian Arabic version— which is how I can follow what is going on in rehearsals and what will also be projected as supertitles during per- formances in Ramallah and Jerusalem. (The play is also scheduled to travel to Hebron and Bethlehem and maybe another town. Of course the actors want it to go to Europe and the U.S., but nothing is planned that I know of.) At any rate, the consulate folks seemed happy about how things are going, and I was whisked back to Ramallah to join the afternoon rehearsal. One piece of gossip one of the con- sulate staff told me was that Al-Kasaba Theatre was built as a gift to George Ibrahim by a wealthy French Jewish woman who was his lover (George had only told me part of the story)—she paid for the whole building complex. She is no longer alive.

There was another wonderful party night this week— given by George for his present lady friend—turns out it was her birthday. She is an interior designer and on his board of directors. Lovely person. Lots of good food, good singing and dancing. These folks really know how to party. There

were some famous artists in the room besides George, who was really famous as an actor throughout Israel I am told, I think appearing in popular TV series in the 80s and 90s. Besides Makram Khoury who I mentioned meeting in my last letter, who has done a lot of work with Peter Brook, there was another actor and director, Mohammad Bakri, very tall. (*Holiday* calls for a picture of the family's grandfather to be in Act I and Act III and the cast put up a photo of Bakri when he was a young man—I was astonished to meet him and see he could be someone's grandfather now.) They are all longtime friends and sang a song that they all sang together in a performance a long time ago.

I know if you watch TV, you probably think things were very hot in the West Bank this week, as I saw on BBC coverage, but the news reports can be likened to how we feel in California when people call us up because they see reports of forest fires and think the whole state is burning. Some quiet demonstrations here, but everyone says Ramallah has always been a cool spot.

Just inside this very cold theater, where I end the day wrapped in my sweater coat and wool stole, it can get very hot!

Love,
Carla

Dear Ishmael

Saw Candoco Dance Company from United Kingdom last night performing a Trisha Brown iconic 1983 work, *Set & Reset*, and it continued to hold up well in their version by disabled and non-disabled dancers, *Set & Reset/Reset*. Looks like her legacy to dance is assured. They also performed "Looking Back," by Algerian/French choreographer Rachid Ouramdane, that incorporated live video images and sound

score.

Yesterday learned the new actress will not arrive until May 1. I think they are still working on the schedule. Am trying to get more information.

Love,
Carla

Dear Ishmael and Tennessee,

Just came back from the theater, where George and I talked about when my departure to the U.S. will be. He says we have to wait a few more days for the decision because he is going through consulate channels for financial arrangements. But we agreed, that if it can be arranged, I will stay until June 1 to see the project through, and they arranged a reservation on a June 1 flight, but that is just to hold a place—not yet changing from May 18 reservation. The premiere is set for the evening of Thursday, May 30.

As with everything on this project, takes a lot of patience.

Love,
Carla

I was surprised tonight to see a dance company from Ramallah (Sareyyet Ramallah Contemporary Dance Company) performing a piece called "Ordinary Madness," that could have been from anywhere, except that they were speaking in Arabic at times. The program described the text as "giving an overview of the Palestinian life under modernity rule and asking the audience to reflect on it." So except for the subject of text, was amazed how international dance aesthetics have become. Wish were not so much.

Only TV I see here in English is BBC and a French news network, although maybe a couple of missionary channels.

Otherwise hundreds of channels are available, mainly in Arabic, from all over the Middle East and North Africa, although maybe some other places. One shows pilgrims circling the Holy of Holies in Mecca, 24 hours a day I think. I didn't realize that went on all year long. Or maybe this is just a recording of the annual Hajj pilgrimage...another sign that I am only partially understanding the life I see here.

Yes trying to mix some relaxing times with the rehearsal world. Thats why tomorrow I will go to visit with the set designer and her family in Bethlehem and probably Thursday will go into Jerusalem to the Old City with Rachel and Noga. I think once May 1 comes and the new actress is here, it will become very intense again, so best to take a breather.

Love,
Carla

Just waking up and sitting down to check email with coffee made from the little pressed coffee maker the Heinsteins loaned me.

Looks like the sun has decided to shine here after days of cold and even wet—everyone saying very unusual, but I think that it is another moment of the earth's new normal. While waiting outside of the theater for one of the international dance festival performances, was all wrapped up in the warmest clothes I brought with me. Passed the time in conversation with Adeeb Safadi, one of the *Holiday* actors. He reminded me that we are living in a desert, which can get very cold at night. Easy to forget Ramallah is situated in a desert, with all its buildings, garden pockets, and hustle and bustle going on around town day and night.

Good evening Ishmael

Just back from my Bethlehem adventure. Did not remember it was such a hill town when we visited there, but maybe because we approached it differently, from Tel Aviv.

The Nastas family was lovely. There was a gathering of the clan to welcome a cousin who lives in Australia and had only met them once before in his life, so it was like Christmas or an Easter gathering. Actually Orthodox Easter is in 2 weeks, so stores are full of Easter bunnies and such.

Back at the hotel, from Jerusalem, and going to a performance at Al-Kasaba in a bit. Had an unfortunate blow-up happen between Noga and Rachel Heinstein with me in the middle.

The Israelis are as hard to understand as the Palestinians. Not used to hearing people yelling in public like that—I think triggered by a confusion about what restaurant site we were to meet at. And also because I was half hour late last time for our meeting at the Israel Museum, due to breakfast with Noga. Should not try to manage to see both of them on the same day. and actually who knows if I will have another day off to go into Jerusalem.

Became very hot weather here overnight also. My hips may appreciate that, I hope.

Love,
Carla

April 26

Dear folks

It's Friday here and have a day off, so taking advantage of some free time to catch you up on my most recent Palestinian adventures. Some of you have heard bits and pieces of this part of my tale, so please indulge me if I repeat myself.

Plans are still in flux as a result of one of the main actresses becoming too sick to continue with the production and having to wait for her replacement to arrive May 1, after her present commitment, when her part in a film project is completed. Although the premiere has been rescheduled for May 30, I still do not know if I will return home on May 18, as originally scheduled, or if my trip will be extended until June 1. As this project is happening through a grant from the U.S. State Department to Al-Kasaba Theatre, the theater's director, George Ibrahim, has requested additional funding through Jerusalem's U.S. consulate, to cover my additional hotel and per diem costs, and we are awaiting their response. That pretty much determines my departure date, although we all agreed, including Ishmael and Tennessee, it would be best if I could see the project through to completion and they will try to make that happen one way or another. They have arranged an airline ticket reservation change for June 1, thinking positively.

Because of waiting for this replacement actress to appear, even longer than we first understood would be the case, this has been a pretty relaxed week for here. Most rehearsals of scenes are on hold because the character the new actress will play appears in about 4/5s of the scenes in the play, and it is difficult to continue to work without her. Many of the actors have scattered to their homes outside of Ramallah, or elsewhere, doing other work projects. It appears they all manage to have very active careers, even though I hear complaints about the poor state of the arts here.

Meanwhile we did continue to move forward on set and costume preparations—heard today that we will be able to rehearse with most of the set pieces in place, starting next week, and that will be very helpful. And we have been writing up the copy for the program booklet.

George surprised everyone with an excellent solution to his wish to have background music based on the waltz. His composer friend, Said Murad, took a haunting Arabian

Sculpture by Fawzy Nastas outside the Nastas' family home
in Bethlehem, Palestine, with two of his grandchildren
taking a ride. (Photo by Carla Blank)

waltz—I'm not sure if it was his original composition or by
another composer—and created a variety of arrangements
to occur throughout the play. Adds another layer that holds
everything together. So the work goes on. Those are big items
on the production's To-Do list.

And I got out of Ramallah twice this week. One day I
took a local bus to Bethlehem, where I was invited to visit
the family home of Fairouze Fawzy Nastas, a young woman
who is the play's set and costume designer. Both her late
grandfather and father are famous sculptors in Palestine[3].
(Actually their home is in the nearby town of Beit Jala.[4])

3. https://www.pef.org.uk/the-stonemasons-of-beit-jala-making-the-
 stones-speak/
4. Beit Jala is "a Palestinian Christian town in the Bethlehem Gover-
 norate of Palestine, in the West Bank. Beit Jala is located 10 km

I had been to Bethlehem briefly, on one of our previous trips to Israel, but did not remember how it is situated in the midst of vast and stark mountains, in a landscape of scattered stones and dust. It is just amazing to me how humans can have wandered the earth across such expanses and then decided where they wanted to create a settlement in the middle of lands that otherwise still look mostly uninhabited. But of course, as we made our way through the mountains there were now many villages tucked along the roadside, and goats, donkeys, horses and sheep were nibbling away at the grasses that the recent rains must have encouraged, besides industrial zones whose purpose I could not figure out for sure, but likely they serve as electrical power stations for the area.

Fairouze's father, Fawzi Jiries Nastas, had just shipped off two huge full body stone sculptures of saints for a church in New York City—he could not remember the church's name for me to tell you. Most of his commissioned work is within the traditions of classical Christian church art, including beautiful carved stone pedestals for the statues, often in elaborate Corinthian style although also the simpler Ionic too. There was a spread-eagle bas relief that Fairouze said was the model for a series of eagles her father carved for the American embassy or consulate buildings, don't remember which. And outside of the house, standing guard by the front door, there was a work by her father that had been commissioned by a West Bank university: a full body length statue of a Palestinian hero, Abd al-Qadr Al-Husseini, whose original head and left arm had to be replaced, Fairouze told me, because Hamas followers had destroyed them when the statue was placed in one of Bethlehem's town squares.

Her mother is a great cook, and I was especially lucky because a young male cousin who lives in Australia was visiting—most of the family had never met him before so everyone

(6.2 mi) Ten km south of Jerusalem."

in family who is currently in Bethlehem turned out (there must have been at least nine little girls there who are daughters of 3 of Fairouze's 5 sisters—no male grandchildren as yet. There is one brother, the youngest child, now living in Hungary and two unmarried sisters living in Cyprus.) It was like a holiday feast with roast chicken, a classic mixture of rice with almonds and onions, fresh green salad, green chick peas from the garden (a seasonal delicacy), stuffed zucchini and stuffed grape leaves from the garden, goat milk, yoghurt, and oven-roasted eggs from their own hens, and for dessert, Turkish coffee and tea cakes with dates and nuts. Fawzi built the home, I think in the early 1980s, and there was beautiful Palestinian marble of varying hues from various sites in the area throughout the house, for floors and stairways, railings and even tables and shelves, etc. Plus handcrafted furniture and pottery, among other crafts and fabrics for pillows and upholstery, many of the best possible quality of handwork, especially in a large formal room upstairs that we viewed but did not use, that is like a museum and I think is saved for the most special occasions. (Fairouze and her mother showed me the difference between even what is considered good embroidery, done for tourist sales, and what is respected by the locals, and you have to have a good eye to notice how things can be not finished just so. Actually Fairouze and I had just purchased some pieces to use to cover chairs in one act of *Holiday*, knowing they would not be perfect but fine for our purposes with long distance viewing from the stage.) The outside of the house and at least one window has bullet holes that Fairouze showed me, from various dates of the series of intifadas since the '80s, because, as I recall her saying, it is located near a settlement that became the focus of much fighting, and their home was on a known "escape" route through people's gardens. All appeared very peaceful now.

Yesterday went to Jerusalem for the day, to visit the Old City, entering by Jaffa Gate, to look around and spend time with my friends that I mentioned before, Rachel Heinstein and

Noga Tarnopolsky. Had a rather uncomfortable moment of recognition about how serious food is to Israelis, when these two locked horns, first over where to choose to eat and then after an honest confusion about where the actual restaurant was located in the Old City, and as a result, who had made whom wait to arrive. The good news is that neither is mad at me, thank heavens, and I now know not to try to mix visits with them both at the same time. But was fun to wander the souk, over the stone streets smoothed by people walking them since at least the time of the Romans. Went into streets new to me, all with incredible fabrics, food, cheap and expensive tourist items, religious icons, carved woods, pottery, gold and silver jewelry and other items, in shop after shop lining the streets. Everywhere was jammed with tourists. However, one shopkeeper explained that business was not as good as it looked, because lately the tourists have been coming into Jerusalem by bus, on day trips, rather than staying overnight or longer, because Jerusalem, and Israel generally, is more expensive than many places in the Middle East.

Came back to Ramallah in time to see two productions of "Romeo & Juliet" last night, one in German by student actors from Essen, Germany, and the other in Arabic by graduating students from Al-Kasaba's training program, under the direction by a Tunisian, Ghazi Zaghbani. Both turned out to be very well done, with modern twists—the German one had 5 Romeos and 5 Juliets and all the actors doubled as musicians. The theaters have an ongoing exchange program—both productions are performed in each originating city, and they are largely funded by the German government under a program that George said will run for at least 3 more years.

Also saw more dance festival concerts last week. Didn't see all the companies (they came from Switzerland, France, Germany, Tunisia, Egypt, Britain, Ireland, Norway and Palestine) but saw the majority of the concerts and am amazed at how international modern dance style has become.

Was touching to see one of Trisha Brown's most famous works, *Set and Reset*, mounted on a British company called Candoco, that claims to be the leading company of non-disabled and disabled performers—recognized one as he was in a wheelchair and another woman who had a prosthetic arm, but not sure if there were others. I had missed what was officially announced as Trisha's final new work, as she is very ill, when it toured to Berkeley during this time I have been in Ramallah, so very touching to see how her works will continue to survive, even internationally. They pretty much got the spirit of her style—it was definitely her work.

The festival is now finished, and starting tomorrow we are back into long rehearsal days. Not sure if there will be any more days off but will be a relief to see this work finally come together. And after the days of rain and cold, it is now warm, even hot here, although the theater is still probably an ice box....

Will let you know my date of return to California, as soon as confirmed.

Love, Carla

Just getting up here. Sitting down with my first cup of coffee.

Today is a long day—rehearsal, performance, and then dinner party at George's house for all the young actors from Germany and Al-Kasaba after their performance. Rehearsals continue onward including Sunday (Friday is like Sunday here, even though lots of Christians.)

I hear Israel attacked Syria again last night.

Good evening Ishmael,

Just was dropped off by George from the meeting the Consulate arranged. Turned out to be 3 America House people new to

me, plus Palestinian writers, an arts administrator (Mahmoud Darwish Museum director), and an American short story writer from South Carolina, whose name is escaping me, who is the second writer brought on the consulate program of which you were the first as I learned tonight.

No news about my return date. Still sounds like more paperwork is required from the theater before the consulate can approve the budget.

However, the Consulate people did say they think there will not be war with Syria, and that I would get a red alert very quickly should there be a change.

Ramallah continues to be very calm—haven't noticed any posters, no loud speakers going thru the streets as did happen when a Palestinian died in an Israeli prison and for some other prison-related event. Just everyday life—really lots of people out shopping for food especially, and clothing, electronics, etc.

Love,
Carla

Long day here. George has turned over directing to Yussef Abu Warda, the older actor playing the father—I think I may have already told you this—today he tells me Yussef can work the actors thru to May 15—he is checking everyone's motivations for each action and is stripping away the staging that George did, which was showy but did not work for the actors or the play, so I am glad to see this, and hope George does not reverse things again.

Love,
Carla

that's show biz, right? IR

Thought you'd enjoy this piece of news, [*that*] greeted me when I came in just now, after rehearsal ended at 10 pm.

George told me everything has been arranged for me to stay through June 1.

Postscript

The Al-Kasaba premiere of "Holiday" played to a full house. Among the audience were the Consulate people, my friends CNN commentator Noga Tarnopolsky, Rachel Heinstein and her husband Jonathan, who arrived with Fadi, my trusted taxi driver and his wife.

The supertitles were appreciated, and I felt good about the production's success. I think George Ibrahim and the cast agreed.

Fairouze Nastas had already left to work on another production. Muaz Al Jubah, the lighting designer/tech director, who was a pleasure to work with, told me he thought it was a good show, but had held even higher hopes for how we could have realized a great production. I laughed because I feel sometimes I fall short of greatness. Who doesn't?

After viewing most of the second performance the following day, I left Ramallah. I regretted that I was not able to say goodbye to the actors in person. My handwritten notes to them would have to suffice. However George, the project coordinator, Suad Rishmawi, and I had a lovely lunch earlier in the day, where we thanked each other for the experience.

I arrived at Ben Gurion Airport in Tel Aviv way ahead of departure time, but quickly became worried I would not make it home that day. At the last possible moment, I was cleared to board the plane bound for New York, the final person to be seated as the doors closed behind me.

The problems started when, in response to questions by airport security personnel, I explained that my place of residence since arriving in Israel had been Ramallah. Even show-

ing papers confirming the U.S. Consulate's approval of my trip and the reason for my stay did not grant me ready access to the plane. Looking grim, the security personnel meticulously went through all of my luggage. Twice! Inshallah—all turned out well and there were no more surprises for me or my luggage on the rides to New York, where I went through customs without a hitch, and boarded my connecting flight home to the San Francisco Bay area.

Printed by Imprimerie Gauvin
Gatineau, Québec